Busy Woman's Organizer

Susan Tatsui-D'Arcy

PRENTICE HALL
Paramus, New Jersey 07652

To Rob, Nicole, and Jaclyn

Acquisitions Editor: *Ellen Schneid Coleman*
Developmental Editor: *Sybil Grace*
Production Editor: *Jacqueline Roulette*
Formatting: *Robyn Beckerman*
Interior Design: *Christine Gehring-Wolf*

Printed in the United States of America

10 9 8 7 6 5 4 3 2 1

ISBN 0-13-655424-5

ATTENTION: CORPORATIONS AND SCHOOLS

Prentice Hall books are available at quantity discounts with bulk purchase for educational, business, or sales promotional use. For information, please write to: Prentice Hall Special Sales, 240 Frisch Court, Paramus, New Jersey 07652. Please supply: title of book, ISBN, quantity, how the book will be used, date needed.

PRENTICE HALL
Paramus, NJ 07652

A Simon & Schuster Company

On the World Wide Web at http://www.phdirect.com

Prentice Hall International (UK) Limited, *London*
Prentice Hall of Australia Pty. Limited, *Sydney*
Prentice Hall Canada, Inc., *Toronto*
Prentice Hall Hispanoamericana, S.A., *Mexico*
Prentice Hall of India Private Limited, *New Delhi*
Prentice Hall of Japan, Inc., *Tokyo*
Simon & Schuster Asia Pte. Ltd., *Singapore*
Editora Prentice Hall do Brasil, Ltda., *Rio de Janeiro*

Contents

Part Two
Caring for Your Children: Parenting

Chapter 6
Get Help: Managing Child Care 115

Chapter 7
School Days 147

Chapter 8
When School Is Out 167

Part Three
Doctors and Lawyers:
Medical and Legal Planning

Introduction

If you're like most women, you're working harder than your mother did and juggling many more responsibilities, too. The electronic age has brought information and entertainment to us in seconds. Unlike our mothers, we are working full time and managing our households, caring for our children and husbands, worrying about our aging parents, and trying to squeeze in some time for fun with our families and friends.

We want it all—great jobs, wonderful children, happy marriages, healthy parents, close friendships, and time to enjoy them all. Well, after a long day at work, doing the laundry, shopping for groceries, carting the kids off to Little League and dance lessons, picking up Mom from elder care, who has time to clean the house?

When was the last time you had a leisurely dinner with your husband—alone? Are your weekends consumed with "catch-up activities" and projects? Do your conversations center around discussing who's picking up the kids, who's buying the gifts for birthday parties, and what to do about the problems of Dad's failing health?

Life's short timeline isn't well balanced: We work full time, raise children, and at the same time, care for our aging parents. Then, when we retire and have time for our families, we discover that the children are grown up, parents have passed away, and the nest is empty. During those busy years, it is essential that women get organized, so they can enjoy the wonderful things that are happening.

With the rising cost of education, housing, and living expenses, many women don't have the luxury of staying at home with their children. All the same, they are still responsible for clothing, feeding, educating, socializing, and loving their children; often while working full time and commuting long distances to work, sometimes without the help of a spouse.

To add to the stress, inevitably our parents reach the end of their productive years and enter the downhill slide where their health, mental alertness, and ability to function on their own dissipate. We struggle to manage and maintain our households while facing difficult choices about our aging parents. In many instances, our parents and siblings may be in denial, adding yet another level of stress.

Today, more than 50 percent of marriages end in divorce, leaving thousands of single women as heads of their households. Working full time, raising children, and caring for aging parents make us very busy women. But don't throw in the towel. Get organized and use your precious time carefully.

Do you feel that it's impossible to do all the things you would like to do? Do you feel that you're not enjoying your life—marriage, children, or job the way you would like to? Do you spend time worrying about the welfare of your children with their child-care provider or school?

Well, take a deep breath. Combining work schedules with changing diapers, hiring child-care sitters, cleaning house, and finding adult day care *can work*. I've helped organize hundreds of families as a Time Management Consultant and have written the *Busy Woman's Organizer* to help you regain control over your life.

This book is intended to help organize the busy woman. Whether you're single, divorced, widowed, married with a nonparticipatory husband, or happily married, you'll find helpful tips and forms to give you more control over your time and life.

You will be surprised how smoothly your household can run when you use the forms in this book and reorganize your family. Effective time management techniques will give you more time for yourself. Recruiting family members or hiring a housekeeper will minimize the time you spend cleaning the house. Keeping track of important dates will take the worrisome burden off you. You'll have peace of mind knowing that your children are well cared for until you get home. If you decide you need in-home help, you can enjoy coming home to a clean house and meals on the table. By organizing carpools, you can spend less time driving and more time with your children. Managing your time efficiently will allow you to enjoy giving parties for your children, planning for vacations, and moving to a new location with ease. If there's an emergency, you will have already completed the most comprehensive Emergency Form available. You'll be prepared for disasters, and the whole family will be properly educated about what to do. Filing insurance claims will be easier since you'll have written and video records. When it becomes necessary to take control of your parents' care and estate, you can get a sense of control over their future, as well as over yours.

And finally, in the case of death, your family will have clear information about your desires. All of your decisions about guardianship and the estate will be clearly documented. Now, get going! Take control of your life and enjoy it!

Part One
Managing Your Household

Chapter 1

Time Management and Housekeeping

Keeping track of each family member's schedules, planning meals, making shopping lists, running errands, cleaning house, hiring and setting up a housekeeper, or setting up a recycling center all take good planning. Managing your time effectively can mean the difference between a calm, consistent, dependable home and a chaotic, frustrating home.

Eight Ways to Better Manage Your Time

Time management is really a frame of mind. Organize your days so that you accomplish all of your goals. Set priorities to ensure that all the important activities and tasks are done in a timely fashion.

Use an Appointment Book

Your appointment book should be with you always. Keep an erasable ink pen and a highlighter in the appointment book. Write everything down. Enter all appointments along with routine activities (Jaclyn to dance lessons on Fridays at 3:30; Ross to soccer practice on Tuesdays and Thursdays at 4:00). This will help avoid double booking your available

3

time. If you enter all of the scheduled activities for their duration (usually eight to ten weeks), you'll be able to easily schedule errands in the same part of town.

When booking routine visits for dental, medical, or other appointments, look at your appointment book and try to schedule a day when you'll already be on that side of town. Set up your appointments to meet *your* needs. Your schedule should allow you to go from one appointment to the next scheduled activity with just enough time to get there comfortably. Try not to schedule appointments with large gaps of time between them. If it's unavoidable, save your shopping and errands to do between appointments. Bring along reading material or projects that you can do while you wait. Include the errands and shopping in your appointment book. Change your schedule until it meets your needs. You'll be pleased with the amount of time you save simply by setting your own schedules and deadlines.

Screen Your Calls

When you get home from a hectic day at work, you want just a few minutes of peace and time to find out what went on in your children's day. The phone seems to always ring while you're eating dinner, giving baths, or reading stories. How can you have family time and time for friends and other calls?

Your home should provide solitude and privacy for you and your family. But if you're like most people, whenever the phone rings, you drop whatever you happen to be doing and run to answer the phone within two to three rings. If this happens to you a lot, chances are yours is not a peaceful home. Purchase an answering machine with the call-screening feature. This allows you to hear the caller's message. You can then answer the phone, if it's a call you want to take; otherwise, you can return the message at your convenience.

Many calls made in the early evening are from telephone salespeople trying to sell you something you don't want. Other calls may require that you retrieve information from inconvenient locations in your home, requiring that you stop everything to run to another room. Some calls can be easily returned the next day from your office, or after the children go to sleep.

Return calls and leave answers to the caller's questions on the caller's home answering machine the next day. In less than one minute, you have returned the call. It also helps to cut out idle chatter that you may not have time or desire for.

You can also respond to calls by writing a quick note or sending e-mail. The note takes only a few seconds to write and eliminates lengthy phone calls with long-winded callers. Again, you're respectfully responding to their calls, while maintaining control of your time.

Make Time for Yourself

Despite taking care of your job, your husband, your children, your friends, your family, and your home, you still need to schedule time for yourself.

It's a good idea to block off at least one hour per week, depending upon your lifestyle, so you don't completely fill your days. Personal space always seems to get squeezed out if you don't consciously set time aside. Take a hot bath, read those magazines that have been piling up, browse your favorite book cafe, shop for your clothes, or give yourself a manicure. You don't even necessarily need to leave your home as long as everyone knows that this time is blocked off for you. If it is impossible to stay home and have private time simultaneously, arrange to have your spouse, caregiver, or friend stay with your children while you go out for your private time. It is wonderful and rejuvenating to have quiet time to do things for yourself. You deserve it!

Schedule Time with Your Spouse

Remember those wonderful times B.C. (before children), when you would spontaneously go out to dinner and see a movie? Do those romantic walks on the beach or at the park seem as if they took place in past lives? Raising children and working often consumes 100 percent of your time and energy.

If possible, try to arrange to have a caregiver entertain your children once a week, every other week, or once a month. Schedule it in your appointment book. That way, you don't accidentally fill the night with another activity. Once you have a routine set up, you can look forward to that special time with each other.

Even going on "dates" once a month will give you the opportunity to stop the daily treadmill and spend quality time together. You can even "talk shop" and discuss your child's disposition without worrying about whether the children will hear. If there are problems with your children emotionally, academically, socially, or physically, discuss your plans to remedy the situation. It's nice to be able to sit back and appreciate those special relationships in your family. Sometimes it is difficult to appreciate your good fortune when you're working hard.

These "dates" can help to keep your marriage and your relationships alive and well. Enjoy your time together. If finances are a concern, your date can take place at a book cafe where you sip coffee in a warm comfortable atmosphere, at a park or at the beach, or even at home (make sure the children are visiting friends).

Trade Caregiving with Friends

Another alternative is to trade child care with other couples, if "date" nights or babysitters cause financial strain. Offer to watch your friends' children once or twice a month and, in turn, they will watch your children. This allows you to have your personal and/or date time without the added expense of paying a caregiver, and it also helps to remind you to take your personal or date time. If you would like to set up frequent dates, organize trades with several sets of friends. Everyone wins!

Sign Up for Activities

If you're inconsistent with your personal time, sign up for art, music, or dance classes. Scheduling activities and paying fees will force you to take the time to do enjoyable activities. Join sport teams or clubs such as softball, tennis, golf, and running. You'll get in shape and get out and about. Try getting season tickets to your favorite theater, symphony, or sports events.

Allocate Responsibilities

Allocating responsibilities helps to keep your household together. If your schedule looks as if there really is no room to get it all done, delegate the responsibilities. There are always some errands, shopping for your personal items—for example, makeup, clothing, important gifts—that you'll need to do yourself. But other tasks, such as picking up the dry cleaning or developed photographs, can be done by anyone—even your spouse! Ask him to pick up items and drop things off on the way home from work or during the lunch hour.

It's not a good idea to rely on verbal communication alone. When signals get crossed, it's sure to lead to arguments. Write detailed notes, listing the date, time, location, directions, and details about what to pick up, buy, or drop off. If the responsibility involves the children, be clear about where and when the children are to be picked up or dropped off. Leave information about time frames and phone numbers.

Spouses who use appointment books usually complete the tasks on time. Those who don't use appointment books to keep track of their schedules should be given notes. Give the first note as soon as you know you'll need their help. Give another note on the day of the task as a reminder. Place notes in their shoes, briefcases, or cars. Follow-up calls may be helpful for "irresponsible" spouses.

Share Responsibilities with Friends

Many of us are single parents, or have a spouse who is unable or unwilling to help in day-to-day household responsibilities, and to share errands and carpooling with friends. Set up days for specific errands. For instance, Mondays are for grocery shopping, Tuesdays are for errands on the north side of town, Wednesdays are for errands on the south side of town, Thursdays are for errands on the east side of town, and Fridays are for errands on the west side of town.

Then, get one to four other people to participate. Give the person who is running the errands your list and either include checks made out to the merchants, leaving the amount blank to be filled in at the time of purchase, or call ahead and give your credit card number over the phone. If you use checks, you need to attach a note giving your permission for the errand runner to fill in the amount of purchase. Also include a phone number where you can be reached in case the merchants have any questions. On the

check, write "for amount of purchase only." This helps to safeguard you against someone writing a check for the amount of purchase, plus $100.00 cash!

Instead of dropping what you're doing to run to the local store when you run out of something, rethink and restructure your shopping so that you use your time and money wisely.

Call Ahead and Let Your Fingers Do the Walking

When you need to shop for groceries, gifts, clothing, or specialty items, pull out the Yellow Pages. This will save you time and money as you check prices at several stores to find the store with the best prices or a store that happens to have the item on sale. Most merchants will gladly check their inventory to make sure that you don't drive all the way across town, only to find that they are temporarily out of stock. Many stores will also hold an item for 24 hours. Make sure that every trip you take will provide you with the goods you set out to purchase.

Once you know which stores carry the products you need at the lowest prices, schedule a day to take care of your shopping. Do it on days when you're driving the carpool to baseball practice, or some day when you're having a luncheon with a friend on that side of town. You save time by avoiding two trips to that destination, and you'll save fuel, too.

Order by Phone, Fax, or Computer

Many retail stores can take your order over the phone and ship products to you if you charge the order on your credit card. Some stores can take orders over the Internet via computer, and many more will do so in the future.

Shopping on the phone or by computer also saves time, if you know exactly what you want. For instance, if you want to purchase your regular makeup, office supplies, or specialty items, just place the order over the phone and give your credit card number to pay for the purchase and your mailing address. You should receive your order within one to two days if purchased locally. Department stores and specialty shops are most likely to ship orders placed over the phone.

Call in Your Order to Speed Up Your Errands

If you know what you want, in many cases you can call the retail store or service store ahead of time to process your credit card purchases. This gives the people at the retail store time to find the items you want to purchase,

ring up the total, process the credit card, and wrap up your order at their convenience. Then, you just walk in, sign your credit card slip, and walk right out the door with your purchase. There's no need to spend all the time it takes to find the product, wait in line, then wait for the credit card machine to accept your credit card purchase, and finally, wait for them to wrap up your goods.

If someone else is going to be picking up the order for you, ask the store receptionist to have the package ready by a certain time and to put the person's name on the bag. This will make it easy for the errand-runner.

Have Someone Else Run Your Errands

When a caregiver runs errands and shops, many times you will find that your savings will exceed the cost of having her shop for you. Use the "Weekly Menu and Shopping List" on page 21. Indicate what errands need to be taken care of in the "Other" section.

Through Catalogs

Save those catalogs! When you glance through the catalogs, circle items of interest for yourself or for gifts. Fold the corner of the page or place a tab to make it easy to retrieve information at a later date. Keep your catalogs together in a file or box.

Catalog shopping allows you to compare prices of products between catalogs. If a local store also carries the product, call and check pricing. When buying from an out-of-state catalog, you usually don't pay sales tax, but you do pay shipping. When shopping locally you'll have to pay sales tax but save on the shipping. Call the local store if it is not conveniently located to see if they'll ship the product to you. Consider your time and the wear and tear on your car when purchases can be made over the phone.

Organize Your Family with a Calendar of Events

There are many other things you can do to help organize your household. To keep the rest of your family aware of the carpool schedules, children's parties, homework due dates, baseball practices and games, and board meetings, buy a calendar for family events. This also helps the children take responsibility for their own personal scheduling—such as homework, chores, and parties.

Post a large calendar, to be used by the entire family, on the refrigerator or in a central location in your home. Although you have your own

appointment book, enter your appointments and schedule on the calendar too. Each family member enters test dates, report-due dates, game schedules, meetings, doctors' appointments, and other important dates so that everybody is aware of the family calendar of events. This will help to organize each individual member of the family.

The whole family will know that you will be late on Monday because you're hosting a board meeting. Jaclyn will remember to take her book report to school on Monday and Nicole will remember her dance shoes on Wednesday. Before children ask you about going to a slumber party or a dance, they can look at the calendar to see that the family is going to the theater or that you're hosting a dinner party for family friends. Wouldn't it be nice for the children to make decisions (based on the family calendar) themselves? You won't always have to be the bearer of bad news. They can see that there are plans already set and will decline the invitation themselves. Moreover, this system would encourage family members to get activities on the calendar quickly to make sure that time is set aside for their important events. Children will try to get their dates on the calendar as soon as possible, making them responsible for their schedules.

Don't Nag: How to Make Lists That Work for Your Family

Have you been accused of being the family dictator? Does your husband say that all you do is nag? Do your children need to be told three or four times before they do their chores or take care of their responsibilities? Divvy up the chores and individual tasks so all family members take part in running the household. Children as young as four years old can take part in this system. Use the "Household-Chores Form" on page 23. Fill out a form for each family member. Then list all the jobs that need to be done. Consider each person's age and ability to follow directions as you allocate responsibilities. Be specific about the jobs and when they need to be completed. Then do tasks on your list and leave everyone alone.

If you set up the chores for the weekend, have family members check off their lists and return them to you by Sunday at 4:00 P.M. If tasks aren't completed by the deadlines, reevaluate the quantity of tasks listed. You might consider giving the lists out on Monday so they have all week to complete their chores.

As a group, decide how to handle those who do not complete their lists. Perhaps those who don't finish their lists have to make dinner or do the dinner cleanup. Or, set up a reward system so that when all lists are completed, the whole family goes to the park or out for pizza.

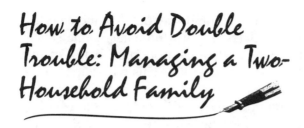

How to Avoid Double Trouble: Managing a Two-Household Family

Managing one household was more than you could handle before your husband and you split up. Now, with the kids living in two houses with different bedtimes, rules, and expectations, is it still possible to have a sense of control?

Note Activities on Your Calendar and in Your Appointment Books

With your children living in two households, it is essential they use their appointment books to keep track of their multiple family tasks and activities. Enter important plans as soon as you hear about them. That way Dad will know that a special day or weekend is booked. Likewise, review their appointment books when they are with you, to see what their dad has scheduled so you can adjust your schedule. Enter all activities on a family calendar (which should be kept in a central location in your home), so everybody can check it at a glance.

Using the appointment book as a method of communication between two households works well only when both parents use it. If each parent respects the custody agreement and agrees to scheduling changes readily when requested, both families win. If you give up a weekend with your kids because they need to go to a family reunion with their father, you should get a weekend in return when you have a special activity planned for the children.

By checking your children's appointment books before they go back to their other home, you can prepare them for future activities. This also helps your children make the transition from one house to the next. Oftentimes, children of divorced parents feel frustrated because they leave something they need at their other house. By reviewing appointment books, everybody knows what is on the agenda. Likewise, your children can make lists of belongings they'll need to take to the other household. That way they'll be confident they're not forgetting anything. Children of two households must be extra organized and efficient in order to be secure.

Respect Different Lifestyles

The fact that your children live in two different households probably has something to do with the fact you and your ex-spouse have different life and parenting styles. Don't expect both households to have the same rules. Your children will adjust to each family's rules if both parents respect them. When parents complain about the children's activities when they are in the custody of the other parent, the children become confused. This may be difficult, especially if there is a new stepmother in the family. For the children's sake, unless there is neglect or abuse taking place in the other household, concern yourself with providing consistent, loving care for your children when they are in your custody.

If you are on good terms with your ex-spouse, set up meetings to discuss rules, chores, schools, homework, sports, transportation, child care, and consequences. Naturally it's best for the children to have similar guidelines at each household. Periodic meetings to keep both of you abreast of your busy lives help to accomplish this goal.

Write Out the Family Rules

Children may get confused about rules set in different households. Some will even fabricate lies about rules in the "other" family. To keep kids honest, it's a good idea to write out the rules and consequences for breaking them for each household. Post them in their bedroom and in their appointment books. When possible, observe the rules in the other household and modify yours. Discuss differences between households before your children make the transition to their father's house.

Good communication between households and the use of the children's appointment books will help the children make the transition between two households as painless as possible. Update the appointment books as soon as you receive them and pass along messages and future plans the same way.

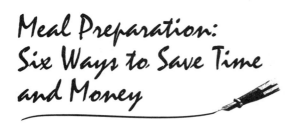

Meal Preparation: Six Ways to Save Time and Money

You used to love to cook, but now you find that you're stuck in a rut—always preparing the same meals to save time. It seems as if no sooner do you get finished preparing a meal, then someone is hungry again. You don't want to serve "fast foods" or frozen dinners, but you don't want to spend hours in the kitchen either. There is a solution to the meal-preparation problem.

Use a Weekly Menu and Shopping List

Planning a complete menu for all meals for one week will save you many unnecessary trips to the grocery store. You'll also save money by eliminating impulse buying each time you enter the store.

Start by looking through your appointment book or calendar. Check to see what events will take place during the week. Enter "party at the Johnstons'" on the "Weekly Menu and Shopping List" on page 21 if you have a party to attend and won't need to plan dinner. Fill in the complete menu for parties you will be hosting. Think about commitments to bake or cook for school or office events. Then fill in breakfast, lunch, and dinner menus for the rest of the meals that you will prepare at home.

Once your menu is complete and you've entered all meals, fill in the "Weekly Menu and Shopping List." Start by reviewing all breakfast meals. Enter ingredients you'll need to prepare each meal. Check your cupboards

and refrigerator to see what you don't already have and then add missing ingredients to your shopping list. Take a moment to think about all ingredients, seasonings, and condiments needed to prepare the meal. For instance, if you'll be making pancakes, make sure you have the pancake mix or basic ingredients as well as the syrup. Then plan the lunch menu. Check your bread supply and staples such as mayonnaise, mustard, and lunch snack foods. When checking ingredients for the dinner menu, consider ingredients for each dish individually. For instance, to plan for lasagna, list lasagna noodles, mozzarella cheese, ricotta cheese, and sausage. Also, check to make sure you have the Italian seasonings, tomato sauce, and tomato paste you'll need for the sauce. If salad and garlic bread are on the menu, list all salad ingredients and dressings as well as the French bread, butter, and garlic needed for garlic bread. For those who like a glass of Chianti with lasagna, add it to the list. And don't forget dessert ingredients.

After completing the "Weekly Menu and Shopping List," glance over the entire list to see if you are running low on any supplies. Items that are often overlooked are cleaning supplies, pet food, toiletries, and staples.

Once you've shopped, place the "Weekly Menu and Shopping List" on your refrigerator or in a visible location so that you'll know what to thaw out for dinner. Decisions about breakfasts and lunches (for school-aged children) will already be posted on the Menu. Place a new "Weekly Menu and Shopping List" next to the current Menu on a clipboard. Family members and you can fill in the "Weekly Menu and Shopping List" when they need something or they or you use the last of an item. The family can also fill in the Menu with meals they would like or indicate when there is a special event. When the family works as a team to fill in the "Weekly Menu and Shopping List" you'll find that you won't run out of ingredients and the family will be happier with the meals. They'll be responsible for the menu whether or not they contribute.

Cook Triple Batches

Many meals can be prepared ahead of time and frozen to serve on busy days. It doesn't take much more time to prepare three lasagnas than it takes to make one. Likewise, if you're making waffles or French toast, tripling the batches will give you two quick breakfasts in the future.

Use Healthful Prepackaged Meals

If freezer space is a problem for you, prepackaged meals offer a good alternative. Health food stores have a variety of "healthful" quick meals that make serving "fast food" a guilt-free experience in your home.

Buy in Bulk

Warehouse stores offer good discounts if you purchase multiple packages or case quantities. If your children enjoy chips, crackers, or cookies, prepackage them in small plastic sandwich bags or plastic storage containers ahead of time.

Make juice in quantities and pour into drink containers. Reusing 12-ounce water or juice bottles for lunches is environmentally friendly and saves money too. By prepackaging snacks, putting lunches together is quick and easy.

Get Input from Your Children

If your children refuse to eat meals you've prepared, you're not alone. Common school parking-lot discussions center around parents' frustrations with unpacking full lunch boxes at the end of the day.

Young children often like the same bland meal day after day. Then right when you think you know what they like and dislike, they get tired of their favorite meal. Some children seem to be intrigued with other children's meals. If you're like other parents, you probably hear about how *wonderful* Ryan's lunches are and how nice *his* mommy is because he gets special treats in *his* lunch box!

Get your child's input for lunch and other meal choices. When you make your weekly shopping list, include snacks, lunches, and dinners to accommodate your entire family. Ask what fruit, snacks, sandwiches, and dinners they would like for the upcoming week.

If your children complain about meals, suggest that they help decide next week's menu. When planning entrees that may not be favorites for all, compromise by making a side dish (salad, rice, potatoes) that your picky eaters will enjoy.

Prepare Lunches the Night Before

If your mornings are hectic while you get breakfast on the table, dress the kids, and make lunches, ease the burden by starting the lunches the night before. Load the lunch boxes with snacks, crackers, and nonperishable goods. Fill juice containers and place with other items that need refrigeration. If you have more than one lunch to make, put each person's refrigerated snacks in plastic bags to delineate between lunches. In the morning, simply put each bag into the corresponding lunch boxes.

If you're making hot soups or stews, prepare the rest of the lunch ahead of time and add the hot item in a heat-insulated container in the morning. Some children prefer their sandwiches be made fresh so the bread doesn't get soggy. By taking care of the bulk of the lunch the night before, you can even fulfill special requests.

How to Hire a Housekeeper

If you have the luxury of employing a housekeeper, your household chores list for each family member will be less comprehensive. Having lighter cleaning tasks won't consume your weekends, and everyone will be responsible for his or her room and weekly maintenance.

Use a Housekeeping Agency

Hiring a housekeeper from a housekeeping agency has some advantages. First, you don't have to interview housekeepers or wonder about their integrity. Second, you won't have to worry about housekeepers being sick or quitting just before the in-laws come into town. Third, the house-keeping agencies are insured and bonded so any missing items will be replaced.

Housekeeping agencies advertise in the telephone book's Yellow Pages and newspapers' classified ads. Call agencies to get estimates. Inquire about policies and scheduling.

Housekeeping agencies offer basic cleaning services: dusting, vacu-uming, mopping, cleaning bathrooms and kitchens. Some charge by the hour; others charge a flat fee. Make sure you get the entire job description in writing before you sign a contract. If you would like laundry, windows, or refrigerators cleaned weekly, put it in the contract. Use the "Housekeeping-Agency Evaluation Checklist" on page 24 to keep track of policies, rates, and services offered.

Once you've selected an agency and before you sign the contract, con-tact the Better Business Bureau to see if there are complaints made against the agency. Review complaints, if any, and rebuttals. Sign a contract with the company with which you feel the most comfortable.

Do It Yourself

Although hiring a housekeeper through an agency is easier, it is more cost-ly. Hiring your own housekeeper has its advantages beyond cost. You can set the job description to include any tasks you want. You won't get sur-charged for cleaning windows, organizing drawers, separating recyclables, or doing laundry. You can be specific about the types of cleansers used on your furniture and floors. Instead of working within the parameters of a particular agency, you set the rules and guidelines.

Fill out the "Housekeeper Job Description" form on page 25 to determine your needs. Estimate the number of hours needed to complete the job. Check the local newspaper's classified section to see what other housekeepers charge by the hour. You can either pay by the job to ensure consistent cleaning fees, or pay by the hour if you know that some weeks may take longer than others. If you will have the housekeeper do just basic cleaning without laundry, ovens, windows, and so forth, you're bet-ter off paying by the job. You're protected against housekeepers who clean slowly to charge more. On the other hand, if you're always asking the housekeeper to do extra tasks, the housekeeper will become disgrun-tled with a set fee. In this case, calculate the number of hours it takes to do regular cleaning and add additional hours needed for the "extra" tasks. The housekeeper receives more compensation, yet she is still working within an agreed-upon number of hours to complete the job.

Advertise in the Newspaper

Lay out an ad that includes job responsibilities, schedule, and wages. (See "Put an Ad in the Newspaper" on page 97.)

SAMPLE AD

Housekeeper for 2,800 sq. ft. house. Heavy housecleaning, laundry, and windows. Fridays: 10-3; $10/hr. Call 555-0701.

Once the ad is in the paper, make sure you change your answering machine to handle the calls. You may want your machine to answer.

SAMPLE TELEPHONE MESSAGE FOR INQUIRIES

Hi! You've reached the Hondas. If you're calling in response to the ad, please leave your name and number and we'll call back as soon as possible.

After the position is filled, you might want to change your machine to handle the influx of calls.

SAMPLE TELEPHONE MESSAGE FOR A FILLED POSITION

Hi! You've reached the Lees. If you're calling about the ad, the position has been filled. Thanks for calling. If you would like to leave a message for the Lees, please do so after the beep.

Interview by Telephone

Be prepared to receive several calls from your ad. Make a list of questions to ask the caller to weed out the wrong people. You may get calls from professional housekeepers, mothers with small children, and even homeless people. Ask all callers the same questions, and take notes as they answer.

SAMPLE TELEPHONE INTERVIEW QUESTIONS

1. Are you looking for a full-time job?
2. How long have you been cleaning houses professionally?
3. Are you a college student? What is your current and future schedule?
4. How do you respond to constructive criticism?
5. How long would you be able to commit to this schedule?
6. Are you available to clean on _____ from _____ to _____?
7. Do you like to clean: __windows, __ carpets, _____?

During the course of your telephone conversation, you will get a feel for the caller. If it is somebody you would like to interview, set a date in the near future (within a day). Interviewees usually call lots of potential employers and may get another job if you set the interview date too far in the future. Good prospects find jobs quickly. When callers are definitely the

wrong person for the job, take their name and phone number and tell them that you will call them back if you decide to request an interview.

Interview in Person

Ask the prospective housekeeper to fill out the "Housekeeper Application Form" on page 30. Give him or her a table or desk with plenty of room and a telephone book for addresses and phone numbers to complete the "Housekeeper Application Form."

After the applicant has completed the "Housekeeper Application Form," review it with him or her. Fill in details in the boxes provided. Allow the applicant to talk about himself or herself. This is a good way to learn more about the applicant.

Show the applicants the "Housekeeper Job Description." Give him or her a few minutes to review it, to make sure the person understands the scope of the job. Ask the applicant how he or she feels about the tasks listed and discuss wages. Take the applicant on a tour of the house. Make sure that he or she completely understands the job and compensation.

When the applicant leaves, write general descriptions about the person and your gut feelings about hiring him or her. If you're sure you won't hire this applicant, place a "No" at the top of the application form. Place a "Yes" if you're interested in hiring this applicant.

Check References

Call all references listed on the "Housekeeper Application Form" of prospective housekeepers. Verify that the applicant worked during the period and received the wages as stated. Ask if the applicant was a good housekeeper. Inquire about attendance and attitude. Check to see if items were missing or how often belongings were damaged.

Establish Pay Periods

Most housekeepers request to be paid upon completion of the job. You can leave a check with the job description if the compensation is consistent. If you pay by the hour and the housekeeper requires payment at the completion of the job, arrange the person's hours so that you will be home upon completion.

If the housekeeper cleans houses for others, and housekeeping is his or her primary form of employment, then he or she is most likely an independent contractor. See "Handle Tax Issues" on page 123.

Confirm Insurance Coverage

Check your homeowner's insurance policy to make sure that your policy covers housekeepers (domestic help). If your housekeeper gets hurt in your

home while cleaning, your homeowner's coverage should provide workers' compensation insurance for your housekeeper. There is usually a clause that covers domestic workers as long as their hours don't exceed approximately ten per week. If your housekeeper works more than your policy allows for domestic help, inquire about additional coverage. The cost is minimal, and the protection is important.

If you don't own your own home, look at your renter's insurance policy. Check to see if you have coverage for domestic workers. Again, call your agent to see if your housekeeper is covered under your policy.

Add Specific Information to the Housekeeper Job-Description Form

LAUNDRY Indicate which laundry baskets to collect in your home. Enter the temperature of the water for wash and rinse cycles. If you use bleach, indicate which colors you would like bleached. List the location you prefer to keep the ironing pile. Indicate whether she should iron clothes only or table linen, too. If you would like the folded clothes put in appropriate drawers and closets in each room, list instructions.

HAND LAUNDRY If you would like the housekeeper to wash some clothing pieces by hand, put these articles in a special location so they don't get washed in the washing machine by accident. List the detergent you would like the housekeeper to use on hand-laundered clothing.

DISHWASHER Would you like all dishes wiped down with a dish towel, have lids to plastic containers stacked, or have crystal hand-washed? Make special requests for loading and unloading dishwasher on the form.

BEDROOMS Indicate where the linen is kept. Also list which furniture polish and window cleaner you prefer. Enter details about each room under "other." This is where you can mention that the antique doll case has a broken frame, so wipe the glass carefully.

KITCHEN AND DINING ROOM Indicate which cleansers are to be used on counters, refrigerator, appliances, cabinets, and floors. If you want the old oak hutch hand-oiled, write detailed instructions about which oils and cloths to use.

BATHROOMS Indicate which cleansers are to be used on showers and tubs, mirrors, toilets, and floors.

LIVING ROOM, FAMILY ROOM, AND OTHER ROOMS List which cleansers and polishes are to be used. If you have a beautiful grand piano and want the wood hand-rubbed and the keys carefully wiped down, leave clear instructions.

TRASH AND RECYCLING BINS Describe where trash-can liners and recycling bins are located. If you would like white paper or plastics sorted before they go into the recycling bins, list details. Have recycling bins clearly labeled so the housekeeper can easily find each bin. Make sure that you have

recycling bags in every room throughout the house. She can sort glass, cans, paper, magazines, and cardboard quickly and efficiently. Check with your local landfill for recycle drop-off centers or neighborhood curbside programs in your area.

WINDOWS Indicate which types of window cleansers you prefer. There are good professional window-cleaning solutions that can be purchased at janitorial-supply stores.

STEAM-CLEAN CARPETS If your housekeeper will periodically clean your carpets, indicate which prespotters and cleansers to use. Be careful about the type of carpet cleansers you use. Many carpet cleansers have butyl-cellosolve (hazard rating of "3"—the worst rating possible), perchloroethylene (a known human carcinogen), and naphthalene (toxic if inhaled). Purchase carpet cleansers that don't have these ingredients. If you choose to use toxic cleansers, ask your housekeeper to do a clean-water rinse after cleaning the carpet. She will just steam clean with fresh hot water. That will get most of the carpet cleanser out. Leave the windows open for ventilation.

WATER INDOOR PLANTS If you would like your indoor plants watered, list location of the water can. Also indicate how often you would like the housekeeper to add plant food to the water. If you would like certain plant leaves wiped with a cloth or trimmed back, give specific instructions.

POLISH SILVER Silver left out for display will tarnish. Have your housekeeper periodically polish the silver. Indicate which pieces need polishing and which polish you prefer.

CLEAN GARAGE Most garages are hard to clean because of the nature of the contents: lawn mowers, power tools, and so forth. A quick dusting and sweeping can help keep the garage dirt out of the house. Indicate if you would like this service added to the job description.

SWEEP WALKWAYS AND DRIVEWAYS If you would like patios, walkways, and driveways swept, check off the job description. Leaf blowers pay for themselves quickly if you have long walkways and driveways. Supply the leaf blower along with a dust mask, earplugs, and goggles.

CLEAN OVEN Put the self-cleaning oven on at night before the housekeeper comes. For energy savings, put the self-cleaning oven on after you use the oven for baking. The housekeeper can wipe the ashes away from the walls of the oven after it has cooled. If there are stubborn areas, suggest the cleanser to use.

For regular ovens, list the oven cleansers you prefer.

ORGANIZE DRAWERS OR CABINETS Indicate which drawers and cabinets need to be cleaned or organized. Describe how you would like the housekeeper to organize the cabinets. Have him or her put all throwaway items in boxes for you to go through before they get tossed. Provide labels so it'll be easy for all family members to find items and to continue to keep cabinets and drawers organized in the future.

Creating a No-Hassle Green Household

Organizing the family and keeping up with work and family obligations keeps everybody busy. Learning about environmental products and keeping up with the list of materials that are recyclable may seem like an unnecessary burden to add. You may find that your children will insist on making environmental changes at home. After all, it is their future here on earth. They want to breathe clean air, drink nontoxic water, and live on a sustainable planet.

Reduce, Reuse, Recycle

Reduce your impact on the earth. Purchase products that use minimal packaging. Do you really need your goods encased in plastic or Styrofoam? Manufacturers often package a two-inch product in twelve inches of packaging to make the product more marketable. Meat is placed on Styrofoam trays to offer a nice display.

Buy soaps, oils, grains, flour, and seasonings in bulk. This reduces the need for packaging and saves you money. Write letters to manufacturers asking them to reduce the packaging used. Buy products made from recycled materials.

When you shop for meat at the local grocery store, request that the Styrofoam packaging be removed and that the meat be wrapped in plastic or paper wrap. The Styrofoam is not necessary, and it may not be recyclable, depending on your community.

Reuse products and their packaging. Paper bags and boxes can be reused several times before they need to be recycled. Junk mail is usually printed on one side, leaving the other side available for notes.

Purchase goods made of wood and metal that can be repaired when broken. Plastic goods are not designed to last as long as their wooden or metal counterparts.

Items you consider junk may be valuable to another. Sell unwanted goods at a garage sale or flea market. Donate items to the Salvation Army or Goodwill. Give extra packaging materials to child-care centers for art projects.

Recycle your glass, aluminum cans, plastic containers, newspapers, magazines, white paper, colored paper, metal cans, and cardboard. If you don't have curbside pickup, call your local recycling centers to find out what recycled goods they accept.

Did you know that Americans throw away enough aluminum every three months to rebuild our entire commercial airline fleet? If we collected office paper waste for one year and stacked it 12 feet high, it would span from New York to Los Angeles! There are enough plastic soda bottles thrown out each year to circle the earth four times! It would take only two weeks to fill the World Trade Center with glass bottles and jars that are discarded!

Set Up a Recycling Center in Your Home

Place a paper bag (and label it) for recyclables next to every trash can in your home. When family members use the trash can, they can toss the item into the paper bag if it is recyclable. On trash day, throw out regular trash and sort recyclables in your garage.

Set up a system to organize your recyclables. If you have curbside recycling in your neighborhood, use the plastic crates provided. Recycling centers often give you large cans in which you can collect bottles and cans. Use large boxes, large trash cans, or plastic bags to keep your recyclables sorted. Label your bins clearly with indelible ink markers.

Those who don't have curbside recycling can drop off recyclables at the recycling centers. Most landfills have recycling bins. Some private recycling organizations will pick up recyclables for businesses and home businesses. Other recycling centers pay by the pound for recyclable materials.

Summing Up

In managing your time more efficiently, you'll have more time to spend with your family, your children, and you will have more time for yourself. Get your family together by using a Family Calendar of Events to schedule individual and family outings. Plan ahead for your meals, so that all necessary ingredients are on hand when you make meals. Divvy up the chores, so you're not the drill sergeant in your house. Hire a housekeeper to help with the heavy cleaning. And, finally, set up recycling in your home to teach your children about their responsibility in making their world a clean and safe place to live.

Time-Management Organizers

Weekly Menu and Shopping List
Household-Chores Form
Housekeeping-Agency Evaluation Checklist
Housekeeper Job Description
Housekeeper Application Form

Weekly Menu and Shopping List

	Week of: _____		Weekly Menu				
Meal	**Sunday**	**Monday**	**Tuesday**	**Wednesday**	**Thursday**	**Friday**	**Saturday**
B:							
L:							
D:							

Weekly Shopping List

Vegetables		Fruit		Meat		Frozen Foods	
Asparagus		Apples		Beef: ground		Desserts:	
Avocados		Bananas		Beef: ribs		Dinners:	
Broccoli		Blueberries		Beef: roast		Ice Cream:	
Cabbage		Cantaloupe		Beef: short ribs		Juice:	
Carrots		Cherries		Beef: steaks		Juice:	
Cauliflower		Grapefruit		Chicken: boneless		Juice:	
Celery		Grapes		Chicken: breasts		Veg: broccoli	
Cucumbers		Lemons		Chicken: legs		Veg: corn	
Eggplant		Limes		Chicken: thighs		Veg: mixed vegetables	
Garlic		Mangos		Chicken: whole		Veg: spinach	
Ginger		Melons		Chicken: wings			
Green Chilies		Oranges		Deli meat:		**Dairy**	
Green Onions		Peaches		Game Hens		Butter	
Green Peppers		Pears		Hot dogs		Cheese:	
Lettuce		Pineapples		Lamb: chops		Cheese:	
Mushrooms		Plums		Lamb: leg		Cottage Cheese	
Onions		Pomegranate		Pork: bacon		Cream	
Parsley		Raspberries		Pork: chops		Cream Cheese	
Potatoes		Strawberries		Pork: ground		Eggs	
Squash		Tangerines		Pork: roast		Margarine	
Sprouts				Sausage: breakfast		Milk:	
String beans		**Seasonings**		Sausage: pork		Sour cream:	
Tomatoes		Chili powder		Sausage: turkey		Yogurt:	
Zucchini		Garlic powder		Seafood:		**Drinks**	
Liquor		Pepper		Seafood:		Juice:	
Beer:		Salt		Turkey: ground		Mixers:	
Brandy		Seasoning salt		Turkey:		Soda:	
Wine:		Soy sauce		Veal: cutlets			
Other:		Vinegar		Veal:			

21

Weekly Menu and Shopping List *(continued)*

Weekly Shopping List

Packaged Goods		Baking Goods		Canned Goods		Kitchen Supplies	
Cereal:		Baking soda		Fruit:		Coffee filters	
Chocolate		Baking powder		Fruit:		Dish detergent	
Coffee		Cake mix:		Fruit:		Dishwasher detergent	
Cookies:		Baking chips		Pickles		Foil	
Crackers:		Flour		Refried beans		Freezer bags	
Dried Fruit:		Frosting mix:		Sauce:		Garbage bags	
Noodles:		Honey		Sauce:		Napkins	
Rice:		Nuts		Seafood: clams		Oven cleaner	
Soups:		Oil:		Seafood: tuna		Paper towels	
Stuffing		Shortening		Soup:		Plastic wrap	
Rice		Sugar:		Soup:		Sandwich bags	
Tea				Veg: beans		Trash bags	
		Toiletries		Veg: beets			
Bottled Goods		Conditioner		Veg: corn			
Bar-b-que sauce		Cotton balls		Veg: kidney beans		**Cleaning Supplies**	
Cocktail sauce		Cotton swabs		Veg: mushrooms		Ammonia	
Jam/Jellies:		Dental floss		Veg: olives		Bathroom cleanser	
Ketchup		Deodorant		Veg: peas		Bleach	
Mayonnaise		Facial tissue		Veg: tomatoes		Broom	
Mustard		Lotion				Cleanser	
Peanut butter		Polish/Remover		**Pet Supplies**		Distilled water	
Relish		Razor blades		Bird seed		Dust pan	
Salad dressing		Rubbing alcohol		Cat food		Fabric softener	
Salsa		Sanitary napkins		Dog biscuits		Feather duster	
		Shampoo		Dog food		Furniture polish	
		Shaving cream		Fish food		Handwash soap	
Bakery		Tampons		Flea collar		Laundry detergent	
Bagels:		Toilet tissue		Pet shampoo		Mop ends	
Bread:		Toothbrush				Rubber gloves	
Breadsticks:		Toothpaste				Vacuum bags	
Muffins:				**Other**			
Pastries:							
Pizza dough							
Rolls:							
Tortillas:							

Household-Chores Form
for:_____

1.

2.

3.

4.

5.

6.

7.

8.

9.

10.

Please complete these chores by:_____

Thank You!

Housekeeping-Agency Evaluation Checklist

Questions/Agency Name	1:	2:	3:	4:
Location:				
Phone:				
Manager:				
Housekeeper:				
Rates:				
Insurance:				
Bonded?				
Travel charge?				
Dates:				
Hours:				
Do laundry?				
Wash windows?				
Clean ovens?				
Clean refrigerators?				
Polish silver?				
Clean carpets?				
Water plants?				
Unload dishwasher?				
Remove cobwebs?				
Maintain plants?				
Clean miniblinds?				
Clean fireplace?				
Sweep garage?				
Sweep walkways?				
Other:				

Housekeeper Job Description

Name: _____

Address: _____ City: _____ ZIP Code: _____

Home phone: _____ Work phone: _____

Scheduled cleaning day: _____ Arrival time: _____ Departure time: _____

Payment method: _____

Please do the cleaning tasks that are checked below. All cleaning supplies are located in _____

If you are running low on any supplies, please list supplies needed on the last page.

☐ **Laundry:**

Collect laundry from the bedrooms and _____. Sort laundry by colors; do towels separately. Please do full loads only. Use _____ (temp.) water to wash and _____ (temp.) water to rinse. Read directions on the laundry detergent bottle. Use bleach for _____ (color) only. Please clean the lint tray in the dryer after each use. Fold clothes immediately to avoid wrinkles. Put all clothes that need ironing in _____. Put folded laundry in each bedroom or _____. Iron clothes using _____ (water or starch).

☐ **Hand Laundry:**

Hand-wash the laundry located in _____. Use _____ in _____ water. Roll garment in a dry towel to absorb moisture. Lay flat on towel to dry.

☐ **Dishwasher:**

If the dishwasher is full, please run it and put clean dishes in their appropriate locations in the kitchen.

☐ **Master Bedroom:**

Strip down the bed and put new sheets on the mattress. Sheets are kept in _____. Wash the mattress pad and blankets once a month. Dust all furniture with _____. Clean mirrors with _____. Feather-dust lamp shades and lightbulbs. Vacuum entire room, moving chairs and light furniture to get behind them. Other: _____

☐ **Bedroom #1 (_____):**

Strip down the bed and put new sheets on the mattress. Wash the mattress pad and blankets once a month. Dust all furniture with the same _____ as in master bedroom. Clean mirrors with same cleanser as master bedroom. Feather-dust lamp shades and lightbulbs. Vacuum entire room, moving chairs and light furniture to get behind them. Other: _____

Housekeeper Job Description *(continued)*

☐ **Bedroom #2 (_____):**

Strip down the bed and put new sheets on the mattress. Wash the mattress pad and blankets once a month. Dust all furniture with the same _____ as in master bedroom. Clean mirrors with same cleanser as master bedroom. Feather-dust lamp shades and lightbulbs. Vacuum entire room, moving chairs and light furniture to get behind them.

Other: _____

☐ **Bedroom #3 (_____):**

Strip down the bed and put new sheets on the mattress. Wash the mattress pad and blankets once a month. Dust all furniture with the same _____ as in master bedroom. Clean mirrors with same cleanser as master bedroom. Feather-dust lamp shades and lightbulbs. Vacuum entire room, moving chairs and light furniture to get behind them.

Other: _____

☐ **Kitchen and Dining Room:**

Clean all appliances on the counters with _____. Unplug appliances to avoid a shock. Pull out the tray in toaster oven and clean crumbs. Clean coffeemaker. Wipe counters with _____. Please clean under small appliances.

Empty refrigerator and wipe interior walls and shelves with _____. Wash out vegetable drawers. Put all contents back when done.

Clean the exterior of the refrigerator, oven, dishwasher, microwave, trash compactor, and _____ with _____.

Wipe cabinet surfaces where needed with _____. Wipe kitchen and dining-room tables with _____.

Sweep floors and mop with _____. Shake out area rugs and replace when floors are dry.

☐ **Master Bathroom:**

Clean shower and tub with _____. Rinse well so all cleanser residue is removed. Wipe sinks and counters with _____. Clean mirrors with _____. Scrub toilet with brush and _____. Wipe inner toilet bowl and exterior with a sponge and _____. Please make sure that the sponge is used only on toilets. Sweep and mop floors with _____.

Housekeeper Job Description *(continued)*

☐ **Bathroom #1 (_____):**

Clean shower and tub with _____. Rinse well so all cleanser residue is removed. Wipe sinks and counters with _____. Clean mirrors with _____. Scrub toilet with brush and _____. Wipe inner toilet bowl and exterior with a sponge and _____. Please make sure that the sponge is used only on toilets. Sweep and mop floors with _____. Other: _____

☐ **Bathroom #2 (_____):**

Clean shower and tub with _____. Rinse well so all cleanser residue is removed. Wipe sinks and counters with _____. Clean mirrors with _____. Scrub toilet with brush and _____. Wipe inner toilet bowl and exterior with a sponge and _____. Please make sure that the sponge is used only on toilets. Sweep and mop floors with _____. Other: _____

☐ **Living Room:**

Dust all surfaces with _____. Clean blinds or vacuum curtains and draperies. Move small decorations to dust underneath. For glass, use _____. Dust the TV screen and other electronic devices with a damp cloth or a feather-duster. Be careful not to get electronic devices wet. Vacuum carpet and move small pieces of furniture to get behind them. Feather-dust all lamps and exposed lightbulbs.

☐ **Family Room or Rec Room:**

Dust all surfaces with _____. Put away toys. Move small decorations to dust underneath. For glass, use _____. Dust the TV screen and other electronic systems with a damp cloth or a feather-duster. Be careful not to get electronic devices wet. Vacuum carpet and move small pieces of furniture to get behind them. Feather-dust all lamps and exposed lightbulbs.

☐ **Other Room: _____**

Dust all surfaces with _____. Move small decorations to dust underneath. For glass, use _____. Dust the TV screen and other electronic systems with a damp cloth or a feather-duster. Be careful not to get electronic devices wet. Vacuum carpet and move small pieces of furniture to get behind them. Feather-dust all lamps and exposed lightbulbs.

☐ **Trash/Recyclables:**

Collect trash from all rooms and put in outside trash cans. Replace trash-can liners (kept in _____). Put recyclables in appropriate recycling bins located in _____.

Please sort the following recyclables: _____

Housekeeper Job Description (continued)

☐ **Windows:**

Wash interior windows with _____. Use a scrub brush to get off tough spots, then use sponge to wash the windows. Remove everything from the window sill and lay out a towel on the window sill to catch the water as you squeegee each window. Wipe the blade after each stroke. Dry the window sill and put decorative items back.

Wash exterior windows with _____. Use an extension pole for windows that can't be easily reached.

☐ **Steam-Clean Carpets:**

Vacuum all carpets first. Follow instructions for the steam-cleaner unit. Prespot stains with _____ and use _____ carpet-cleaning solution in the unit. Open windows (with screens) to allow air circulation and quicken drying time. Rinse steam-cleaning unit out with a hose.

☐ **Water Indoor Plants:**

Use watering can located in _____. Touch soil in each house plant to determine water needs. Add plant food to water _____ per month. Plant food is located in _____. Pick off dead leaves or stems. Special care for the following plants: _____ _____.

☐ **Polish Silver:**

Polish silver with _____. Silver polish is located: _____. Polish the following pieces: _____ _____.

☐ **Clean Garage:**

Dust surfaces with _____. Sweep floor. Other: _____.

☐ **Sweep Patios, Walkways, and Driveway:**

Sweep patio, walkways and driveway. Put leaves in _____. Leaf blower is located in _____.

☐ **Clean Oven:**

For self-cleaning ovens, I'll put the self-cleaning oven on the night before so all you will need to do is wipe the ashes out of the oven and use _____ to clean off stubborn areas.

For regular ovens, please use _____ to clean the interior. Wipe thoroughly to remove chemical residues. Leave door open to air dry.

Housekeeper Job Description (continued)

☐ **Organize Drawers or Cabinets:**

Organize the following drawers and/or cabinets: _____

_____.

Wipe shelves and drawers with _____. Label shelves so items are easily located.

THANK YOU FOR DOING A GREAT JOB! Please list supplies that need to be replaced before your next cleaning day.

Notes from Us

Note from Housekeeper
(Supplies needed and cleaning problems)

Housekeeper Application Form

Personal Information

Name: _____

Maiden name or any other name used: _____

Current address: _____ City: _____ ZIP Code: _____

Home phone number: _____ Work phone number: _____

In case of emergency, person to contact: _____ Phone number: _____

Social Security #: _____ Number of dependents (optional): _____

General Information

What is your current work schedule? _____

What days and hours are you available? _____

How long have you been cleaning houses professionally? _____

What is your favorite part of cleaning houses? _____

Are you an independent contractor or an employee? _____

Do you own your own car? _____ If "yes," is your car in good running condition? _____

Do you have liability insurance? _____

Have you ever been convicted of a crime? _____ If "yes," please describe: _____

Please check the following housekeeping duties you would consider, above and beyond regular dusting, mopping, vacuuming, and cleaning:

_____ Clean garage	_____ Polish silver	_____ Iron
_____ Clean ovens	_____ Organize drawers/cabinets	_____ Clean pet cage
_____ Clean ashes out of fireplace	_____ Buff/oil furniture	_____ Clean litter box
_____ Clean fingerprints off walls/doors	_____ Clean windows (inside/outside)	
_____ Water plants/trim back plants	_____ Do laundry (fold and sort)	
_____ Steam-clean carpets	_____ Do hand laundry	
_____ Sweep walkways, driveway	_____ Drive to landfill or recycling center	

References

Name	Address	Phone	Dates Worked	Employer's Notes (Leave Blank)

Is there any information about yourself you would like to share with us? _____

All of the above information is true to the best of my knowledge.

_____ _____
Date Applicant's Signature

Don't Forget:
Important Dates to
Remember

Do you ever wake up in the middle of the night wondering if you sent a birthday card to Uncle John or paid your life-insurance premium? It's hard to keep track of all of those special events and responsibilities that crop up each year without reminders. In this chapter, we discuss how to put all of your permanent, important dates into a "permanent calendar" that you can refer to each month. We'll also talk about how to organize a holiday card list once and maintain it with only minimal effort for years.

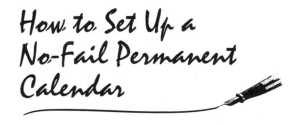

How to Set Up a No-Fail Permanent Calendar

With the busy life you lead, it's almost impossible to remember all of the dates that you are supposed to keep track of over the course of the year, such as Aunt Amy's anniversary or your secretary's birthday. By placing all of these dates into a "Permanent Calendar" (page 39), however, you can keep up with them at a glance.

Permanent calendars are easy to set up. Jot down all of the family birthdays and anniversaries on this calendar. If you don't have all the dates

you need, almost every family has someone you can call who has all these dates at his or her fingertips. To help keep track of children's ages, write their birth years next to their names. You can even impress your niece by sending her that "sweet sixteen" birthday card on her sixteenth birthday—not her seventeenth!

Permanent Calendar Checklist

Here is a checklist to remind you of important dates to enter on your Permanent Calendar:

- ☐ Your family's birthdays
- ☐ Your in-laws' birthdays
- ☐ Your family's anniversaries
- ☐ Your in-laws' anniversaries
- ☐ Your employees' or colleagues' birthdays
- ☐ Your boss's birthday
- ☐ Friends' birthdays
- ☐ Friends' children's birthdays
- ☐ Important death dates
- ☐ Date to update Information for Trustee form
- ☐ Date to update list of credit cards
- ☐ Date to update inventory and take photo inventory
- ☐ Annual physical exams (including mammograms, Pap smears, prostate)
- ☐ Children's immunizations and checkups
- ☐ Dental checkup and cleaning
- ☐ Orthodontic checkups
- ☐ Pet immunizations and checkups
- ☐ Vehicle tune-ups, oil changes, brake inspections, and safety inspections
- ☐ Date to get annual family portraits
- ☐ Date to take holiday portraits
- ☐ Date to order holiday cards
- ☐ Date to plan special gifts or parties
- ☐ Date to check fire extinguishers and smoke-alarm batteries (the beginning and end of daylight savings time are easy dates to remember)
- ☐ Other:

Celebrating Everybody's Birthday

Birthdays are acknowledged or celebrated in a variety of ways, depending on the birthday person's age, family, culture, and religion.

Children and Young Adults

Birthdays are exciting for children and young adults. Send cards, make phone calls, and/or send gifts to wish a happy birthday to friends and relatives: cousins, nephews, nieces, stepchildren, or stepsiblings.

Over Thirty-Something

After thirty, some people may be a bit sensitive about birthdays. That doesn't mean that you should ignore their birthdays, only that you may need to be more careful about the types of cards or gifts you give. It's always nice to let somebody know that they are special because of things they have accomplished and just because of who they are. Let them know how special they are to you. Don't mention age. A lot of people may not want to face the fact that they are one year older.

Family Members

Always acknowledge immediate family members' birthdays: parents, siblings, and children. In some families, grandparents, aunts, uncles, and cousins should also be acknowledged.

Cards, calls, and/or gifts are appreciated by the birthday person. People can become depressed if their birthdays are forgotten by family members.

In-Laws

In-laws, as family, should be acknowledged on their birthdays. Who writes the cards or makes the phone calls is a question that has been asked for years. Traditionally, a wife sends cards and/or gifts to her husband's family. This may have started back when the husband worked away from home while the wife stayed home with the children. One of the wife's responsibilities as a homemaker was to handle correspondence with families and friends.

These days, most households have two working parents, which changes the structure of birthday etiquette. Each spouse needs to take responsibility for sending birthday greetings to his or her own family.

Believe it or not, however, deals can sometimes be worked out between spouses. If the wife is better at remembering and sending birthday greetings, it makes sense for her to handle that job while her husband handles a task she doesn't enjoy.

Friends

Parties, lunches, and gifts can be part of celebrating birthdays with friends. Considering the type and length of friendship, your gift or acknowledgment can be a simple "happy birthday" greeting or an elaborate surprise birthday party.

Unless you are independently wealthy, be careful to avoid getting into the habit of exchanging expensive gifts with friends. You'll find that your personal finances may be drained by the multitude of gifts you must buy. If you're already in a gift-giving ritual that has gotten out of control, suggest that you celebrate future birthdays by having lunch together (either out or at home). Or, get several friends to contribute toward one gift for the birthday person. If your friends live far away, a nice card or warm letter is often more appreciated than an expensive gift.

Business Associates

Business associates and colleagues should be acknowledged if their birthdays are known. Some people prefer to keep birthdays a secret and celebrate only with their families and close friends. If special or important colleagues enjoy celebrating birthdays, send cards or flowers, or take them out to lunch. It is also appropriate to acknowledge the birthday with a "Happy Birthday."

Many businesses and workplaces have some type of informal birthday policy. Some firms have big catered parties after hours, while others simply supply a cake. Groups of co-workers get together for lunch or dinner to celebrate birthdays. Whatever your company's policy is, birthdays are a good way to get together with your co-workers in an informal atmosphere of fun, where you can get to know one another outside the usual business setting.

Celebrating Anniversaries

Obviously, don't forget your own anniversary, but there are normally other ones that are important to remember, too. Parents' anniversaries and children's anniversaries should be acknowledged; and don't forget the anniversaries of close friends and relatives, either.

Wedding Anniversaries

An appropriate anniversary card, letter, or phone call will help make the recipients' anniversary special. For relatives and close friends, it's nice to offer to prepare dinner at your house or take them out to their favorite restaurant. Small gifts are also nice (but not required).

Contemporary husbands and wives give each other anniversary gifts ranging from a special homemade dinner to a diamond anniversary ring. Gifts can also be something that both can appreciate together. For instance, if they both want a new CD player or a weekend getaway to San Francisco, they can organize it and pay for it jointly. For decade anniversaries—10, 20, 30, and 40—vacations or weekend getaways are nice. A couple's twenty-fifth and fiftieth anniversaries are often celebrated with flair.

Twenty-fifth and Fiftieth Anniversaries

Children often give their parents twenty-fifth- and fiftieth-anniversary parties. They can also be given by friends and other family members. Celebrations could take the form of family potlucks, family reunions, or recreating the wedding day itself, with all of the traditional pomp and circumstance.

Gifts made of silver are traditionally given for twenty-fifth anniversaries, and gold for the fiftieth. Other couples may shy away from the limelight and prefer spending a weekend getaway together.

Remember Death Anniversaries

Although remembering death dates of family and friends may be depressing, there is nevertheless some proper etiquette to consider. If a spouse, parent, or child has recently died, gathering with other family members on an important anniversary date to remember the good times and celebrate his or her life can help the healing process or serve as a way to help to keep family stories alive.

On big anniversaries, such as the tenth, twentieth, or twenty-fifth, get together with close friends and family for a religious or festive gathering. Bring out old photo albums and tell stories about this special person. Videotape the gathering to pass on to future generations. This is a nice way to pass on a video or photo family tree and history.

For death anniversaries of distant relatives and friends, a warm, friendly phone call or a "thinking of you" card is normally appreciated. Just being a good listener for a family member or friend can often help someone who is grieving through a difficult time.

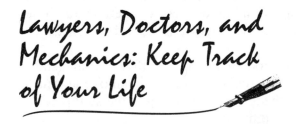

Lawyers, Doctors, and Mechanics: Keep Track of Your Life

Keep records of important legal and medical dates, as well as household and auto-maintenance schedules. You'll really be on top of things.

Remember Important Legal Dates

Legal dates tend to be the easiest dates to forget. Updating your "Information for Personal Representative Form" (page 223) once a year is important, to ensure that your children will be properly cared for in the event of your death and that you have an accurate listing of assets and debts.

It's important to make sure that you update your credit-card lists and bank information at least annually. A year goes by quickly, and many things can change in that period.

Lease agreements may also need renewal or revamping. Updating insurance policies, if a child has moved out, for instance, can save you money. Having a current personal inventory and getting appraisals on jewelry or antiques collected during the year will help you deal with insurance companies in case of a fire or theft.

If you purchased real estate or vehicles during the year, you'll want to add that to your list. Copyrights, patents, and trademarks are also important. Include I.R.A.s, retirement, profit-sharing, and securities documents. Partnership Agreements and Notes Receivable and Payable should be updated, too.

Record Medical Dates

Physicals for children as well as adults should be done annually. Young children require vaccinations and may need more than one checkup per year. Women need annual Pap smears and mammograms, while men need annual prostate exams. Eye and hearing exams should also be regularly scheduled.

Annual visits to the dental hygienist and dentist may prevent gum and tooth disease in later years.

Children wearing orthodontic gear will be scheduled for frequent checkups during the correction period. After correction has taken place, annual checkups may be scheduled to ensure straight teeth in adulthood.

Schedule Routine Maintenance for Car and Home

Despite their best intentions, many people seem to attend to vehicle maintenance only when the car stops running or gets dangerous to drive. Schedule your tune-ups, oil changes, brake inspections, and safety inspections so they become routine.

Many other things can be done to help keep your life and home stable and safe. Refill fire extinguishers and replace batteries in smoke alarms at the same time each year. (Try to schedule these dates near the start of summer, before the risk of fire is at its highest.)

Proper routine maintenance of your house can help save energy dollars and prolong the life of your appliances. If you live in a seasonal climate, you should prepare your home for the winter near the end of October. Replace screen doors with storm doors; clean the gutters around the house; replace the furnace filter and check the furnace pump; clean fireplace flues; wrap the water heater with an insulated blanket; wrap exposed water pipes with insulated blankets; bring the window air conditioner inside and cover the window; turn off the outdoor water lines and spigots; and drain outdoor hoses.

Likewise, in April, after the last freeze, it's time to remove the storm doors and turn on the outdoor water lines and spigots; get the window air conditioner in the window opening; and bring out the water hoses.

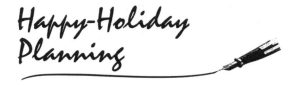

Happy-Holiday Planning

Plan ahead! You'll enjoy snag-free holidays. Bring your gift list with you when you attend those summer craft fairs. You'll be surprised at how much you can accomplish.

Plan for Photos and Holiday Gifts

It's a good idea to have your children's annual photos and family portraits taken during the late summer or early fall, to allow plenty of time for re-shoots if the pictures don't turn out well. This is particularly true if you are planning to frame them and give them as holiday gifts or to reuse them on your holiday greeting cards.

If you have a large gift list, it's generally a good idea to schedule a date to start looking for holiday gifts or ordering through catalogs. Many catalog orders may take two to eight weeks for delivery. If products are back-ordered (that is, not in stock), you may need to allow even more time for shipment.

Many people who make their own gifts for birthdays and holidays often run out of time. Instead of cramming and adding pressure to complete gifts during the holidays, however, if you can schedule two to four weeks in the summer or fall to make and wrap all the gifts, you will have time to enjoy the holidays and send the packages out in regular mail, not overnight express, saving you postage.

Make Holiday Arrangements in Advance

For holiday plans that require flights, make reservations six to twelve months before the holiday. If using frequent-flyer tickets, you may even need to make reservations up to a year in advance.

On the other hand, if you are planning to host holiday festivities, make your announcement a year in advance. This will give your guests ample time to make necessary travel arrangements or to arrange visits with other family and friends throughout the year. You'll need to make reservations for lodging if your home isn't large enough to house all of your guests.

Create a Holiday-Card List

Do you forget to send holiday greetings to special people? Would you like to reduce your holiday card exchange by sending cards only to those who reciprocate? The "Holiday-Card List" (page 45) will help you organize your names and addresses and keep track of friends you've exchanged greetings with in past years.

Copy the "Holiday-Card List" as many times as needed. Organize your holiday-card list either alphabetically or by category (that is, Dressel Family, Williams Family, church, and so forth). Enter the year card is sent in the "Sent" box. When you receive cards, enter the date in the "Rec'd" box. Keep this list on a clipboard near your stack of holiday cards. It will be easy to enter the date cards are received, to verify addresses, and to send holiday cards. This way, you can be sure that you don't forget special friends.

Summing Up

If you use the Permanent Calendar, there shouldn't be any need to worry about forgetting important birthdays, medical checkups, or holiday preparation. Simply refer to it, once a month, and enter all the important dates you find there into your appointment book or calendar. The knowledge that all your important dates are scheduled to be taken care of will give you additional peace of mind and will make your life that much smoother.

Keeping track of holiday cards is a cinch with the "Holiday-Card List." You'll know to whom you've sent cards and who has sent them to you, and you'll even be able to keep track of address changes, too.

Important-Dates Organizers

Permanent Calendar
Holiday-Card List

Permanent Calendar

January

New Year's Day 1	2	3	4	5	6	Update credit card list 7
8	Annual medical exams 9	10	11	12	13	Update inventory list 14
15	16 Martin Luther King, Jr.'s birthday (3rd Monday in January)	17	18	19	20	21
22	23	24	25	26	27	28
29	30	Qtrly. taxes, 31 W2s, and 1099s due				

February

1	2	3	4	5	6	Update information for personal representative 7
8	Annual dental exams 9	10	11	Lincoln's Birthday 12	13	Valentine's Day 14
15	16 Washington's Birthday (3rd Monday in February)	17	18	19	20	Update "Notes to Guardian" Form 21
22	23	24	25	26	27	1099s due 28 to I.R.S.
Leap Year 29						

March

1	2	3	4	5	6	7
8	9	10	11	12	13	14
15	16	St. Patrick's Day 17	18	19	20	21
22	23	24	25	26	27	28
29	30	31				

April

(Daylight Savings Time) Check smoke detectors and fire extinguishers 1	2	3	4	5	6	7
8	9	10	11	12	13	14
Personal taxes due 15	16	17	18	19	20	21
Summer prep: screen doors, air conditioner, waterlines on, spigots on 22	23	24	25	26	Professional Secretary's Day 27	28
29	Qtrly. taxes due 30					

Permanent Calendar (continued)

May

1	Auto maintenance 2	3	4	5	6	7
Mother's Day (2nd Sunday in May) 8	9	10	11	12	13	14
15	16	17	18	19	20	Armed Forces Day 21
22	23	24	25	26	27	28
29	Memorial Day (Last Monday in May) 30	31				

June

1	2	3	4	5	6	7
8	9	10	11	12	13	Flag Day 14
Father's Day (3rd Sunday in June) 15	16	17	18	19	20	21
22	23	24	25	26	27	28
29	30					

July

1	2	3	Independence 4 Day	5	6	7
8	9	10	11	12	13	14
15	16	17	18	19	20	21
22	23	24	25	26	27	28
29	30	Qtrly. taxes 31 due				

August

1	2	3	4	5	6	7
8	9	10	11	12	13	14
Organize carpool for school 15	16	17	18	19	20	21
22	23	24	25	26	27	28
29	30	31				

Permanent Calendar (continued)

September

Update emergency form **1**	Labor Day (1st Monday in September) **2**	**3**	**4**	**5**	**6**	**7**
8	**9**	**10**	**11**	Check disaster kit **12**	**13**	**14**
15	Start holiday shopping (catalogs, costumes, and sales) **16**	**17**	**18**	**19**	**20**	**21**
22	**23**	**24**	**25**	**26**	**27**	**28**
29	**30**					

October

1	**2**	**3**	**4**	**5**	**6**	**7**
8	**9**	**10**	**11**	**12**	**13**	**14**
Take holiday photographs **15**	**16**	**17**	**18**	**19**	**20**	**21**
22	**23**	United Nations Day **24**	**25**	**26**	**27**	(Daylight Savings Time ends) check smoke detectors and fire extinguishers **28**
Winter prep: storm doors, clean gutters, furnace filter, furnace pump **29**	Drain hoses outdoor water-lines off, spigots off, water heater blanket **30**	Halloween **31**				

43

Permanent Calendar (continued)

November

Write holiday cards 1	Auto maintenance 2	Election Day 3 (1st Tuesday after the 1st Monday in November)	4	5	6	7
8	9	10	Veteran's Day 11	12	13	14
15	16	17	18	19	20	21
22	23	24	25	26 Thanksgiving (4th Thursday in November)	27	28
29	30					

December

1	Chanukah 2 (movable feast)	3	4	5	6	7
8	Send holiday gifts and cards 9	10	11	12	13	14
15	16	17	18	19	20	21
22	23	24	Christmas 25	26	27	28
29	30	31				

Holiday-Card List

	Year:	Year:	Year:	Year:	Year:	Year:	Year:	Year:
Name	Sent	Sent	Sent	Sent	Sent	Sent	Sent	Sent
Address	Rec'd	Rec'd	Rec'd	Rec'd	Rec'd	Rec'd	Rec'd	Rec'd
City State Zip Code	Sent	Sent	Sent	Sent	Sent	Sent	Sent	Sent
	Rec'd	Rec'd	Rec'd	Rec'd	Rec'd	Rec'd	Rec'd	Rec'd
	Sent	Sent	Sent	Sent	Sent	Sent	Sent	Sent
	Rec'd	Rec'd	Rec'd	Rec'd	Rec'd	Rec'd	Rec'd	Rec'd
	Sent	Sent	Sent	Sent	Sent	Sent	Sent	Sent
	Rec'd	Rec'd	Rec'd	Rec'd	Rec'd	Rec'd	Rec'd	Rec'd
	Sent	Sent	Sent	Sent	Sent	Sent	Sent	Sent
	Rec'd	Rec'd	Rec'd	Rec'd	Rec'd	Rec'd	Rec'd	Rec'd
	Sent	Sent	Sent	Sent	Sent	Sent	Sent	Sent
	Rec'd	Rec'd	Rec'd	Rec'd	Rec'd	Rec'd	Rec'd	Rec'd
	Sent	Sent	Sent	Sent	Sent	Sent	Sent	Sent
	Rec'd	Rec'd	Rec'd	Rec'd	Rec'd	Rec'd	Rec'd	Rec'd
	Sent	Sent	Sent	Sent	Sent	Sent	Sent	Sent
	Rec'd	Rec'd	Rec'd	Rec'd	Rec'd	Rec'd	Rec'd	Rec'd
	Sent	Sent	Sent	Sent	Sent	Sent	Sent	Sent
	Rec'd	Rec'd	Rec'd	Rec'd	Rec'd	Rec'd	Rec'd	Rec'd
	Sent	Sent	Sent	Sent	Sent	Sent	Sent	Sent
	Rec'd	Rec'd	Rec'd	Rec'd	Rec'd	Rec'd	Rec'd	Rec'd

Notes

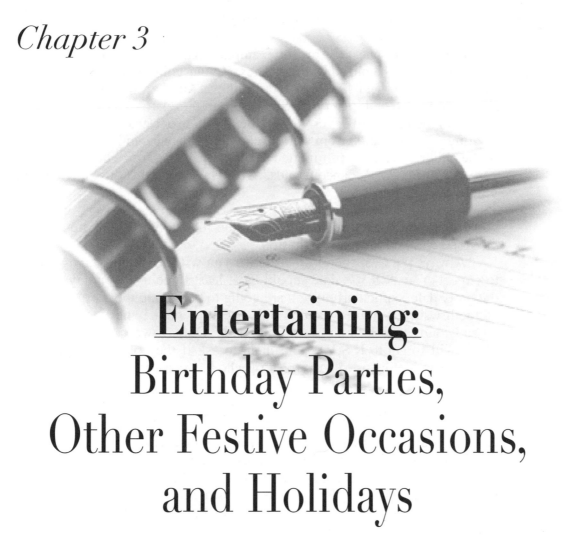

Entertaining: Birthday Parties, Other Festive Occasions, and Holidays

Whether it's only a birthday party for your five-year-old, a simple gathering of friends with hors d'oeuvres and drinks, or an elaborate catered event with professional entertainment, successful parties require good planning. Getting ready for a birthday is a lot easier once you've organized your household. After all, the hosts, like the guests, should enjoy themselves.

How to Give a Memorable Birthday Party

Celebrating your child's birthdays will always bring fond memories. Be sure to take lots of pictures to record these special events.

Select Appropriate Guests

If you have limited space and plan to host a party in your home, close friends and family should have the first priority on your guest list. Think

about limiting the guest list by, for example, inviting only children who are the same age as the birthday child. Thus, if your child will be turning five, invite only four- and five-year-old children. Another way is to invite a select group of children (Girl Scouts, church, relatives, school, sports, dance) to the party. However you decide to limit your group, *be consistent*. Inviting just a few kids from school, church, or dance can hurt the feelings of the children who weren't invited. It's okay to say, "We're having a small party for just Nicole's dance friends." That way, you don't offend friends at school or church.

On the envelope of the invitation, write the invited guest's name. If you are inviting the entire family, write "the Johnstons." If you are inviting only one child, write "Ross Johnston."

Always put a "respond by" date, so you will know how many guests to expect. Your R.S.V.P. date should be at least three to seven days before the party date, particularly if you are going to be having the party at a rented facility such as a roller-skating rink, because you may need to give them a head count a week or so prior to the party. One or two of the guests you invite will forget to R.S.V.P. Call them to ask if they plan to attend. The Party Guest List helps to keep track of who has responded.

Get Organized with a Party Guest List

Use the "Party Guest List" on page 61 to organize your parties. Fill in the names and addresses of all invited guests. Check the "Inv. Sent" column once invitations are sent and the "R.S.V.P." column when responses are received. This form can also be used to indicate party bags made, to record gifts received, and thank-you notes sent. The Party Guest List also makes a good memento.

This record of who gave what can also help you when it comes time to buy a gift for one of the children who attended your child's party. You'll have some idea of what the child might like to have.

Send Invitations

Stationery stores carry a wide variety of birthday-party invitations. They usually have 8 cards per pack.

Your children can make their own birthday invitations. When inviting just a few friends, they can make individual invitations for each friend. For larger guest lists, your child can make a single invitation on an 8 1/2" × 11" white paper using black ink, and you can copy it on a copier for each of the guests. Your child can then color each invitation, or you can copy the invitation on colored paper. If your child enjoys using the computer, he or she can create an invitation on the computer, add clip art and graphics, then print out the number needed on a color printer.

You should send out the invitations two weeks before the party, or four weeks before if the party date is on a holiday weekend. This allows plenty of time for guests to plan around the party and to shop for gifts.

Select Food for the Party

Offer snacks or meals if the party takes place at meal time. Parties that are scheduled after meals in the morning, afternoon, or evening should provide snacks. Parties that run through lunch (11:30 A.M.-1:00 P.M.) or dinner hours (5:00-7:00 P.M.) should include a meal.

Favorite snacks for children are cheese and crackers, pretzels, chips, sliced fruit, nuts, dried fruit, and vegetable sticks. Avoid bite-size hot dog slices, sliced carrots (nickel size), hard-candy balls, or other food that can get lodged in a child's throat. Bottled, boxed, or canned drinks tend to be wasted. The children have a sip, set it down, and play. They lose track of their drinks and simply open another one.

Fruit juice mixed with club soda makes a wonderful sparkling drink without the sugar and additives. Fill a huge punch bowl and slice lemons for flavor and visual appeal. Serve drinks in cups with name tags to avoid going through your complete supply of glasses and cups. Plastic drink cups are handy and they're reusable. Just put them in your dishwasher and use them over and over again. Making huge pitchers or punch bowls full of juice is economical and ecologically sound as well.

If you plan to serve a meal, set a place for each guest at your table. They get so excited at parties they don't want to waste time eating. Announce that all guests should remain in their seats until everyone has finished eating. This will slow down those children who want to take one bite and run outside.

Serve the children their favorite foods. Parties are not the right time to instill healthful habits: You won't make points by serving spinach quiches to the children. Pizzas, mini hot dogs, and macaroni and cheese are favorites. Don't bother with salads or vegetables; they won't get eaten. Serve tiny portions and ask kids if they want seconds. That helps to eliminate waste and also makes the children feel like big eaters.

HAVE A SPECIAL CAKE Birthdays, like weddings, generally require only a cake and something to drink. The centerpiece of a birthday party is always the birthday cake. Children rush into the room to see the cake when it is brought in, covered with bright, glowing candles. Theme cakes are fun for young children. They enjoy seeing their favorite characters on the cake next to their names.

If you are buying a birthday cake, you should place your order with the bakery at least one week before the party. (Many grocery stores have bakery sections that bake cakes daily and are reasonably priced compared to bakeries.) White, yellow, or chocolate cakes top the list for most kids. If the cake has a whipped cream frosting, you need to keep the cake refrigerated until two hours before serving, at the earliest. If you don't have enough room in your refrigerator to keep the cake cold until it is ready to serve, order a cake with a butter-cream frosting.

Homemade cakes or cupcakes are always fun. You can decorate them with sprinkles or with premade candy letters. If you have an artistic touch, try decorating with the decorator icing that is sold in grocery stores, or by using a pastry bag.

Party themes and activities vary, and will change as children get older. The number of children invited also dictates the types of activities and space needed.

Following are some party theme and activity suggestions.

1-2 Years

☐ Art: Handprints in Paint or Plaster, Spin Art
☐ Face Painting
☐ Cupcake Decorating

For children of this age, you want to keep the party theme and activities simple. Young children can easily become overwhelmed with all the attention, children, and games. Parties for children this age often become a social gathering for the parents, too.

3-4 Years

☐ Costume or Dress-Up Theme
☐ Special Visitor: Teddy Bear, Clown, Favorite Character
☐ Games: Bean Bag Toss-and-Catch Games, Piñata Games, Treasure Hunt
☐ Art: Finger Painting, String Painting, Sponge Painting, Decorate Bags to Gather Treasure-Hunt Items
☐ Storytelling

5-6 Years

☐ Games: Relays, Musical Chairs, Pin the Tail, Treasure Hunt
☐ Outings: Roller Skating, Ice Skating, Miniature Golf, Park, Beach, Inflatable Bouncing Room
☐ Special Visitor: Magician, Favorite Character
☐ Art: Paint T-Shirts/Bags, Tie-Dye T-Shirts, Bead Jewelry, Sand Painting/Sculpture

7-8 Years

☐ Amusement Park, Movie, Theater, Roller Skating, Flying Kites, Bumper Bowling
☐ Special Visitor: Magician, Science Experiment Demonstrator
☐ Art: Ribbon Barrettes, Jewelry, Leather Belts, Book Binding (Journals), Decorate Stationery, Marbleize Paper or T-Shirts
☐ Games: Treasure Hunt, Races, Piñata Games, Board Games

9-10 Years

☐ Outings: Video Arcade, Amusement Park, Theater, Ice Skating, Bowling, Swimming, Museum, Aquarium
☐ Murder-Mystery Party (modify adult games)
☐ Art: Origami Boxes and Projects, Painting on Canvas Boards, Beading, Paper Making, Picture Frames

11+ Years

By this age, your child will generally let you know what he or she wants for a birthday celebration. Activity-based celebrations, such as amusement parks and movies, tend to be favorites. The number of guests at this age usually shrinks to fewer than eight.

Use the "Birthday Party Checklist" on page 60 to plan the party. Follow the "Things-to-Do" list. Start your planning at least four weeks before the party date.

Set Up a Birthday-Party Agenda

Children like structure, even (or especially) when they're at a party. It gives them security to know that they will first do an art project, after that, Chuckles the Clown will come, followed by outdoor games, then cake and ice cream. See the "Birthday-Party Agenda" (Sample) on page 62.

When you set an agenda, you should allow 30 minutes or so for all the guests to arrive. Many guests may be locating your house for the first time. Arriving on time with children, gifts, and party clothes is difficult for even the most punctual people. Plan an activity in which guests can participate as they arrive. This allows guests to arrive at their leisure and prevents the children from having to wait around anxiously for the latecomers for the party to get going.

After all the guests have arrived, you can start the party by showing the children the Birthday-Party Agenda. For younger children, check off each activity as it's completed. That way, they know what will happen next and how many activities take place before the cake is served. (Use the "Birthday-Party Agenda" form on page 63.)

Offer Party Favors

This is a relatively new idea. Party bags are given to each guest at the end of a party as "thank-you's" for attending the party.

A party bag usually consists of a plastic bag filled with inexpensive toys and gadgets that kids throw away as soon as they get home.

If you want to give party bags, make them yourself and fill them with items such as pencils, pads, stickers, bubble liquid, markers, and erasers in animal shapes.

If your party includes art projects, you can wrap them up and send them home in the party bag.

Send Thank-You Notes

Every gift received deserves a handwritten thank-you note. Giving a verbal "thank you" at the party may replace thank-you notes, if the thanks come from the child and parent to the guest and the guest's parent. When gifts are opened after the guests leave, all of the gift givers should get a thank-you note.

Thank-you notes are most appreciated if they are written by the child. Even young children who don't write yet can sign their names, or scribble at the end of the parent's written thank-you note. Children can also dictate the thank-you letters to the parents or can thank their friends on the telephone.

A thank-you note should mention the gift. Add a description of how it will be used, or a special appreciation for the gift. Photographs of the child using or wearing the gift are a nice touch in thank-you notes, too.

Six Tips for a Successful Birthday Party

It's generally a good idea to place balloons or signs at strategic points near your home to help your child's guests find the house with ease, particularly if you live in an out-of-the-way location or it is complicated to get to your house. Latex balloons should be filled with air, not helium. Helium balloons often escape into the atmosphere; then, when gravity pulls them down, birds and other animals ingest the popped balloons, causing them to choke or suffocate.

Young birthday children may sometimes have trouble handling all the attention and the high energy of a birthday party. Set the time of the party to best suit your child—avoid nap time.

Plenty of finger foods should be provided for the guests, but limit the amount of sugar you offer. Cake and ice cream should always be served at the end of the party.

Opening gifts when the guests are there causes three problems: (1) it takes at least 15 minutes to open gifts, taking precious party time away from the children; (2) younger guests don't understand why the gifts are not for them; and (3) guests often come from different socioeconomic levels, and gift-givers can feel uncomfortable if their gifts aren't as elaborate or expensive as the next guest's. If your child opens his or her gifts when the guests leave, or after a nap/rest period, the birthday child can really enjoy each gift.

If opening gifts with all the guests gathered around is traditional in your family or circle of friends, by all means, open gifts with everybody. The ideal time to open gifts is after all the party activities are over, just before the guests begin to leave.

Party bags, if given, should be distributed to guests when they leave. This avoids problems with children misplacing items in the bag, or accusing other children of having "their" little gifts. Likewise, if party bags are opened at the party, you might get a call the next day from a parent asking if their child's pencil was left behind, or something similar, and then you have to arrange a time to return lost items, which can become inconvenient.

It's Formal: You're Throwing a Great Party

Throughout the year, you may host and participate in a number of festivities and parties, such as a graduation party, a Bar or Bat Mitzvah, or a Holy Communion celebration. Like birthday parties, successful

parties for adults require good planning. See the section on Birthday Parties for guidelines about whom to invite, R.S.V.P. cards, thank-you notes, checklists, and invitation sheets.

Using a Caterer

Having a party catered relieves you of the problems of having to worry about food, tables, presentation, and so forth. It is definitely recommended that you use a caterer in situations where you are expecting a large number of guests and are planning to have a lot of food (that is, a sit-down dinner). Otherwise, you find yourself running from kitchen to guest, guest to kitchen, beverage counter to kitchen, and when it's over, you find out that you never had a chance to enjoy yourself.

If you have never used a caterer before, get some recommendations from friends. If you have enjoyed a caterer at another party, you should ask the host for the caterer's name and phone number. After you have a few names, call each up and check to see if the caterer is available for the date you have in mind *and* that he or she has the time frame open, too (for example, 7:30 P.M. to midnight). You want to make sure that the caterer doesn't overbook for that date, and that he or she is available to stay longer to accommodate to your needs, if necessary.

The "Caterer-Evaluation Checklist" on page 64 is useful in deciding what caterer you want to hire. Ask for any literature the caterers might have describing their service, policies, entrees, and prices. Ask to visit a function, or get references. Once you select a caterer, ask to taste samples to ensure the quality, quantity, and visual appeal. The "Caterer Cost Sheet" (page 65) helps you to keep track of detailed costs.

Caterers offer a wide variety of entrees, appetizers, salads, and condiments. Most of the time, the cost is based on the number of guests served. Most caterers charge regular rates for children. Be sure to ask about their cancellation policy and overtime charges in case your party runs later than you had planned.

SELECT THE EQUIPMENT If your party will be held in a restaurant or a hotel, the equipment is usually included in the per-person rate. Most caterers also include equipment in the per-person rates. This is a convenient service and makes your planning much easier. Use the "Caterer's Equipment Checklist" on page 66.

Make sure you discuss all the details about equipment with your caterer. You'll need to select napkin and tablecloth colors, table size and shapes, and large equipment such as chafing dishes and fountains. Ask to see their equipment. Make sure that serving dishes and displays are clean and polished. The linen should be clean, pressed, and in good shape (not faded or full of holes).

Catering Your Own Party

There are other times when you will want to cater a party, such as a small dinner or cocktail party, yourself. In that event, you should plan your menu

so that it can be prepared as far in advance as possible. After all, you want to be a part of the party, too.

PLAN THE MENU Consider your budget and your guests. If you plan to serve ethnic or exotic entrees, you might want to offer a traditional American entree as well, for guests who have limited diets. Likewise, when you have a meat main course, make a vegetarian dish available for those who don't eat meat, or vice versa.

Balance is important when planning a menu. A creamy soup will accent prime rib, but not chicken in a white cream sauce (too many creamy sauces). Serve the chicken in a cream sauce with a marinated vegetable salad and wild rice. It's generally a good idea to try to mix hot with cold, crunchy with soft, or sweet and creamy with tart. If you have more than one meat dish, vary them by serving beef and chicken or fish.

The way the entree is displayed creates its ambiance. Entrees served with the right garnishing and color seem to taste better. A plate looks more appetizing when there are splashes of red (tomatoes, beets, red cabbage, radishes, red peppers) or green (lettuce, cabbage, parsley).

RENT YOUR EQUIPMENT Paper plates, plastic drink glasses, and plastic utensils are, quite frankly, "tacky" for formal parties. Renting dishes, glasses, and silverware is inexpensive, makes the food presentation much more appealing, and is environmentally sound, to boot.

Party- and furniture-rental shops carry everything from fine glasses and silver-plated utensils to tents. Some specialty stores carry linen table-cloths, napkins, and lace. Call around to see what services are available. Ask for brochures listing the supplies carried and rental policies.

When you place your order, be prepared to leave a deposit of anywhere from 10 to 50 percent of the estimated total. Make sure you know and understand the store's policies on cancellation, late returns, and broken or missing items. Check the order for quantity, sizes, pick-up or delivery date and time, and any other items or specifications you have requested. Your order will be packed in heavy-duty cartons when it arrives, and it will normally need to be repacked into the cartons after the reception. Read through the contract and make sure you understand the terms.

ORGANIZE YOUR SHOPPING List all ingredients you will need on the "Shopping List for Self-Catered Party" on page 70. Consider the prep date for making entrees when you shop for ingredients.

GET HELPERS TO PREPARE FOOD Unless you're one of those who feel that too many chefs spoil the soup, ask others to help you do the prep cooking. Use recipes, and ask helpers to each make an entree ahead of time. You'll need the extra help for the few fresh dishes you serve on the party day. Making a fruit salad or vegetable sticks on the party morning yourself can be stressful.

Enter all entrees on the "Entrée-Preparation Schedule" on page 71. Schedule the date to prepare each entree to allow sufficient preparation time for each dish. Sauces, marinades, and dressings can be prepared

ahead and added to the entrees the day of the party. Check off the dates when ingredients are purchased and when each entree is prepared and stored.

Borrow Freezers and Refrigerators

Depending upon the number of people you are having, it may be that storing all the food you prepare ahead of time in your side-by-side freezer will be impossible. In that case, you'll need to ask neighbors, friends, and/or family if you can use their freezers until the party. You may also need to borrow a refrigerator a few days in order to store perishable items that can't be frozen. Arrange for your storing locations before you actually need them.

Serving dishes and equipment should be ordered two or three months ahead of time, to ensure that all the equipment can be provided by a single party or furniture-rental shop. Check to see if they have delivery service. For more information about equipment, see the "Caterer's-Equipment Checklist" (page 69).

The food tables, bar, and dining tables should be set up at least four hours before the party begins. Once guests start arriving, it is awkward to have to try to move large tables, or finish with the decorations.

Hire Servers

Hire your servers and bartender. You should call your favorite restaurants and bars for recommendations about party help (many waiters and bartenders will free-lance for parties, too). Once the party starts, you should be free from any more responsibilities in the kitchen and bar. The servers should know where to find all the food and reserves. Give them a timetable for circulating with hors d'oeuvres, food, and drinks.

Suggest a dress code for the servers. If you ask them to wear black trousers and a white, long-sleeved shirt you won't have to worry about them using their own judgment and showing up in shorts and a tank top.

The servers and bartender should be scheduled to arrive 30 minutes to an hour before the start of the party and stay to clean up after the festivities are over. Tell them specifically where items will need to be placed or returned.

Serving Beverages

The bar should be well stocked. You don't want the servers to come up to you and ask where the stirring sticks are while you are mingling with the guests. Make sure you have enough ice.

OFFER NONALCOHOLIC DRINKS Always have nonalcoholic beverages available for your guests. Many adults, pregnant women, and children don't drink liquor. A guest who becomes intoxicated may need something nonalcoholic to drink for the last half of the party if they over-indulged during the cocktail hour.

Many nonalcoholic beverages can be served in a decorative fountain or a punch bowl. To many, sparkling apple cider or grape juice has the same appeal of champagne without the alcohol, particularly if served in champagne glasses, so that your nondrinking guests may toast along with those drinking champagne. Servers may pour soft drinks or sparkling water at the table or at the bar. It is polite to offer coffee and tea after the meal. Don't forget the cream, sugar, and sweetener.

PROVIDE ALCOHOLIC DRINKS Stocking wines and liquor for a party will often be your biggest expense. Fine wines served with a dinner add up. One way of limiting the cost of the alcoholic beverages is to serve premixed drinks (such as margaritas) from pitchers, or champagne punches in a fountain or punch bowl.

A formal dinner served with a selection of fine wine offers the finest in culinary delights. Consider your menu and your guests when selecting the wine. Leave two different bottles of wine on each table so the guests can serve themselves, or the servers can pour.

Setting Up a Bar

A variety of liquor and mixers is necessary to stock a bar. This allows your bartender to whip up specific drink requests and to accommodate the nondrinkers as well. Consider the guests, the season, and the time of day. Some may prefer white wine and blended drinks made with vodka, light rum, and gin. Others may ask for scotch, bourbon, or dry martinis. The lighter mixes are generally popular on hot summer days, while darker drinks may be favorites on a cool winter evening.

If you are buying your liquor from a single source, many liquor stores will give refunds on unopened bottles. See "Estimating Liquor/Beverage Amounts" (page 72) to give you guidelines on ordering liquor.

CALCULATE LIQUOR AMOUNTS You should plan for the amount of alcohol your guests will consume when calculating the amount of liquor to buy. Inquire about their beverage preferences. Always order more than you need, preferably from a liquor store that is willing to buy back unopened bottles. If the party is catered, the bar will be stocked and you'll be charged only for the bottles that are opened.

Depending upon the type of party, for example, a brunch, a cocktail party, or a formal sit-down dinner, an average guest will have between two to five drinks. As each drink normally has about one and one half ounces of liquor, a quart will make about 20 drinks, and a fifth will make somewhere around 18 drinks. People who drink wine throughout the course of a reception may drink one or more bottles each. If you offer champagne just for the toast, you need one liter bottle for every eight guests.

After you have decided on the number of guests, what you are serving, and so forth, you can multiply out the numbers to get a good "guesstimate" of what quantities will be needed. You can use the same formula to calculate what quantities of mixers will be needed and what quantity drinks for your nondrinkers. Mixers, juices, and sodas are harder to calculate

because they are used in mixed drinks as well as in nonalcoholic drinks. Adjust the formula in the chart for drinks per container (liters, 12-ounce cans). Use the "Estimating Liquor/Beverage Amounts" form (page 72) to calculate quantities to buy. The "Bar/Liquor Checklist" (page 73) can be used as your liquor shopping list.

SERVE AFTER-DINNER DRINKS After a formal dinner, offer after-dinner drinks. Your servers can circulate with bottles of brandies and liqueurs. If your budget allows, place a few selected bottles at each table for the guests to enjoy.

OFFER TRAY SERVICE If a hosted bar is out of your budget, offer tray service. Select a few mixed drinks that can be served to the guests at their tables or as they mingle.

ASK ABOUT CORKAGE FEES If your party will take place in a hotel or restaurant, the management will usually require that you purchase all liquor from them. If you insist on bringing your own liquor, they may charge a corkage fee. This fee is a per-bottle charge that covers the servers' opening and pouring the bottles for the guests. Some establishments will let you bring your own liquor only if you have selected brands they cannot get, that is, from private wineries. (Note that in many states, if a restaurant or tavern has a license for on-site liquor consumption, it is illegal for it to allow you to bring your own liquor into its establishment.)

Inquire about corkage fees before you buy the liquor. Sometimes purchasing liquor at wholesale prices doesn't help your budget after corkage fees are added to the cost. If you have a large party, try to negotiate with the salesperson to reduce the corkage fee.

Handling Drunks and Drug Users

It seems that at every party, there are always one or two people who overdo the celebrating and make fools of themselves. Some young people think that parties and getting drunk go hand in hand. Others may overimbibe unintentionally, having a few glasses of wine with dinner and enjoying an after-dinner brandy, without realizing the volume of alcohol they have consumed.

Although you can't change your guests' alcohol-consumption habits, you can do a few things to minimize their alcohol intake. Avoid salty foods such as caviar, pretzels, and chips, which make people thirsty. Offer foods with lots of protein, in order to replenish the body's loss of blood sugar from drinking. And ask a few responsible people to watch for those who overdo it.

If guests become inebriated, the bartender should stop pouring drinks for them. Keep an eye on them to make sure they don't try to drive home. Ask friends or designated drivers to give them a ride home. Call a cab and take their keys away, if you can't arrange other transportation. In some states, a bartender or the host of a party can be held liable for an accident

caused by inebriated guests. It's better to take precautions than to deal with the tragedy of an accident or death.

Although drugs are illegal, they seem to appear at parties nationwide. Some of your guests may feel that they can't enjoy themselves without them. It's difficult to stop guests from taking drugs, since they are often consumed in restrooms, or in cars. If certain guests have a history of using drugs at parties, you may get the word out that you would prefer no drugs at your party, or better yet, simply eliminate the people from your guest list.

How to Be the Best Holiday Hostess

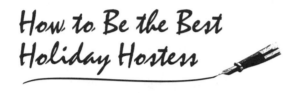

If you're hosting a holiday gathering, draw up an itinerary. This will allow your friends and family to plan their trips around your scheduled events. See "Sample Holiday Itinerary" on page 75.

If your holiday plans include hosting large numbers of guests who will be arriving by plane, contact all your guests to get their approximate arrival and departure times. Then suggest a date and general time to pick up all your guests at the nearest airport. This will help reduce the number of unnecessary trips to the airport while you're getting ready for the holidays. If you're overwhelmed, ask other relatives or friends to help with getting everybody to and from the airport.

Set dates and times for all meals and activities. Indicate who is invited and the nature of the gathering. Include activities to entertain children of all ages. List all planned activities (meetings, meals, outings) so guests will know what they're invited to and when they'll have free time to go off on their own. See "Holiday-Itinerary Worksheet" on page 76. That way, Aunt Clare will know she can shop on Thursday because you'll be in a meeting or at a luncheon with the cousins.

By setting a holiday itinerary, you remain in control of your home and schedule. The various groups of guests will know the "holiday plan" and will join you at the appropriate times. This may eliminate pressure about how you spend your holiday time from your more possessive guests.

Summing Up

Children's birthday parties, as well as formal parties and holiday gatherings, are fun to plan and are enjoyable, memorable events for all. Whether you're planning a special, elaborate event or a simple gathering, spend the time to organize the party to ensure a smooth celebration for your guests and, most important, for you.

Festive Organizers

Birthday-Party Checklist
Party Guest List
Birthday-Party Agenda (and sample)
Caterer-Evaluation Checklist
Caterer Cost Sheet
Caterer's-Equipment Checklist
Shopping List for a Self-Catered Party
Entrée-Preparation Schedule
Estimating Liquor/Beverage Amounts
Bar/Liquor Checklist
Sample Holiday Itinerary
Holiday-Itinerary Worksheet

Birthday-Party Checklist

Things to Do	Quantity	Description	Done
Select party date			
Make guest list			
Buy/make invitations			
Buy postage stamps			
Address invitations			
Order birthday cake			
Buy food/ingredients			
1.			
2.			
3.			
4.			
5.			
6.			
7.			
Buy paper goods:			
1. Plates, utensils			
2. Cups			
3. Napkins			
4. Tablecloth			
Buy decorations:			
1. Balloons			
2. Streamers			
3. Signs, place tags			
Party bags:			
1.			
2.			
3.			
Supplies:			
1.			
2.			
Entertainment:			
1.			
2.			
Activities:			
1.			
2.			

Party Guest List for: _____

Date: _____

Name	Address	Inv. Sent	R.S.V.P	Party Bag	Gift	Thank You Sent

Birthday-Party Agenda

Sample

1:00	Guests arrive
	Decorate bags
1:30	Clown show
	Face painting
	Balloons
	Magic show
2:30	Games:
	Musical chairs
	Treasure hunt
3:30	Cake and ice cream
3:45	Open gifts
4:00	Time to go home!

Birthday-Party Agenda

Caterer-Evaluation Checklist

Questions	#1	#2	#3
Caterer:			
Manager:			
Phone:			
Address:			
Hours:			
Cost per person:			
Cost breakdown:			
Food:			
Service:			
Rentals:			
Caterer serve liquor:			
Corkage fee:			
Ratio of servers/guests:			
Server's attire:			
Condition of equipment:			
Observe their catering:			
Taste samples:			
Sales tax included:			
Gratuities included:			
Overtime charge:			
Cancellation policy:			
References:			
Charge to serve band:			
Initial deposit due:			
Balance due:			
Other:			

Caterer Cost Sheet

Caterer:		Manager:		
Address:				
Phone:		Manager's home phone:		
Hours:		Hours available for party:		
Last date to give head count:		Party location:		
Date:		Set-up time:		
Total head count:		Cost per person:		
Total cost:	Deposit due date:		Balance due date:	

Item	Amount	Selection	Cost Estimate	Actual Cost
Hors d'oeuvres:				
Lunch/dinner menu:				
Dessert:				
Punch:				
Coffee/tea:				
Decorations:				
Taxes:				
Gratuities:				
Overtime charges:				
Other:				
TOTAL:				

Caterer's Equipment Checklist

Party rental store:	Manager:
Address:	Hours:
Phone:	Total Rental Costs:
Delivery date/time:	Pickup date/time:
Cancellation policy:	Deposit due date:
Broken/damaged goods policy:	

Item	Qty.	Description	Extended Cost Each	Person to Cost	Pick/Return
TABLES:					
Round (size:)					
Long (size:)					
Custom:					
CHAIRS					
LINEN:					
Round tables					
Long tables					
Custom:					
Napkins					
Serving napkins					
Kitchen towels					
Aprons					
Other:					
DINNERWARE:					
Dinner plates					
Salad plates					
Bread plates					
Soup bowls					
Luncheon plates					
Cake plates					
Cups/saucers					
Demitasse cups					
Other:					
SILVERWARE:					
Dinner forks					
Salad forks					
Dinner knives					
Steak knives					

Caterer's Equipment Checklist (continued)

Item	Qty.	Description	Cost Each	Extended Cost	Person to Pick/Return
Butter knives					
Teaspoons					
Soup spoons					
Dessert spoons					
Dessert forks					
Demitasse spoons					
Serving forks					
Serving spoons					
Cake knife					
Cake server					
Other:					
GLASSWARE:					
Wine, 10.5 oz.					
Wine, 8 oz.					
Goblet					
Champagne fluted					
Champagne saucer					
Highball					
Double rocks					
Snifter					
Water					
Juice					
Punch cup					
Other:					
TRAYS:					
Round, 12"					
Round, 14"					
Meat platters					
Oval, 13" × 21"					
Oval, 15' × 24"					
Oblong, 10" × 17"					
Oblong, 14" × 22"					
Oblong, 17" × 23"					
Bread baskets					
Condiments trays					

Caterer's Equipment Checklist (continued)

Item	Qty.	Description	Cost Each	Extended Cost	Person to Pick/Return
KITCHEN:					
Chaf. dish, 2 Qt.					
Chaf. dish, 4 Qt.					
Chaf. dish, 8 Qt.					
Hot plates					
Microwave					
Barbecue grill					
Charcoal lighter					
Sterno					
Coolers					
Ice chests					
Waiters' stands					
Waiters' trays					
Trash-cans					
Trash-can liners					
Other:					
MISCELLANEOUS:					
Coffeemaker, 35 c.					
Coffeemaker, 50 c.					
Coffeemaker, 100 c.					
Coffee pitcher					
Silver coffee set					
Creamer/sugar					
Punch bowl, 3 gal.					
Fountain, 3 gal.					
Fountain, 7 gal.					
Salt/Pepper sets					
Table candles					
Table no. stands					
Ashtrays					
Coat racks					
Hangers/cards					
Other:					

Caterer's Equipment Checklist *(continued)*

Item	Qty.	Description	Cost Each	Extended Cost	Person to Pick/Return
BAR:					
Corkscrew					
Bottle opener					
Strainers					
Cocktail shakers					
Electric blender					
Ice bucket					
Ice tongs					
Ice tubs					
Knives					
Spoons					
Serving trays					
Water pitcher					
Drink pitcher					
Condiments tray					
Stirring sticks					
Cocktail napkins					
Cocktail book					
Floor protector					
Plastic/rug					
TOTAL COST					

Shopping List for a Self-Catered Party

Items	Quantity/Person	Total Quantity	Total Cost
Meat:			
Vegetables:			
Fruit:			
Dairy:			
Packaged:			
Seasonings:			
Other:			

Entrée-Preparation Schedule

Entrées	Ingredients	Date to Prepare	Done

Estimating Liquor/Beverage Amounts

Item	# of Guests	× # of Drinks	= Total Drinks	# Servings/Bottle	= Quantities to Buy
Vodka				__ servings/liters	
Gin				__ servings/liters	
Light rum				__ servings/liters	
Dark rum				__ servings/liters	
Scotch				__ servings/liters	
Bourbon				__ servings/liters	
Whiskey				__ servings/liters	
Dry vermouth				__ servings/liters	
Swt. vermouth				__ servings/liters	
Dry sherry				__ servings/liters	
Sweet sherry				__ servings/liters	
Tequila				__ servings/liters	
White wine				8 servings/liter	
Red wine				8 servings/liter	
Rose				8 servings/liter	
Brandy					
Liqueurs					
Champagne				/8 Servings/liter	
Other:					
Other:					
Beer		× 2.5 glasses		÷ 160 glasses/keg	__# kegs
Club soda				/ 24 (12-oz. case)	__# Cases
Seltzer				/ 24 (12-oz. case)	__# Cases
Tonic water				/ 24 (12-oz. case)	__# Cases
Triple Sec					
Lime juice					
Grenadine					
Ginger ale				/ 24 (12-oz. case)	__# Cases
Lemon lime				/ 24 (12-oz. case)	__# Cases
Cola				/ 24 (12-oz. case)	__# Cases
Diet soda				/ 24 (12-oz. case)	__# Cases
Orange juice					
Mineral water					
Bottled water				/ 24 (16-oz. case)	
Other:					

Bar/Liquor Checklist

Liquor store:		Manager:		
Address:		Phone:		
Unopened bottle return policy:				
Date ordered:		Deposit due:	Total cost:	
Pickup time		Delivery time:		
Does manager have list of chilled items:				
Store liquor:				
Other:				

Item	Quantity	Cost Each	Ext. Cost	Chilled	Returns	Actual Cost
Vodka						
Gin						
Light rum						
Dark rum						
Scotch						
Bourbon						
Whiskey						
Dry vermouth						
Sweet vermouth						
Dry sherry						
Sweet sherry						
Tequila						
White wine						
Red wine						
Rose						
Brandy						
Liqueur						
Champagne						
Beer						
Club soda						
Seltzer						
Tonic water						
Triple Sec						
Lime juice						
Grenadine						
Ginger Ale						
Lemon lime						
Cola						

Bar/Liquor Checklist (continued)

Item	Quantity	Cost Each	Ext. Cost	Chilled	Returns	Actual Cost
Root beer						
Diet soda						
Tomato juice						
Orange juice						
Grapefruit juice						
Cranberry juice						
Sparkling cider						
Sparkling grape						
Mineral water						
Bottled water						
Limes						
Lemon peels						
Lime peels						
Maraschino cherries						
Cocktail olives						
Sliced fruit						
Angostura bitters						
Superfine sugar						
Salt						
Ice						
Other:						
Other:						
Other:						
TOTAL						

Sample Holiday Itinerary

Dressel Thanksgiving Holiday

Wednesday, November 27

1:00 P.M.–5:00 P.M.	Guests arrive (Newark Airport)
6:00 P.M.	Hors d'oeuvres at the Dressel's
7:00 P.M.	Dinner at the Dressel's

Thursday, November 28

8:00 A.M.–12:30 P.M.	Meal preparations
1:00 P.M.	Thanksgiving luncheon at the Dressel's (Everyone welcome!)
4:00 P.M.	College football at the Dressel's (Everyone welcome!)
7:00 P.M.	Thanksgiving dinner at the Dressel's (Everyone welcome!)

Friday, November 29

10:00 A.M.	Brunch at Bobby's (State College classmates) 102 Alta Vista Drive, Paramus 555-1018
1:00 P.M.	Metropolitan Museum of Art (Everyone welcome!) New York City
5:00 P.M.	Dinner at the Dressel's (Mitchell family)
8:00 P.M.	Game Night at Patty's (Everyone welcome!) 314 Ross Road, Bloomfield 555-1003

Saturday, November 30

10:00 A.M.	Brunch at Terry's (Lindsay family) 27 Delaware Avenue, Newark 555-1996
1:00 P.M.	2-hour sightseeing tour (Everyone welcome!) Meet at the Dressel's
5:00 P.M.	Dinner at the Dressel's (Everyone welcome!)
8:00 P.M.	Family slide show at the Dressel's

Sunday, December 1

10:00 A.M.	Continental breakfast at the Dressel's
1:00 P.M.	Meet at the Dressel's for ride to the airport

Hope you all had a great time! See you next year!

Holiday-Itinerary Worksheet

Date	Time	Activity	Location	Guests	Misc.

Chapter 4

Let's Get Away:
Vacations

Last year, we took a two-week trip, and it was worse than working 12 hours a day, commuting, and taking care of the kids all at the same time. All of our arrangements got fouled up, we missed planes, hotels were overbooked, and it got to the point where we were having to work to try and have fun. If I ever had to go through a "vacation" like that again, I'll just keep working.

Well, you've finally gotten some time off and can take that family vacation you've been planning for, right? Everybody needs to have a break from his or her routine and to get some "me" time once in a while. Unfortunately, sometimes that hoped-for relaxation is missed because of bad planning, bad timing, or just plain old bad luck. In order to prevent those stressful before-, during-, and after-vacation headaches that can turn your vacation into a real-life version of Home Alone, *it is important to plan your trip well in advance, collect important documents and information, and arrange for a house sitter to manage your house while you are away.*

Making Plans

Once you decide to take a vacation, you set yourself up for a whole new and additional set of "things to do." You'll need to decide when to take your vacation, which involves consideration of your children's school schedule, music lessons, and sports, and involves time off from work for both you and your spouse.

When your family takes a vacation, you might consider bringing your caregiver along. This can give you and your husband the opportunity to enjoy each other and to get away for some adult activities while the kids are being cared for by someone familiar. Single mothers can enjoy a break from the children and meet new people. Of course, you provide all of the transportation, rental, hotel, and meal expenses for your caregiver. Sometimes, depending upon where you are vacationing, the trip in itself may be sufficient compensation.

Low-Budget Vacations

Summer vacations offer a world of camping and outdoor exploration. Camping in state and national parks is safe, clean, entertaining, and fun. Your local bookstore and library have loads of books on campsites all over the country that list not only the nature of the campsites but all "amenities" that are offered in any particular location. Some campgrounds offer tent and R.V. hookups (water and electrical); some have swimming pools, laundry facilities, mini-markets, and even slide shows offered by park rangers. Others have only restrooms.

If you're in great shape and the kids are a bit older, backpacking brings a whole new world of adventure to camping. If you don't already own backpacking gear, sporting-goods stores often rent equipment. You can often find secondhand equipment at reasonable rates at flea markets, garage sales, and through the classified-ad sections of the local paper.

Educational Vacations

Wonderful family vacations often include educational explorations. A vacation that enriches your child's educational program can make the vacation interesting for your child. Ask your child's teacher or principal about the subject areas the children will be studying the following year. For example, if there is going to be a lot of emphasis on dinosaurs, a trip to Utah, Colorado, New Mexico, or Arizona would be fascinating. Likewise, if your child is studying art history or ancient civilizations, museums or trips to sites are both interesting and educational. To enhance foreign-language studies, a trip to a foreign country offers a great opportunity to build conversational skills, as well as to observe a different culture.

Travel Vacations

If budgetary constraints aren't limiting your vacation, travel abroad to really take a break from your regular routine. Tropical vacations are popular for those who live in colder climates. The Hawaiian Islands, the Caribbean, and the South Pacific offer casual and relaxing vacations. Active sports vacations are entertaining and invigorating. Golf, skiing, and tennis vacations can take you all over the United States and the world. Traveling to foreign countries offers insights into new cultures, languages, and the diversity of

human life styles. Many cruise lines and resorts offer special programs for families. Children participate in supervised activities suited to their age group, while you can get away and enjoy adult entertainment without having to worry about what's going on with the kids.

Family Vacations with Other Families

Sharing the family vacation with other couples and children offers great fun for both the children and parents. Couples can trade off watching the children while one set of parents enjoys a night by themselves, or everybody can go out for a night of dancing, and hire a babysitter for the kids. The children, likewise, get a kick out of playing with their friends in new places and sharing their adventures with other kids. Shared family vacations are especially nice for children without brothers and sisters.

Traveling with other families is successful if you allow private time and space for both families. Separate hotel rooms, tents, and cars allow the individual families time alone. Set an itinerary for the families to use as a flexible schedule. That way, you can all join together for meals and exploration one day and have all the families go their own way the next.

This may seem obvious, but you should keep in mind that shared vacations work best when two or three families have had the time to develop a mutually enjoyable relationship with each other. It can be very difficult to spend a couple of weeks with people who are, for all practical purposes, total strangers, or who have different styles of parenting that grate on the sensitivities of other parents. If you are talking with another family about taking a vacation break with them, it's often a good idea to do a "dry run" with that family and go somewhere for a couple of days, in order to make sure that everybody gets along and you're still going to be on speaking terms when you get back. (This goes for the kids, too. Children who play well together at school won't necessarily get along when they find themselves "cooped-up" in a car or a hotel room for two weeks.)

Travel Agents

If you are planning a vacation that has any kind of complicated arrangements, it is best to work through a travel agent. As a client, you don't pay more for your flights, hotels, or travel packages when working with an agent, as they are reimbursed by the airlines, hotels, and travel companies. Because they arrange vacations for people all the time, a travel agent knows about which airlines are offering discounts, hotels in the area you are planning to visit, and the amounts they will be charging, and so forth. They will order tickets to meet deadlines and can advise you about car rentals, local customs, and entertainment options. A good travel agent can save you time, money, and hassle, so when you start to plan your trip, discuss your vacation plans with a travel agent and listen to what he or she has to say. You will often find that agents have valuable information that helps make your trip that much more enjoyable (and cheaper, to boot).

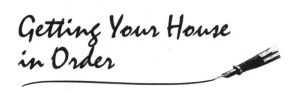
Getting Your House in Order

"We've got a dog, two cats, and an iguana and are going to be gone for two weeks. I'm also kind of worried that someone will notice we're away and take advantage of the situation—you know, those stories about coming home from vacation to find that somebody backed a moving van up to the house. What we really need, I guess, is somebody to watch the house while we're gone, or even to stay there. What should I do?"

Hire a House Sitter

Are you worried about your pets and the security of your home while you're on a vacation or business trip? Do you want (or need) someone to watch your house while you are away? If so, the "House-Sitter Information" form (page 84) will help ensure that your house sitter will be well-informed about your situation. After you've gotten set up with a house sitter, you can relax on your trip.

House sitters are generally an unusual breed. You can't find them in the Yellow Pages. The safest bet is to get someone you know and trust, such as adult sitters, housekeepers, friends, and people at work. Call friends for referrals. College students and single people sharing housing often appreciate the opportunity of having a sanctuary away from the hustle-bustle of their busy households for a few days or weeks.

Usually, a house sitter is not going to charge a fee, unless you want the person to take on additional responsibilities (for example, mowing your lawn or watering plants). After all, providing your home and food is usually considered a fair trade for staying in your home (so the house isn't a target for burglary) and feeding your pets. Nevertheless, make sure you have discussed this with your prospective house sitter ahead of time, so that there's no confusion. And remember to bring back a souvenir or flowers and candy for him or her when you return.

Use the "House-Sitter Information" Form

If you decide you want a house sitter, fill out the "House-Sitter Information" form. The General Information section will help the house sitter reach you through your office or reach your friends in the event of an emergency. The Travel Information section is important for your house sitter (and/or a close friend) to have should something happen. By the same token, if a disaster or similar situation were to occur, friends and family will call your home or office to get more information. By providing a flight and travel agenda, you can alleviate unnecessary worry while you are away. In addition, accommodation and itinerary information is the only way the house sitter will have to contact you in case of emergency at home.

Review the Emergency Information About the House section (page 86) with the members of your household, as well as the house sitter.

Everybody should know where to find the power box and gas valves. Leave wrenches near any valves that are hard to turn; tie them with a cord.

Pet owners should fill out the Pets section (page 86) to ensure appropriate veterinary care. Be specific, so decisions can be made easily.

Responsibilities such as putting out the trash cans on garbage day and watering plants are laid out in the House Information section (page 87). In this section, you need to fill out details about how to use appliances and where to sleep. If you have any items or rooms that are off-limits, make sure to clearly list them. It's easier to lay out rules and guidelines in advance than just to rely on your house sitter's common sense and ethics.

After completing the "House-Sitter Information" form, make two copies; one for the house sitter and one for you to take on your trip.

Prioritize Your Valuables

The last page of the "House-Sitter Information" form is a list of valuables (in order of priority) you would want your house sitter to take in case of an emergency where an evacuation is required. Put any cash or precious jewels in a safe-deposit box at the bank before you leave on your trip. If you have a computer, make backups of files and programs and store them at a different location, so you can restore your system in the event of a disaster.

Make a photo or video inventory of valuables and have them appraised for replacement purposes (see Chapter 9). Old photos, picture albums, home videos, and heirlooms are usually high priority for saving in the event of an emergency. Describe where they're located, so the house sitter can easily find them if he or she has to.

You can also put photo negatives (old and new) in a safe-deposit box or store them in a different location (your office desk or a friend's attic). If your home is destroyed along with your precious photos, you can then have the photos reproduced.

Lock Up the House

If locking up the house is preferable to having a house sitter, prepare the house to prevent disasters while you are away. Turn off the water main to prevent flooding if the water lines burst. For energy savings, turn off your hot-water heater and set your indoor thermostat at the lowest setting (50 degrees).

Put several lamps on timers to go on and off at different times during the night. This gives the illusion that there is activity in the house. Set lights in the kitchen to go on at 6:00 P.M. and off at 8:00 P.M.; the living room to go on at 7:00 P.M. and off at 11:00 P.M.; and the bedroom to go on at 10:00 P.M. and off at midnight. Exterior lights should go on at dusk and off at dawn. Lights inhibit intruders.

Ask a neighbor or friend to water the indoor and outdoor plants while you are gone. Call the circulation office to stop the newspaper and magazines for the duration of your vacation.

The post office requires a written request to stop mail delivery. Write a letter asking them to temporarily stop mail delivery for a specified number of days. Specify the stop and restart dates for delivery. Postal forms are available, and if you call on the phone, they'll mail them to you.

Landscaping and yard-maintenance services can continue in your absence, especially if your trip is more than two weeks long. Overgrown lawns are a signal that the residents are out of town.

Outdoor cats seem to manage fine as long as you have someone checking the stock of cat food regularly. Fish can sustain themselves on time-released food for up to a week fairly successfully.

Cats and dogs that are kept indoors most of the time generally tend to need additional care. If the kennel is not an option, ask a friend to feed your animals and change the litter box daily. Give the friend a copy of the Pets section of the "House-Sitter Information" form (page 86).

Papers Please: Have Your Travel Documents Ready

Once your house and house sitter are set, get your documents ready for travel. Fill out the "Vacation Emergency Form" (page 91). With this checklist, you'll have all the necessary information needed to replace your passport, checks, travelers' checks, medication, credit cards, airline tickets, and the like, if you should lose them while traveling. Calling home to get this information is frustrating, expensive, and a waste of vacation time.

Use the "Vacation Checklist" (page 92) for each member of the family. Either make copies, or use a different-colored pen for each family member. There are checklists for sports gear, to remind you to bring paraphernalia that you don't want to replace at resort costs. Don't forget to stop the newspaper, mail, and so forth, and ask someone to feed the animals if you don't have a house sitter.

Traveling with Children

To pack each child's suitcase, lay out complete outfits with pants, shirt, underwear, socks, and hair accessories. Then put each outfit into a large plastic zippered bag. A bag of extra underwear and socks for the younger kids is generally a good idea, in case of accidents. This will ensure that each child has enough outfits for the duration of your vacation. You'll be able to relax while the children get dressed, knowing that they aren't wearing the socks that were supposed to be worn with the dress slacks. This also keeps

their suitcases organized and eliminates the frustration of having to buy children's clothes in a foreign place (unless, of course, you want to).

Each child should also be allowed to pack a bag of games and toys. If the children are young, select the games for them. Toy manufacturers make good travel games with magnetic pieces. You don't want to be picking up game pieces off the floor of the plane as it takes off, or having kids bouncing all over the car to find some hooziwhatzits that fell between the seats as you're driving through hairpin turns in the Rockies. Travel journals, books, marker and coloring sets, paper on clipboards, and word games are entertaining for kids of all ages. Put the kids' names on all of their games and items for easy identification. You should encourage them to leave room in their bags for new souvenirs.

Summing Up

A vacation is supposed to be a time to relax and have fun. With good planning, you can do just that. You'll have all the necessary documents and copies to replace missing or stolen items with ease. The kids will have toys and games to keep them amused, and will be looking forward to the new adventures that lie ahead. If you get a house sitter, the person will have an itinerary to reach you if necessary. Go ahead—plan your family vacation. You'll find that you can have a more enjoyable time, relax, have fun, and come back rested and refreshed.

Vacation Organizers

House-Sitter Information
Vacation Emergency Form
Vacation Checklist

House-Sitter Information

House sitter's name: _____

House sitter's home address: _____ City: _____ ZIP Code: _____

House sitter's home phone: _____ House sitter's work phone: _____

General Information

Residents' names: _____

Home address: _____ City: _____ ZIP Code: _____

Home phone: _____ Business phone: _____

Husband's employer: _____ Work phone: _____

Wife's employer: _____ Work phone: _____

Friend/family member who can help in case of emergency: _____

Friend's/family's phone: _____ Friend's/family's work phone: _____

Type of Travel

Type of trip (business, wedding): _____ Number of days away: _____

Departure date: _____ Return date: _____

Travel Information

Travel Agent

Travel agency: _____ Travel agent: _____

Agency address: _____ Agency phone: _____

Flight Information: Outbound

Departure date: _____ Departure time: _____

Airline: _____ Flight number: _____

Departure airport: _____ Park/shuttle: _____

Connecting flight number: _____ Layover airport: _____

Destination airport: _____ Arrival time: _____

Flight Information: Inbound

Departure date: _____ Departure time: _____

Airline: _____ Flight number: _____

Departure airport: _____ Park/shuttle: _____

Connecting flight number: _____ Layover airport: _____

Destination airport: _____ Arrival time: _____

Car Rental Information

Car rental agency: _____ Car rental agent: _____

Car rental phone: _____ Reservation number: _____

Type of car: _____ Rental dates: _____

House-Sitter Information (continued)

Other Travel Information

Type of transportation: _____

Departure date: _____ Departure time: _____

Arrival date: _____ Arrival time: _____

Phone: _____ Misc. information: _____

Accommodations

Hotel Accommodations

Hotel: _____ Check-in date/time: _____

Hotel address: _____ Phone: _____

Room number: _____ Check-out date/time: _____ Fax: _____

Hotel: _____ Check-in date/time: _____

Hotel address: _____ Phone: _____

Room number: _____ Check-out date/time: _____ Fax: _____

Hotel: _____ Check-in date/time: _____

Hotel address: _____ Phone: _____

Room number: _____ Check-out date/time: _____ Fax: _____

Other Accommodations:

Location: _____ Date of arrival: _____

Address: _____ Phone: _____

Date of departure: _____ Fax: _____

Location: _____ Date of arrival: _____

Address: _____ Phone: _____

Date of departure: _____ Fax: _____

Itinerary

Date: _____ Activity: _____

Date: _____ Activity: _____

Date: _____ Activity: _____

Date: _____ Activity: _____

Date: _____ Activity: _____

Date: _____ Activity: _____

Miscellaneous Travel Information

House-Sitter Information *(continued)*

Emergency Information About the House

> **911 Emergency**

Electricity

Call the electric company, _____, at _____ for problems with electricity. The power box is located in _____.

Gas

Call the gas company, _____, at _____ for problems with gas. The gas valve is located in _____. You may need a wrench to close the valve. Tools are located in _____.

Water

Call the water company, _____, at _____ for problems with water. The water valve is located in _____.

Fire

Call 911 for all emergencies. For nonemergencies, call the fire department at _____. The fire extinguisher is located _____.

Appliance

Call _____, at _____ for problems with appliance.

Pets

If one of our pets gets sick or hurt, please take him/her to our veterinarian, _____ at _____. Phone number: _____ Emergency phone: _____. In case of emergency, take our pet to the animal hospital, _____, at _____. Hospital phone: _____. If you have a personal emergency and can't continue to take care of our pets, please take them to _____ at _____. Phone: _____.

We, the owners of _____, hereby give _____ authority to authorize emergency treatment for _____ at the discretion of person named above. If the quality of life for my pet will not be comfortable, please ___ do/ ___ do not authorize medical intervention. Please do not authorize treatment if the costs will exceed $_____. Medical records are kept at _____. Our pet is taking the following medication: _____. We will pay all emergency expenses authorized by above-named person.

_____ _____

Pet Owner Date

Insurance

Insurance company: _____ Insurance agent: _____

Address: _____ Phone: _____

Policy number: _____ Type of policy: _____

86

House-Sitter Information (continued)

House Information

Sleeping Quarters

Please sleep in _____ room. Clean sheets are kept in _____. Extra blankets are kept in _____. Extra pillows are kept in _____. Please remove sheets and pillowcases at the end of your stay and put them in the laundry room. Remake the bed with sheets located in _____. Use the bathroom located _____. Clean towels are located _____.

Feeding Pets

Pet: _____ Feed _____ times per day.

Animal food and quantities: _____

Animal food is located: _____

Please keep water bowl full. Water bowl is located: _____

Litter box is located: _____ Litter box instructions: _____

Walking instructions: _____

Other instructions: _____

Pet: _____ Feed _____ times per day.

Animal food and quantities: _____

Animal food is located: _____

Please keep water bowl full. Water bowl is located: _____

Litter box is located: _____ Litter box instructions: _____

Walking instructions: _____

Other instructions: _____

Watering Houseplants

Please water all houseplants _____ times per week or as needed.

Watering can is located _____

Add plant food on _____; plant food is located: _____

Mist plant on _____, with _____

The plants should have plastic trays beneath them to catch the water runoff, but if one should leak, please wipe up with a towel.

Watering Outdoor Plants and Gardens

Please water the lawn _____ times per week for _____ minutes.

Please water the vegetable garden _____ times per week for _____ minutes.

Please water the flower garden _____ times per week for _____ minutes.

Please water _____, _____ times per week for _____ minutes.

The sprinkler system is located _____.

The drip-irrigation system is located _____.

The automatic-timer system is located _____.

Call _____, at _____ for problems with garden or sprinkler system.

House-Sitter Information (continued)

Telephone

Please answer our residential phone and take messages. If caller wants to know where we are or when we'll return, tell caller _____

_____ .

Please put messages on _____ .

Charge your long distance or toll calls to your home phone or use your credit card.

Collecting Newspapers

Please collect all newspapers and put them _____ .

We receive the _____, _____ times per week. It is usually put _____ .

We receive the _____, _____ times per week. It is usually put _____ .

For problems receiving newspapers, our account is listed under (name) _____ .

Newspaper: _____ Phone: _____

Newspaper: _____ Phone: _____

Collecting Mail

Please collect our mail daily and put it _____ .

Our mail box is located _____ .

For problems with mail, call our local post office at _____ .

Putting Trash Cans Out for Pickup

Please collect garbage around the house and fill the trash can outside. The trash can is located _____ .

Please put _____(#) cans out on _____ (indicate day and A.M./P.M.).

Put trash cans (location) _____ .

Please put empty trash cans back in original location after pickup.

Recycling

We recycle the following checked items:

☐ Aluminum cans	☐ Clear glass	☐ Colored glass
☐ White paper	☐ Newspapers	☐ Magazines/Catalogs
☐ Colored paper	☐ Plastic #1	☐ Plastic #2
☐ Plastic #3	☐ Plastic #4	☐ Plastic #5
☐ Cardboard	☐ Tin Cans	☐ Other: _____

Please put recyclables in appropriate bins located in _____ .

Collection date is _____ .

Please drop off the following recyclables at the recycling center, _____ ,

located at _____ . Phone: _____

Recyclables to be dropped off at recycling center: _____

House-Sitter Information _(continued)_

Entertainment Center

Most of our electronic devices are standard and require little explanation. The following items may need a few helpful hints for operation:

- ☐ Receiver: _____
- ☐ Turntable: _____
- ☐ Cassette player: _____
- ☐ CD player: _____
- ☐ TV: _____
- ☐ VCR: _____
- ☐ Cable/satellite: _____
- ☐ Electronic games: _____
- ☐ Other: _____

Washer and Dryer

The washer and dryer are located _____.

Please wash full loads only and follow directions on the machine. Clean the lint filter in the dryer after every use.

Fireplace/Woodburning Stove

Firewood/woodburning pellets is/are located: _____

Make sure the flue is open before you light the fire. To start fire, use _____.

Please make sure screen/doors is/are closed while in use. After embers have cooled, put ashes in _____.

Lights and Lighting

Extra light bulbs are located _____.

Please turn off lights that are not being used to conserve energy. When you leave the house, leave only _____ lights on.

Our lighting system is standard except _____
_____.

Swimming Pool/Spa/Sauna

Pool/spa/sauna hours: _____

Pool/spa/sauna maintenance: _____

Pool/spa/sauna cover: _____

Pool/spa/sauna rules: _____

Locking the House

When leaving the house please make sure all doors and windows are locked except _____.

Pets should be kept _____.

There is a hidden key located at _____.

House-Sitter Information (continued)

Off Limits

For our privacy and because some of our belongings are fragile, please refrain from using the following rooms/items: _____

IN CASE OF MAJOR EMERGENCY, IF YOU HAVE TIME TO SAVE A FEW VALUABLES, PLEASE GET THE FOLLOWING ITEMS LISTED IN ORDER OF PRIORITY:

1. _____

 Located: _____

2. _____

 Located: _____

3. _____

 Located: _____

4. _____

 Located: _____

5. _____

 Located: _____

Note from Us

Hope you enjoy your stay. Thank you for watching our home while we are away.

Sincerely,

Vacation Emergency Form

Husband's driver's license number: _____

Wife's driver's license number: _____

Marriage certificate (packed?): _____

Passports or visa (packed?) (list identification number here): _____

House-Sitter Information Checklist (packed?): _____

Copies of prescriptions: medication, contact lenses/glasses (packed?): _____

Credit Card Numbers List (packed?): _____

Checking-account numbers

Bank: _____ Account #: _____

Address: _____ City: _____ ZIP Code: _____

Contact: _____ Phone: _____

Savings-account numbers

Bank: _____ Account #: _____

Address: _____ City: _____ ZIP Code: _____

Contact: _____ Phone: _____

Traveler's-check numbers

Bank: _____ Account #: _____

Address: _____ City: _____ ZIP Code: _____

Contact: _____ Phone: _____

Physician

Physician: _____ Phone: _____

Address: _____ City: _____ ZIP Code: _____

Travel

Travel agency: _____ Phone: _____

Agent: _____ Hours: _____

Airline tickets (packed?): _____

Train tickets (packed?): _____

Entertainment tickets (plays, amusement parks, etc.) (packed?): _____

Hotel-reservation information (reservation number): _____

Car-rental reservation information (reservation number): _____

Itinerary (packed?): _____

Address book (important phone numbers) (packed?): _____

Other: _____

Other: _____

Other: _____

Vacation Checklist

Clothing	DONE	Toiletries	DONE	Misc. Items	DONE
Underwear		Toothbrush/paste		Camera/film/batteries	
Socks/nylons		Dental floss		Video camera/tape	
T-shirts		Lotion/moisturizer		Video camera batteries	
Pajamas/bathrobes		Brush/comb		Address book	
Lingerie/slippers		Contact lens/glasses		Journal/diary	
Bathing suit/trunks		Make-up		Tickets/itinerary	
Cover up		Hair clips/pins		Passport/visas	
Shorts		Razor/after shave		Credit cards	
Comfortable pants		Perfume/cologne		List of credit cards	
Dress clothing		Suntan lotion		Traveler's checks	
Evening purse		Tampons/pads		Traveler's check stubs	
Jacket/coat/tie		Birth control		Cash	
Dress shoes		Soap		Suitcases	
Tennis shoes		Nail polish/remover		Equipment (see back)	
Sandals		Nail file		Games/books for travel	
Jewelry		Cotton balls/swabs			
Jogging/sweat suits		Nail clipper			
Hats/visors		Hair rollers		**Baby Equipment/Misc.**	DONE
Sunglasses		Hair spray/mousse		Diapers/pins/plastic	
Sports clothing		Curling iron/dryer		Pants	
		Towels		Wipes	
		Shampoo/conditioner		Powder	
		Mouthwash		Lotion/cream	
		Aspirin		Bottles/formula	
		Medication/vitamins		Pacifiers/rattles	
		First aid kit (travel)		Car seat/infant seat	
		Orthodontic accessories		Stroller	
		Diaper bag		Portable crib	
				Swing	

Do	DONE	Stop	DONE	Get	DONE
Water plants		Newspaper		Cat feeder	
Set light timers		Mail		Dog feeder	
Lock up house		Housekeeper		Fish feeder	
Request time off at work		Gardener		Bird feeder	

Vacation Checklist *(continued)*

Snow Ski Gear	DONE	Water Ski Gear	DONE	Camping Gear	DONE
Skis		Water skis and access.		Tents	
Boots		Wet suits		Sleeping bags/pillows	
Poles		Bathing suits/trunks		Sleeping pads	
Leather gloves		Gloves		Folding table/chairs	
After-ski boots		Life jackets		Table cloth	
Ski caps/ear muffs		Hats/visors		Lantern/mantels	
Goggles		Sunglasses		Propane/matches	
Sunglasses		Thongs/sandals		Stove	
Ski masks		Rope		Charcoal/lighter fluid	
Scarf		Radio		Wood	
Ski outfits		Water toys		Rope/clock	
Parka/jackets		Umbrella/tent		Radio/flashlights	
Turtlenecks		Folding chairs		Hatchet/hammer	
Thermal underwear		Blankets		Fire extinguisher	
Sunscreen		Beach towels		Coffee pot/large pot	
Lip protection		Sunscreen		Fry pans	
Ski wax		Cooler/ice		Large bowl	
Snow sealer		Red flag		Plates/cups/flatware	
Car chains/snow scraper		SCUBA/snorkel gear		Spatula/ladle/knives	
				Tongs/large spoon	
				Can opener/peeler	

Tennis/Racquetball Gear	DONE	Golf Gear	DONE	Camping Gear	DONE
Racquets/racquet bag		Golf clubs		Measuring cups	
Balls		Golf balls		Paper towels/napkins	
Ball basket		Golf tees		Dish soap/towel/sponge	
Gloves		Gloves		Pot holders	
Tennis outfits		Golf shoes		Cooler/ice	
Tennis shoes/socks		Golf clothing		Foil/plastic wrap	
Hats/visors		Hats/visors		Thermos/pitcher	
Sunglasses		Sunscreen		Insect repellent	
Sweatbands		Towels			
Towels		Insect repellent			
Sunscreen					
Sunburn ointment					

Notes

On the Go:
Making a Move

Physically moving all of your worldly possessions, leaving friends and family behind, and exploring a new area, schools, work, and friends is stressful, to say the least. Yet today's statistics show that the average American will move more than 11 times over the course of his or her adult life! So, even though the task of moving to a new home is something we all hate to go through, it's also something we will all probably do more than once, and there are ways to make it a little less painful to endure.

Get Ready, Get Set, Move

Reducing your possessions by selling or donating them is always a good idea. Likewise, you will need to notify professional, personal, and service offices and contacts of your future move, and once you have made it, you will need to get to know your new town.

The "Address-Change Worksheet" on page 103 is a good resource (even if you don't plan to move). It lets you list your important personal information about banks, mortgage companies, service organizations, newspapers and magazines, and so forth, where you can refer to it at a glance. Take a few minutes to complete the worksheet and remember to include any other organizations not already listed that should be notified of your move.

See the "Address-Change Letter" on page 107. This letter is, of course, for notifying everybody you need to tell that you are moving. Fill

in the Old Address, the New Address, and the If You Have Any Questions sections. This information will be the same for all recipients. After you have filled in this information, you can then calculate the number of Address-Change Letters you plan to send and make copies of this semi-completed form. This saves an *enormous* amount of time.

Once you have your stack of Address-Change Letters, refer to the Address-Change Worksheet and address letters to each company or person listed. (If you have a word processor on your computer with a "merge" feature, it will go even faster.) You can then fill in the Special Instructions section for each letter as required, to suit your needs. If you plan to continue the service at your new address, put a check in the space and enter the date you plan to be in your new home. If you are planning to discontinue a particular company's services, enter the last day service is required. Some companies require cancellation of services on their own forms. In that case, request their forms. Enter your account number on all letters to service companies.

Once you have sent the letters, you can enter the date they were sent on the "Address-Change Worksheet." This record may come in handy if your letter gets lost in the mail.

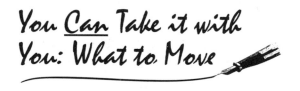

You Can Take it with You: What to Move

If you are moving for job-related reasons, your employer will often be paying moving expenses, either directly or by reimbursing you after you have completed your move. On the other hand, if you are paying for moving costs yourself, it is necessary to evaluate the cost of the volume you want to move and compare it with the cost of selling some of that old furniture and buying new things after you arrive in your new hometown.

Clean Up Your Clutter

It's surprising how much clutter people collect over the years: things you don't use and clothes you don't wear. Go through your closets, drawers, and storage spaces to decide which items will be kept and which items will be given to Goodwill, Salvation Army, or recycling centers. An added bonus is that you get receipts that in most instances you can use as deductions on your taxes.

You should set up some large boxes to collect items you don't plan to keep and label them. For example, boxes can be labeled with their destination or their contents: "Goodwill," "Paper," or "Metal." This makes your job easier as you sort through your belongings. After you have gotten together the items you want to give away, contact your local charity organization for a pickup. Some organizations don't pick up, and you may have

to deliver goods in your vehicle. Most cities and towns have trash haulers who will take your recyclables to the recycling center and your garbage to the landfill.

If, for some reason, the organization you have contacted doesn't want or won't accept the material you want to give it, keep trying. Check with other organizations in your area. It is almost always possible to get rid of used furniture and other clutter through local organizations of one kind or another.

Hold a Garage Sale

As you open those boxes or drawers that haven't been opened in years, you'll come across items that you can part with but don't want to donate to a charity. Separate these items, and have a garage sale or moving sale. After all, one person's garbage is somebody else's treasure. After you have decided to hold a garage sale, you will need to put an ad in your local paper.

Put an Ad in the Newspaper

When you place an ad in the classified section of your local paper, try to limit the number of words you use. Newspapers charge for each word of a classified advertisement. Newspapers often have specials for running the same ad for several consecutive days.

Sample Ads

Call the local newspapers to get information for placing your ad. Most newspapers will take your classified ad over the phone. Some require payment first. Be prepared to dictate your ad to the telephone salesperson. Indicate capital letters and punctuation marks. They'll assist with abbreviations. Place the ad under "garage sales."

> Garage Sale: fridge, pool table, ski equipment. Saturday: 7–4
> 123 Main Street

You will need to give your address, directions if your home is difficult to find, the hours you plan to run the sale, and a list of a few higher-priced or more interesting items to attract the right buyers. Remember to post signs on major streets leading to your home the night before the sale. This helps shoppers to find you.

Get cash at the bank before your garage sale. Put one $10 bill, two $5 bills, twenty $1 bills, one roll of quarters, one roll of dimes, and one roll of nickels in a safe place. Fanny packs are ideal because they're lightweight and they're on your body at all times. Additionally, there is less of a chance that you will accidentally leave it out on a table, risking losing all your hard-earned dollars.

Beware of professional garage-sale shoppers. They love newcomers to the garage-sale world. They'll knock on your door at the crack of dawn and

ask you to "pull out the goods." If you haven't posted specific hours in the newspaper, put a sign on your door the night before the sale stating when you will be starting the garage sale (for example, 7:00 A.M.) and that the items you are selling will go on display at that time.

During the last two hours of your garage sale, it's generally a good idea to slash your prices. This helps to increase your sales and minimize the amount of goods that will end up being donated to charity.

When you end your garage sale, box items and take them to the charity organization of your choice. For large items, you may need to hire a hauler to transport the goods. Some charities will pick up quality items that they can resell. Get a receipt.

A word of caution: Some cities (Los Angeles, for example) require that you obtain a permit to hold a garage sale. Check with your local police department or city hall to find out. If you do live in an area where garage sales aren't allowed, or that is difficult for people to find, you might consider selling your goods at a flea market. Remember, the point of the exercise is to get rid of all those unnecessary items, so you don't have to spend time packing them, and money moving them.

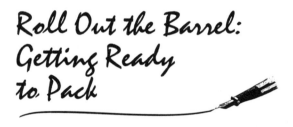

Roll Out the Barrel: Getting Ready to Pack

After you have gotten rid of as much "extra baggage" as you possibly can, the time has come to pack up everything else. This is one of those steps in the moving process that everybody hates, but nobody can get around.

Pack It Yourself

Purchase sturdy moving boxes from a moving company or office-supply store. It's well worth the expense when you consider the strength of the boxes and their uniform size, which makes stacking more efficient. Sometimes, you can place an ad in your local paper's classified section for second-hand moving boxes, which can save you a tremendous amount of money. If you're hiring a moving company to do your move but are doing your own packing, ask if you can rent your boxes instead of buying them, or ask if you can buy second-hand boxes. Different companies have different policies, but if you can rent or use second-hand boxes, it can save plenty of money.

Boxes should be filled to the top to prevent them from collapsing under pressure. If you have room at the top of your box, fill the space with crumpled newspapers or magazines.

Pack fragile items in newspapers individually, creating about 1 inch of padding around the item. Stack items carefully and mark "FRAGILE" on the outside of the box in several places, to make sure that the movers will

handle the item with care. Each expensive, fragile article should be packed in its own box, with at least six inches of padding around the box. Dishes, glasses, and most kitchenware should be wrapped individually with newspapers. Heavy items should go in special "dish-pack" boxes that are designed to handle the weight of stacks of chinaware.

Organize similar items together. This will make it easier to unpack and set up your new household. Mark all boxes clearly. In large letters, specify the room where the box is to end up and a general description of the contents (for example, "Ross's Room: dinosaur collection" or "Rob's Office: printer ribbons"). This will save a lot of time and energy, because you don't want to have to search 15 different boxes for a paper clip or have to keep moving the same boxes over and over again.

Items that are used daily should be separated from less frequently used items and kept in a few boxes specially separated from the others. Label them "VIB" (Very Important Box) in red letters. Tell the movers where you would like VIB boxes placed and where you will want them put in your new home after they have been unloaded. This ensures that the VIB boxes are loaded *last* and unloaded *first* and don't end up buried in the back of the moving truck under the china.

Use Professional Packers

Moving companies charge by the hour to pack your personal belongings into boxes. Trained movers do an excellent job to ensure that every plate is properly wrapped and packed. They have mattress, garment, dish-pack, and a variety of specialty boxes.

If you need help with the larger items but want to pack the smaller items yourself, ask the moving company to write a bid based on your needs. It's helpful to get large appliances (refrigerators, washers and dryers, pianos, beds, couches, tables) moved by professionals. Awkward or easily damaged items such as picture frames, paintings, sculptures, vases, antiques, and plants are also good items for movers to handle.

Negotiate the use of their boxes as part of the contract. Moving companies often assume that you'll pay for new boxes; then, once you're unpacked, they keep them. If that is their policy, ask them to use second-hand boxes. This can save you hundreds of dollars.

You Can Drive a Truck: Handling the Moving Yourself

The "Moving Equipment Rental" section in your Yellow Pages will help you to locate a truck to rent. Call around to get rates and see what other options are available from different agencies. How does the agency handle engine trouble when you're en route? Select a reli-

able, large organization and check with the Better Business Bureau to make sure that the company you select is reputable. Nationally known companies may have local agencies that are individually owned. In that case, each rental agency sets its own rental and customer-service policies.

Read your contract carefully and make sure you fully understand the agreement. If you are paying an additional fee for mileage (or for mileage over a certain allowed number of miles), make sure the contract clearly lays out the cost per mile and that you understand when this charge will start being applied.

Check Your Automobile Insurance

Your personal automobile insurance policy may cover you while you rent the truck, so you can save money by not purchasing the additional insurance for the rental. If you have full coverage on one of your vehicles that includes collision and comprehensive coverage, your automobile policy will normally cover the cost of repairing a truck rental, minus the deductible. Check with your insurance agent, just to be sure.

How to Hire a Moving Company

If you have the luxury of hiring a moving company, your move will, in most cases, be less painful both emotionally and physically. Get references from friends or family for good movers, and make sure that the person in charge of your move will be there throughout the entire move. Some companies send out their best salesmen to get the contracts signed, but when you're ready to move, you end up with a group of untrained kids and a recipe for disaster.

Make Sure You're Insured

Check your homeowner's insurance policy before signing the moving contract. Most homeowner's insurance policies insure your personal belongings anywhere in the world and in transit between homes. The policy usually covers theft or vandalism, but doesn't cover replacing items that were broken in transit. Most homeowner's policies are good for 30 days after you move, for protection while you are in the process of moving. Of course, you will need a new homeowner's policy once you buy a new home.

Look into Movers Who Charge by the Hour

Some movers will charge by the hour, for two or more men and a truck.

One family I know has used movers who work this way for two of their moves, each time saving nearly half of the original bid. Wanting the cost to be as low as possible, they spent about two weeks packing boxes and

stacking them in the garage. On moving day, they lined up four friends to help. They all carried the boxes from the garage and smaller furniture from the house; the movers spent most of their time inside the van, loading and tying down. VIBs, the cats, and awkward items from the children's rooms went into their own cars. Then at the new house, everyone unloaded: the movers handled the furniture and heavy items, while the family and their friends helped with boxes and small items. At the end of the day, they took their friends out to dinner and still saved hundreds of dollars.

Contracts and insurance are generally the same as for moving companies.

Supervise the Movers

Once you've selected a mover, your work has just begun. If the movers are also packing your goods, you'll need to be there every minute to tell them what the items are, where they're going, and which boxes contain VIB items. The time spent with packers will save you hours of frustration and/or confusion at the destination site.

If your movers are moving only big items and boxes, you'll still need to help them organize the order in which you want the boxes loaded and unloaded. Consider whether you're going straight to your new home, or if the load will be stored in an interim location. You need to help organize a multiple-destination move yourself.

Your presence during the move also helps to ensure that your goods are handled properly and efficiently. Stay with the crew. Offer them coffee and doughnuts and thank them for a good job.

At the destination site, stand in a central location to direct movers to the appropriate rooms or locations. Undirected movers often will place all of the boxes in a single location, such as the living room or the garage, which means that you will end up having to move the boxes again.

Once you get to the destination, you should label each room in the house with a paper sign. (Actually, this is a good thing to do in advance of the move.) That way, even if you are not there to direct them, the movers can walk in and glance at the box and find the labeled room where the box should go. When a lull occurs in the mover traffic, or during their breaks, you should check each room to make sure that the boxes are correctly located. If there are any boxes in the wrong rooms, make sure you ask the movers to place them in the appropriate rooms before they leave. You need to save your energy for unpacking. Let the movers do what you paid them for. Be visible, and always try to be available to direct them and answer their questions.

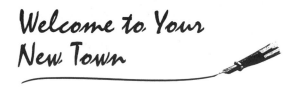

Welcome to Your New Town

Having survived the moving ordeal and while you are getting settled in your new home, spend an afternoon getting to know your new town. You can call the Chamber of Commerce and Tourist Bureau for

their brochures and calendar of events, even before you move. Museums, amusement parks, ethnic gatherings, and historical celebrations will be listed in the information given by the Chamber of Commerce. After you have looked through all the literature you receive, you can visit the sites of interest. Jot down local events on your family calendar. Join new clubs, which can open doors to new friendships.

Contact the local parks and recreation department to learn about local sports, art, dance, music, and theater opportunities for your children. Boys and Girls Clubs, Boy Scouts, and Girl Scouts are just a few of the many other avenues to help your children adjust to their new hometown.

Likewise, you can visit different churches, synagogues, or other places of worship to find the one that meets your needs. Religious activities and clubs offer a complete network of people who share similar ideals, beliefs, and life styles.

Summing Up

Although moving is a stressful task, you can ensure a smoother transition by taking a few minutes to organize your strategy. Send the "Address-Change Letters" to inform your personal and business contacts of your move. Reduce the quantity of items you will have to move by holding a garage sale or by selling items at a flea market. Hire a reliable moving company, or move yourself. By organizing your move before it's actually time to do it, you will find that everything works much more smoothly, and you'll have more time to enjoy your new home, and get to know your new neighborhood.

Moving Organizers

Address-Change Worksheet
Address-Change Letter
Mover-Evaluation Checklist
Moving Timetable
List of Moving Boxes
Sample Moving Box Label
New-Town Checklist

Address-Change Worksheet

Company	Account Number	Address	Phone	Done
Attorneys:				
Bank accounts:				
Cable:				
Catalogs:				
Church:				
Clubs:				
Credit cards:				
Credit union:				

Address-Change Worksheet (continued)

Company	Account Number	Address	Phone	Done
Dentist:				
DMV: driver's license				
DMV: auto registration				
Doctors:				
Garbage:				
Insurance: car				
Insurance: dental				
Insurance: disability				
Insurance: home				
Insurance: life				
Insurance: medical				
Insurance: property				
Insurance: renter's				
Insurance: umbrella				
Insurance: other				
Investments:				

Address-Change Worksheet (continued)

Company	Account Number	Address	Phone	Done
IRAs:				
Libraries:				
Loans:				
Magazines:				
Mortgage Co.:				
Newspapers:				
Organizations:				
Passports/visas:				
Pensions:				
Property titles:				
Safe-deposit box:				
Schools:				

Address-Change Worksheet (continued)

Company	Account Number	Address	Phone	Done
Social Security:				
Stocks:				
Telephone co.:				
Trusts:				
Unions:				
Utilities:				
Veterinarian:				
Voter registration:				
Water company:				
Other:				
Family/friends:				

Address-Change Letter

Date

Dear _____,

We would like to inform you of our future move. Please see information below:

Old Address: _____
 Street Address (Apt. # or Rural Box #)

 City State Zip Code

New Address: _____
 Street Address (Apt. # or Rural Box #)

 City State Zip Code

Special Instructions:

 ☐ We plan to continue service at new address on (date) _____.

 ☐ We plan to discontinue service on _____.

 ☐ Please send necessary forms for address correction.

 ☐ Our account number is: _____

If you have any questions, please contact us at (____) _____

before _____ or (____) _____

after _____.

 Sincerely,

Mover-Evaluation Checklist

Mover #1: _____

Address: _____

Manager: _____

Phone: _____ Hours: _____

Contract fee: _____

Hourly rate: _____ Mileage rate: _____ Packing rate: _____

Insurance: _____

Cost of moving boxes: _____ Cost of used boxes: _____

Better Business Bureau reports? _____

Availability on moving day? _____

Mover #2: _____

Address: _____

Manager: _____

Phone: _____ Hours: _____

Contract fee: _____

Hourly rate: _____ Mileage rate: _____ Packing rate: _____

Insurance: _____

Cost of moving boxes: _____ Cost of used boxes: _____

Better Business Bureau reports? _____

Availability on moving day? _____

Mover #3: _____

Address: _____

Manager: _____

Phone: _____ Hours: _____

Contract fee: _____

Hourly rate: _____ Mileage rate: _____ Packing rate: _____

Insurance: _____

Cost of moving boxes: _____ Cost of used boxes: _____

Better Business Bureau reports? _____

Availability on moving day? _____

Moving Timetable

Task	Description	Schedule	Date Completed
Select mover			
Check homeowner's insurance policy			
Garage sales			
Goodwill/Salvation Army			
Dump			
Pack kitchen			
Pack dining room			
Pack living room			
Pack master bedroom			
Pack master bathroom			
Pack bedroom #1			
Pack bedroom #2			
Pack bedroom #3			
Pack bedroom #4			
Pack den			
Pack family room			
Pack rec room			
Pack bath #1			
Pack bath #2			
Pack bath #3			
Pack patio			
Pack garage			
Pack tool shed			
Pack play equipment			
Pack sports equipment			
Pack power tools			
Pack storage shed			
Separate VIB from other boxes			
Move out			
Place boxes in appropriate rooms			
Unpack			
Resell used moving boxes			

List of Moving Boxes

Box #	Contents	Packed	Moved	Unpacked
Box 1				
Box 2				
Box 3				
Box 4				
Box 5				
Box 6				
Box 7				
Box 8				
Box 9				
Box 10				
Box 11				
Box 12				
Box 13				
Box 14				
Box 15				
Box 16				
Box 17				
Box 18				
Box 19				
Box 20				
Box 21				
Box 22				
Box 23				
Box 24				
Box 25				
Box 26				
Box 27				
Box 28				
Box 29				
Box 30				
Box 31				
Box 32				
Box 33				
Box 34				
(200 boxes)				

Sample Moving Box Label

Box #: _____

Contents: _____

Deliver to: _____(room)

☐ VIB (Very Important Box)

☐ Fragile

☐ Sturdy

☐ Other _____

New-Town Checklist

Agency/Store	Address	Phone
Fire Dept.:		
Police Dept.:		
Sheriff Dept.:		
Emergency Medical Service:		
Poison Control:		
Hospital:		
Family doctor:		
Pediatrician:		
Specialist:		
Dentist:		
Orthodontist:		
Electric co.:		
Gas co.:		
Garbage co.:		
Water co.:		
Landscaper:		
Pool maintenance:		
Kennel:		
Post Office:		
Supermarket:		
Drug store:		
Office-supply store:		
Elementary school:		
Middle school:		
High school:		
Community college:		
University:		
Clubs:		
Movie theaters:		
Video rental:		
Parks and recreation:		
Kids clubs:		
Community activities:		

Part Two
Caring for Your Children: Parenting

Chapter 6
Get Help: Managing Child Care

Chapter 7
School Days

Chapter 8
When School Is Out

Chapter 6

Get Help:
Managing Child Care

Whether you need a caregiver the moment you bring your baby into the world or when your toddler is more independent, you'll need to make decisions about child care. You'll need to think about having a caregiver in your home or using day care outside your home. If your children are in school, you'll need to consider after-school care and transportation to and from school as well as after-school sports, art, and clubs.

Making Choices: An In-Home Caregiver

Between work, the house and the kids, you need 15 hands and a 60-hour day. It would be great to have someone around the house to help out. All the same, you might be concerned that a live-in would invade your private family time. And everybody's heard horror stories about live-ins who take advantage of your phone and food. How can you tell if your family will benefit from a live-in?

Many households are enhanced by the luxury of a live-in. This option gives you the flexibility of changing your schedule, arriving home late, and knowing that your children are being cared for by the competent person living with you. However, having an extra adult in the house means that you will lose some privacy. Review the options and stipulate house and job rules from the onset. By laying down rules when your live-in starts, you'll find that both parties will be secure with their roles.

Most caregivers are women, and for that reason caregivers will be referred to as females in this book even though men also make excellent caregivers.

Review Your Life Style

When making the decision about live-in versus live-out caregivers, consider your life style. Ask yourself the following questions:

1. Would you feel comfortable having a caregiver living in your home when you are relaxing or having private conversations with family members?
2. Would you be comfortable sharing your household belongings (kitchenware, toiletries, entertainment devices, transportation, and tools) with a caregiver?
3. Could you separate your caregiver's work time from personal time?
4. Are you flexible enough to live with the additional noise, traffic, and personal conversations in your home?
5. Do you have an extra bedroom and bathroom for a caregiver?
6. Do you need to provide room and board in order to finance your child care?

If you answered "yes" to all the preceding questions, you are a good candidate for a live-in. Remember, you'll have to give up some privacy and the dynamics of your home will change. But, the right caregiver may enhance your family life.

On the other hand, if you answered "no" to some or all of the questions above, you may be better off having a caregiver who lives outside your home. That way, you have the luxury of in-home care without the loss of privacy.

All About Live-in Nannies

Nannies are professional caregivers who usually have completed a nanny-training program. Most live in the home, and their primary job is to care for the children. Job responsibilities usually include preparing children's meals, bathing, entertaining, and driving children, and laundering their clothes.

Professional nanny programs are offered in colleges in the United States and abroad. Course requirements include early childhood education, health and safety, child development, family systems, professional issues, and practicum. Nannies must clear a criminal record check, health exam, and a TB test. Admission to professional-nanny programs often requires personal interviews by faculty members to determine if the applicant has the personality and characteristics appropriate for interpersonal relationships with children.

Nannies tend to stay with the family for longer periods of time than do other caregivers. Because they have made a commitment to receive professional training, they will be less likely to seek a career change once hired.

You should be prepared to pay more for a nanny than for other care-givers. You may be expected to pay for her flights (if the nanny is coming from other parts of the country or abroad) as well as provide a private bed-room, use of a car, and wages. If you use a placement agency to help find your nanny, you'll have to pay a finder's fee. (See "Use a Domestic Placement Agency" on page 119.)

All About Live-in Au Pairs

Au pairs are live-in caregivers who usually don't have professional training in caregiving. Most au pairs are from different states or countries coming to live in your home while they establish residency. Au pairs become part of the family while they are working for you. They often join the family for meals and outings.

Compensation for au pairs is less than for nannies but you may still need to provide a private bedroom, use of a car, and wages.

The In-Home, Live-Out Caregiver

If you do not use a live-in caregiver, some time during parenthood, you'll need to hire a caregiver who lives out. There are two types of caregivers: the full-time child-care provider who cares for your child while you are at work or traveling for an extended period of time; and the short-term, part-time caregiver who occasionally watches your children while you go out to dinner or a movie.

A *FULL-TIME CAREGIVER* provides care for your children, but does not live in your home. She can prepare meals, do light housekeeping, run errands, and provide transportation for your children. Full-time caregivers usually don't have professional nanny-school education, but many have taken early childhood education courses and have worked with children.

A *PART-TIME CAREGIVER* (babysitter) usually cares for your children while you go out on occasional outings. Babysitters come in all types and descriptions: They can be teenagers, college students, friends, other parents, or retirees. Their responsibilities usually consist only of entertaining and feeding the children.

Developing a Job Description

Parents are often uncomfortable asking caregivers to help out with clean-ing, meals, and errands. Mary Poppins never washed dishes or vacuumed the living room. However, many caregivers today are willing to do house-hold work to help meet the needs of the busy families.

It is important to write out a clear job description before you hire your caregiver. Whether you hire a nanny, au pair, or caregiver, complete the job description so both parties know exactly what the job responsibilities are. Think about all the tasks that are important to you. Do you want to come home to a clean house with dinner on the table? Do you want your children

to do special projects during the day? Do you want your caregiver to do laundry, feed the dog, collect the mail, take phone messages, or help with homework? Be clear about your expectations. (See "In-Home Caregiver's Job Description and Contract" on page 134.) Check appropriate job responsibilities and fill in details. Review this job description carefully. Once you've hired your caregiver, this job description is your signed contract. Adding more responsibilities later will mean, in many cases, that you will have to increase wages or provide more benefits.

After completing the job description, you then start the hiring process.

How to Hire a Caregiver

Hiring your first caregiver can be stressful. You may have feelings of guilt about leaving your child with a stranger, or you may fear child abuse. It's really fear of the unknown. As you interview applicants, you'll immediately see the qualities that are important to you. After you've interviewed several caregivers, you'll become more confident, and the decision-making process will become easier.

If you already know someone who is qualified and looking for a job, finding a caregiver is easy. All the same, it's a good idea to run an ad and interview others even if you think you already have the "perfect caregiver." It's also a good idea to have backups available should this perfect person change her mind and leave you in the lurch.

If you don't already have someone in mind for this position you'll need to put an ad in your local newspaper. (See Chapter 5, "Put an Ad in the Newspaper.")

It's a good idea to start with a two-week ad. If you find someone sooner, you can call the newspaper and cancel the ad. Most newspapers bill only for the actual number of days an ad runs. Your ad should include a general job description, hours, and pay schedule. This will eliminate calls from people who can't work certain hours, or who require higher wages than you are offering. Don't hide the unpleasant parts of the job. If you want your caregiver to do more than just take care of the kids, your ad should let a prospective applicant know what all the responsibilities are, so you don't waste your time interviewing people who don't like some of the duties you expect them to do, such as housekeeping, cooking, or changing cloth diapers.

Post an Ad at the Local College or University

You should also place the ad at the local college or university. Most colleges have job-placement services and school newspapers. Job-placement services are usually free to employers, and classified ads in school newspapers are usually less expensive than in other local newspapers. You may find a student looking for part-time work or someone who wishes to take a year off.

Use a Domestic Placement Agency

If seeking out a caregiver seems difficult, or time and work considerations make it hard to give proper attention to this initial part of the process, domestic placement agencies (small employment agencies that cater to your needs) may be the solution. Domestic placement agencies screen candidates for criminal, moving violation, credit, and child-abuse records. They can meet with your family and set up interviews with several applicants. It is always your responsibility to select the best caregiver. Agency fees are usually 60-200 percent of the caregiver's first month wages. Many placement agencies guarantee that the caregiver will work for two months or they'll place a new caregiver or refund the placement fee. (Check with the agency about its specific policy.)

The placement agency also helps in the negotiation process to determine the caregiver's hourly fee or monthly salary.

Conduct a Telephone Interview

After placing an ad in the newspaper and posting an ad on the job boards at your local colleges, be prepared for inquiries from a variety of people. Make a list of questions to ask callers. This will help you weed out the wrong people for the job. You'll get calls from people looking for a temporary job until they find a better paying job, bored housewives, students looking for part-time work, grandmothers, mothers of young children, and more. Make a decision about the type of person you want and ask questions to help filter undesirable applicants; don't waste time interviewing someone who isn't really a candidate. If your instincts tell you that the caller is definitely wrong for the job, take the name and phone number, then indicate that you'll call back if you decide to interview.

Sample Questions

1. Are you looking for part-time or full-time work?
2. Do you have a reliable car?
3. Do you have auto insurance?
4. Are you a college student? What is your current and future schedule?
5. What is your experience working with children ages (_____)?
6. What activities do you enjoy doing with children?
7. How do you respond to constructive criticism?
8. Why are you looking for a new job?
9. How long would you be willing to work in this position?
10. How long have you lived here? How long do you anticipate staying in this area?

During the telephone conversation, take notes to help you determine whether or not you want to meet with this person to get more information. If you do, set up an interview within a few days. Interviewees usually call lots of potential employers; they may get another job before your interview

date if you set it too far in the future. *Good caregivers quickly find jobs.* Schedule interviews one at a time; allow approximately 45 minutes for each interview. If time allows, send each interviewee the "In-Home Caregiver Application Form" (page 142) to fill out and bring to the interview.

Conduct a Personal Interview

After you have interviewed several prospective candidates over the phone, it's time to start the personal-interview process. You should schedule the interviews at a time when you are not going to be disturbed and when you can devote your whole attention to the applicant. Personal interviews are also a good chance for the applicants to meet the children and see how they get along together. Schedule enough time for each interview so that you're not rushed; allow time to talk with the applicants, show them the house, and have them meet the children. Make sure that you have some flexibility; if you schedule too many people too closely together, you'll find yourself rushed and unable to get a good feel for how good a candidate your applicant really is.

Go through the completed "Job Application" form with each applicant. Ask questions about her responses and jot down pertinent information in the spaces provided on the application form. You should encourage applicants to talk about themselves; personal anecdotes, information, and history give good insights.

Ask questions about their philosophies of education, discipline, and family, and (if the job description calls for it) their willingness to house-clean, cook, run errands, and so forth. After they describe their philosophy, you should discuss yours. Be perceptive about how they react to your ideas. Show them your schedule and job description and discuss it. Again, note their responses.

When you are finished, always thank the applicant for her time and for completing the application and the interview. Tell the applicant that you will be checking references and give an idea of how soon you think it will be before you will make a decision. If you are thinking of hiring an applicant, say that you will call with your decision either way (and do so).

During the interview, you should note the applicant's dress, personal hygiene, speech, manners, and mode of transportation. After the interview, write down your impressions about your discussion. Did the applicant seem enthusiastic and capable of performing the full scope of the job? By making notes, you can remember the particulars of each person as you continue the interview process. If the person is not right for the job, place a "No" in the upper corner of the application form. If the person is a candidate for the position, write "Yes" in the upper corner. That way, you don't have to read through each application to see whom you liked or didn't like.

Try not to burn any bridges with people who were strong candidates, but whom you didn't hire. You will always need substitutes to fill in when your regular caregiver is sick or on vacation. In addition, occasionally the person you hire just doesn't work out after the first week or so. In that case,

you can go back to your list of applicants to select a new caregiver without starting the whole advertising/interviewing process again.

Five Precautions to Take Before You Hire

CHECK FIRST-AID EDUCATION THOROUGHLY In-home caregivers should have pediatric CPR and first-aid training. They are the only adults in your home with your children while you are away. If an accident should occur, a caregiver with pediatric CPR and first-aid training will be more likely to save your child's life than will a caregiver who can only call 911 for help. The American Red Cross offers excellent classes at reasonable rates.

CHECK REFERENCES Call all employers and references listed on an application. Verify that the applicant worked during the periods listed and received the wages indicated. You should also ask about the applicant's conscientiousness, how often she was sick, her work attitude and attitude with the children, and how well she worked with others. You should briefly describe the position you are offering and ask for an opinion about how the applicant will do. If you are calling a former employer, ask about the reason(s) for the applicant's termination.

Conversations with references can be informative. Obviously, the applicants will not put down bad references, but they will have to account for their employment history. You should be concerned about any large gaps in a job history and ask about it at the time of the interview.

INQUIRY ABOUT FAMILY HISTORY It is important to know as much as you can about your caregiver and her background. The more information you get from the applicant, the better equipped you are to make a hiring decision. For example, there are a few questions on the job application about discipline in the applicant's family. When reviewing these, ask more questions about her background.

REVIEW THE APPLICANT'S DRIVING RECORD If your caregiver will be driving your children to and from school and to other activities, it is a good idea to check her DMV driving record. A driving record has valuable information. It lists all traffic violations and accidents the driver has had over the past three years. In many states, you can request information over the past six years for the same fee. A person's driving record will also include any physical and mental conditions that might affect her ability to drive, such as lapses in consciousness or other medical disabilities.

In most states, a prospective applicant can go directly to her local Department of Motor Vehicles or Highway Patrol and get a copy of her driving record over the counter. There is a nominal fee, and the copy is provided immediately. You can request that an applicant provide the original driving record with the DMV seal to ensure receiving an unaltered document.

If you would prefer to get the driving record yourself, get the request form at the DMV. In some states, such as California, you'll need to provide a statement of your reasons for requesting this information. The applicant is then notified by the DMV that you are seeking information about her

driving record and has to approve the request before the DMV will release the driving record to you. Allow approximately three to four weeks to receive the information.

ASK FOR ANY HISTORY OF CHILD ABUSE Hiring a caregiver you don't know is one of the hardest aspects of setting up child care. Screening out people with histories of physical, mental, or sexual child abuse are real concerns in any child-care situation. If the service is available in the area where you live, it's a good precautionary measure to run a prospective employee's name through a child-abuse index (state or federal) and to get fingerprints from them (if your state has a child-abuse index program available for parents). This will give you assurance that you're not hiring a convicted child abuser.

Many states provide the child-abuse index for "licensed" day-care providers but not for the public (to protect child abusers from vigilantism). If your state allows public access to the child-abuse index, simply have applicants get their fingerprints taken at the local police station. Call your district attorney or Department of Social Services to find out whether the service is available and to request instructions and forms.

There are government-funded and private agencies that offer services for investigating caregivers. These programs check for criminal records and verify credit history, driver license, employment, professional license, Social Security, and education of the applicant. Check with child-abuse organizations to get a listing for resources in your area. Some agencies will do complete investigations while others will check only criminal or child-abuse histories.

Private surveillance companies are opening up nationwide. They provide a hidden video camera to secretly tape your caregiver while she is working with your children. The cameras are hidden inside stuffed animals, toys, and appliances. The video tapes can be motion-activated or set to record for four to five hours.

Although parents are divided on the ethics of videotaping, most agree that their children's emotional, physical, and sexual safety is more important than the caregiver's privacy. Should parents inform caregivers that they will be videotaped? Some states have privacy laws that may be violated if the caregivers are not aware of the taping. Check with the surveillance companies and your attorney to protect yourself.

Determine Wages and Benefits

You'll have to do a little research to determine the appropriate child-care wages and benefits in your area. The best resource is your local newspaper under "Child Care." You can also call child-care centers and inquire about employees' wages and benefits. Although you'll want to keep your child-care costs down, you also want to provide wages that are high enough to motivate your caregiver to do a good job. If any of your friends have caregivers, talk to them to see how much they pay for comparable services. Any decision about wages and benefits should be based on the input you have received and your candidate's experience.

SETTLE ON A FAIR WAGE Nannies and au pairs require different wages. They receive room and board and often use of a car. Wages depend on the going rate in your area, unless the nanny or au pair was placed by an agency. In that case, the wages are usually agreed upon by all three parties: the agency, the nanny or au pair, and the employer.

ESTABLISH PAY PERIODS The pay period can be every week, every two weeks, every month, or bi-monthly. Discuss it with the caregiver and make a decision that is mutually beneficial. It's easier to pay once a month, but many caregivers usually prefer being paid at least once every two weeks, or even weekly.

HANDLE TAX ISSUES Caregivers who work for several families, where working with children is their primary business, may be independent contractors. As independent contractors they pay their own state and federal taxes, and all you need to do is fill out a 1099 form at the end of the year, or immediately after they terminate their employment with you. You need to send the 1099 to the caregiver by January 31 and the IRS by February 28. Keep a record of this form in your files.

Note: The matter of independent contractors versus employees is a gray area legally, and you should consult with the IRS, your state's Employment Development Office, and/or your C.P.A. or attorney about your caregiver's specific employment status.

On the other hand, caregivers who are employees, not independent contractors, must have their state and federal taxes deducted from their wages, as well as unemployment, disability, and Social Security. State and federal regulations change frequently. Call the IRS at 1-800-829-1040 to get their Publication 942: Employer's Quarterly Tax Return for Household Employees, 942 tax forms, Circular E (F.I.C.A.), and W4 and W2 forms. Describe your employee situation to the IRS representative and request that they send you all the forms you will need.

The "nanny-tax" exemption excuses employers from payroll taxes on household employees who earn less than $1,000 a year. Household employees who earn more than $1,000 a year have to be reported once a year, not quarterly, and can do so on their own federal tax forms.

You should also call your local state employment-development office or state employment agency to get the appropriate state tax publications and tax forms. In many instances, state tax regulations may be the same as the federal nanny tax, but you should always make sure you're not violating any quarterly reporting requirements for unemployment and/or state income taxes.

MAKE SURE YOUR INSURANCE COVERS YOUR CAREGIVER Check with your insurance agent to make sure that your homeowner's policy covers child-care providers. Your coverage should also provide worker's compensation insurance for your caregiver, in case she is injured in your home, while working with the kids, or driving your car. Many homeowner's policies have a clause that covers domestic workers as long as their hours don't exceed ten hours or so per week. If your caregiver works more hours than your policy allows, inquire about additional coverage.

Many insurance companies require that live-in nannies or au pairs have a special "in-house servant's endorsement" to cover their worker's compensation. This "rider" is in addition to a standard homeowner's policy and is offered by the insurance company. The cost is minimal and the protection is important.

If you don't own your home, check your renter's insurance policy to see if you have coverage for domestic workers. If it doesn't say, or you can't tell from the policy, call your agent to see if your caregiver is covered under your policy.

If your nanny or au pair has the use of your car, contact your automobile insurance company to add her as a driver in your household. Your caregiver will then be treated as one of the members of the household. If she is under 25 years old and single, your policy fees will probably increase. Many au pairs will not have a valid driver's license in your state, and some may even have an international driver's license. You need to make sure that your caregiver will be covered in case of an accident. Most auto-insurance policies will cover any authorized driver in your household.

OFFER BENEFITS The better the benefits, the more likely your caregiver will stay with you. Check with other caregivers and employers to compare benefits received. Depending upon your financial status, you may offer a car (for her use while in your employment); health insurance; and/or paid holidays, vacations, and sick days.

Vacation Benefits Full-time caregivers are entitled to reasonable vacations, like any employee. Vacations offer time for both the caregiver and the family/children to take a break and become refreshed. During the first year, a one- to two-week vacation without pay is standard. After the first year, a one-week paid vacation offers a nice bonus.

OFFER PERKS Your caregiver works hard for her paychecks. Working with children is exhausting and not always rewarding. "Perks," or little gifts over and above their normal wages and benefits, help your caregiver know that the job she does is important and that you recognize how valuable she is to your family. Treat your caregiver to dinner without the children. (This can be a good time to tell the caregiver how much you appreciate her work.) You can also give gift certificates to her favorite stores, restaurants, and theaters.

You should enter your caregiver's birthday on the "Permanent Calendar" (page 39). Little gifts, such as candies or flowers or tickets to a game or show, make her feel special and appreciated. These perks pay off ten-fold—your caregiver will be more enthusiastic about playing and working with your children and will put that much more energy into her job.

MANAGE THE NEW EMPLOYEE'S TRIAL PERIOD So you've checked references, reviewed the DMV driver's record, received a clearance from the child-abuse index (if applicable), and finally decided on the person you want. Now it's time to start the new caregiver on a trial basis. You should call the applicant as soon as possible, to avoid losing her to another job opportunity. Fix the starting date and specify a probationary period (normally two to three weeks) to evaluate your new caregiver's job performance and attitude. This will also

allow the children plenty of time to get familiar with her, observe their interactions, and for you to see if you are comfortable with the caregiver and satisfied with the situation.

USE THE IN-HOME CAREGIVER'S DAILY INFORMATION FORM The "In-Home Caregiver's Daily Information Form" (page 144) is for new in-home caregivers or for caregivers who will watch your children while you go to a movie or out to dinner occasionally. All the important information they need to know is listed, along with a brief job description.

If you have a situation where you have the same caregiver every time, fill out the information that doesn't change (family rules, first aid, and medication), and then copy it so you don't need to fill it out each day. You can then add information about transportation, meals, and daily itinerary as needed.

ESTABLISH OPEN COMMUNICATION Because your caregiver will be a new partner in the most important job you have (raising the kids), it is vital that you have good, open communication and that information is passed efficiently and constructively. Therefore, you need to set up a system for communication.

You will need to decide when the caregiver should contact you to ask questions or let you know how things are going. Should she call you at the office, write a note, or wait until you come home to discuss problems? For example, you can specify a specific clipboard or note pad for communication. You can leave notes and/or questions, and your caregiver can respond on the same pad. That way, if everyone knows (and follows) the system that is set up, you can be reasonably sure that you are getting the information you need, your caregiver is getting the information she needs, and both of you are aware of what your expectations are and when you want various jobs completed.

MOTIVATE YOUR CAREGIVER All employees need to feel appreciated by their employers. Employers who understand how to motivate their employees keep them longer and receive better results. Caregivers who get sincere, positive feedback about their work feel good about what they're doing and will strive to do a better job.

You should share the little successes you notice in your children with your caregiver. When your child makes progress potty training or learning his alphabet letters, thank your caregiver. Your excitement carries over, and she pays more attention in those areas and will give you more reports. Likewise, if you want your caregiver to concentrate on another task or try a new technique, make suggestions and discuss them with her, don't just "order" her to do it. Involving your caregiver in your child's development will get her excited and less likely to get defensive if disagreements should occur. If the house looks extra clean or the children seem especially happy, *thank her*. Positive reinforcement works wonders on adults as well as children.

Everyone, at some point in child rearing, will need an in-home caregiver. Whether you hire a nanny, au pair, or caregiver (or even an occasional babysitter), the selection process is the same. In-home caregivers can

give you the security of knowing your children are being well cared for in your own home, with a person you have selected.

However, you may prefer out-of-home day care.

Making Choices: An Out-of-Home Caregiver

If in-home child care doesn't work for you, your next option is day care provided in a caregiver's home or day-care center. There are small-family day-care homes, large-family day-care homes, day-care centers, after-school programs, sick-care services, and drop-in centers.

Look Into a Small-Family Day-Care Home

If your child is very young, you may be concerned that a huge day-care center, with a lot of children, won't offer the kind of attention he needs. You may worry that the child will be intimidated by the other children.

Small-family day-care homes are designed to offer a "homelike" atmosphere for groups of one to six children. The caregiver usually resides in the home and also has children of her own. In most states, the caregiver's children are counted in the total number of children allowed. Hours are usually 7:30 A.M.-6:00 P.M.

Many small-family day-care homes are licensed (or are supposed to be licensed) by the state or county. However, licensing requirements vary widely from state to state over the country, and many of these small-family homes are not licensed, either because this is not required under the laws of that particular area, or because they are being run "on the side," generally by women who enjoy taking care of children. Unlicensed child-care homes vary widely in the quality of care provided, but are also somewhat less expensive than are licensed day-care facilities. If, because of cost considerations or for other reasons, you are considering sending your children to an unlicensed facility, you need to be extremely careful before actually making a decision one way or another, and you need to carefully follow the suggestions listed in Chapter 6.

In California and several other states, licensed day-care homes are required to have smoke alarms and fire extinguishers. All dangerous chemicals, cleansers, and sharp objects are required to be kept in locked cabinets. The caregiver, employees, and members of the household are required to get TB tests and fingerprints checks and to file a Criminal Record Statement. Each day-care licensing agency follows regulations set forth by the state or county. Check with your local child-care licensing department for a list of regulations.

Small-family day-care homes offer an intimate family environment that is very good for small children. The typical age range for a small-family

day-care home will generally be between one (although some will take children as young as three to six months) and four or five. In a small group, your child will always be cared for and will generally receive the personalized attention that larger day-care facilities don't necessarily provide.

Examine a Large-Family Day-Care Home

If your child was fine when he was little, going to his aunt's house, but is starting to get bored there, needs more interaction with kids his own age. If you think he's still a bit young to start in a formal preschool-type of program, look into a large-family day-care program. Such a program often suits an active four-year-old.

Large-family day-care homes are licensed for 7 to 12 children. The licensing agency requires providers to hire employees (to keep a small child/provider ratio) and to conform to stricter fire regulations. In many counties, a fire-marshal clearance is required to increase licensing capacity to 12. The fire clearance often includes a manual fire alarm, escape plan, and two exit doors to the outside. The hours are usually similar to those of small-family day-care homes.

Large-family day-care homes tend to offer more group activities than do the small-family day-care homes and are generally designed with slightly older children in mind (that is, from about three years old up to eight or nine years old in after-school care). Many large-family day-care homes, like many day-care centers, will not take children who are not potty trained. With up to 12 children, it is more likely that there will be children of the same age and sex as your children. Your child will have more opportunities to make friends.

Opt for a Day-Care Center

If your three-year-old is starting to get interested in learning her letters and numbers, consider sending her to a preschool or some kind of day-care center. They offer formal programs that keep children engaged and interested.

Professional day-care centers are licensed by the state and are required to follow stricter regulations for health and safety, land use, and employee credentials than are homes where family day care is provided. Most of the time, day-care centers are located in commercial buildings or converted houses. They are usually required to meet handicap, fire-marshal, and land-use ordinances. (Call your day-care-center licensing agency for more information on local rules and regulations.) Normal operating hours vary, but professional day-care centers are usually open a little longer than family day-care homes: 6:00 A.M.–7:00 P.M. These hours tend to be less flexible than in family day-care homes, and many day-care centers charge extra if children are not picked up on time or if they have to open up early to receive a child.

Day-care centers enroll the largest number of children. Some states have set different regulations for centers with under 50 children than for those with more than 50.

Day-care centers adopt early childhood philosophies or themes and will often have formal preschool programs. Specialty classes in gymnastics, theater, song, and dance are periodically offered.

Explore a Drop-In Center for Hourly Care

If you and your spouse both work out of the home and share the parenting duties for your child, occasionally both of you might have a meeting or something to do, and neither of you can bring your child along. Sometimes, it's hard to get a babysitter on the spur of the moment, and even if you can, they can be really expensive. Look for some kind of day-care place where you can arrange to drop the child off for a few hours when you need to.

For those who don't live in neighborhoods filled with children and homemaker mothers, where dropping your child off at a neighbor's home for a few hours while you run an errand is commonplace, there are drop-in day-care centers.

Drop-in day-care centers are designed to meet the needs of busy families with erratic schedules. After your initial registration, you can pretty much leave your child there anytime they are open, without notice and without reservations. The number of children at drop-in centers varies each day. The programs offer art, recreation, stories, and meals. Some children enjoy this kind of new environment, while others may have trouble with a new, short-term program, at least initially. Most drop-in centers allow a maximum of five hours for any visit. Rates are comparable to other day-care facilities. They are regulated under the same laws and ordinances as are regular day-care centers.

Select an After-School Program

Bobby's in first grade and is doing just great. Now that he's in school for most of the day, you want to go back to work. Your husband commutes and usually doesn't get home until 7:00 or 8:00 P.M. You can't really afford a housekeeper, but your baby is not going to become a latch-key kid at the age of six. What can you do?

Many after-school programs are offered at day-care centers, family day-care homes, and schools. With so many households consisting of single parents or two working parents, most children attending school need after-school care. The licensing requirements for after-school programs are usually based on the type of facility where the program is being offered (that is, whether it is a small-family day-care home, large-family day-care home, or a professional day-care center).

Some after-school programs even offer a pickup service at local schools. Many others are located in close proximity to schools, so that children can walk to the program after school. Hours are usually set to accommodate working parents by staying open until 6:30 or 7:00 P.M.

After-school programs vary in philosophy and structure. Some offer tutorial assistance to encourage the students to complete their homework, while others offer arts and crafts, or sports.

Selecting Your Child-Care Facility

Choosing the right day-care program can be a nerve-wracking experience, particularly if it's the first time. Get child-care references from friends and family (as many as you can) and then call the director or caregiver of each center and ask about their facility, programs, philosophy, meals, and fees. Fully discuss both your needs and your child's. Most of the time, you'll know if you want to visit the site just by your conversation with the caregiver.

After you have talked with the people at the various centers or homes over the telephone, you should then visit *each* of them, if possible. When you visit a site, be observant. Are there lots of books, games, and activities available? Are the children interested and engaged in these activities, or do they look as if they want to be doing something else? Are the children healthy, or do they have coughs and runny noses? Is the facility safe: locks on cabinets, safety gates, fences around play area, and safe outdoor play equipment? Are the teachers aware of the children's needs and making sure the children aren't fighting or being rude to one another?

Call the child-care licensing agency to make sure that the day-care provider is in compliance with all state and county regulations. If possible, verify that the employees and the facility have been appropriately screened for health and safety. Also, ask them if they have received any complaints about the provider, or the provider's employees.

Ask for a list of current student references. This will give you the opportunity to call other parents and ask questions about how satisfied they are with the facility. This way, you'll get the benefit of their perspective on the program, employees, and health and safety.

Once you've selected the best program for your child, enroll for one month as a trial period. This will give you and your child the opportunity to decide if the program you have selected meets your needs and is good for your child.

The "Day-Care Evaluation Checklist" (page 146) is designed to help you evaluate a number of day-care centers and judge which one is right for you and your child. First, call various facilities that you are considering for day care, to get general information, and fill in for each center. This will help you keep your information clear. Take the "Day-Care Evaluation Checklist" with you when you go to observe the facility. Review the questions beforehand and take notes as you observe.

Introducing Your Child to Day Care

If your child has never gone to a day-care program before, you may want to arrange a trial period to get him acclimated. Arrange to go with him to observe for a whole day before you actually start him at the facility. You'll both get a chance to see exactly what takes place throughout the day. Then leave your child for two hours, then a half day, and then the full day. Reassure your child that you will be there at a specific time to pick him up and make sure you're not a minute late.

Children will often cry the first few times you leave. Tell him you are going to work (or wherever) and that his teacher is going to care for him. You should tell him what time you plan to pick him up (actually, you should always do this, if possible), give him a hug and kiss, and then turn around and walk out. No matter how much your child cries and hollers, keep going. It'll probably break your heart, but it will make the break clean, and your child will start enjoying his time in the class much sooner. If you turn around and indulge the crying jag, your child will end up spending his energy manipulating you, instead of making new friends.

Handling Your Day-Care Anxieties

Giving your child to a caregiver outside the home is often traumatic for parents. Every parent has memories of driving away from the day-care center in tears on the first day he or she left the child with "someone else." Every parent asks his or her child (if they are old enough to speak) multitudes of questions about what she did, what she ate, and who she played with, hoping to hear that the child's little world away from home is a perfect utopia. If you suspect something is wrong, those parental-protection wheels start moving. While you may never have felt those strong feelings before, a rise in blood pressure is normal in situations where you don't have control over your child's well-being.

FIND OUT WHAT REALLY HAPPENS Many parents have questions about school policies, teacher attitudes, and unfortunately, child-abuse issues. Observing day care when they are expecting you, or during regularly scheduled visitation hours, will give you only a picture-perfect snapshot of the program in most cases. The teachers have their classrooms extra tidy and are on their best behavior. They often ask the children to be "extra good" during visitation hours. Children also tend to act differently when there is a visitor in the room.

The best way to see the inner workings of your child's day-care program is to volunteer in the classroom. If you schedule to volunteer once a week or twice a month, you become part of the class structure. Then, as the teacher and children become familiar with you, they stop the "show" they do for visitors. By helping out in the classroom, you become a "fly on the wall" that nobody notices. While you're busy stapling booklets together for the teacher, the class is in full operation and you can see and hear everything. You can observe the children's interactions with each other, how the teacher instructs and guides them, and if the teacher creates a stimulating and nurturing environment. The input you receive from this kind of observation is invaluable. You'll see how your child relates with both the teacher and other children.

DISCUSS PROBLEMS IMMEDIATELY More often than not, your child is enjoying a good program in the hands of caring, competent caregivers. If you believe that there is a problem, call the director and arrange a time to discuss your concerns. Be friendly and positive. There are always two sides to every story, and discussions that turn into confrontations tend to be counterproductive.

Don't forget that caregivers are people, too. They have their good days and bad days and can be sensitive about accusations concerning their work. Most caregivers receive wages just above the minimum-wage standard. They have chosen this occupation because they enjoy working with children. Unfortunately, a caregiver's job is often thankless. They are taken for granted, and in most cases, are without adult interaction for hours. When they do meet with parents, it is generally to discuss problems, not "strokes."

Do you work with unpleasant or negative co-workers? Do you avoid those co-workers and gravitate toward friendly and positive co-workers? That is human nature. Parents who rant and rave to caregivers may negatively affect their children's day-care experiences. Some caregivers have difficulty separating the child from the problem parent.

When you meet with a caregiver to discuss your concerns, start by listing positive aspects about the program, for example, that your son or daughter loved the art project he or she did, and has taught all the neighborhood children the technique. Or, thank the teacher for her positive, caring attitude that makes it so easy for you to leave your child with her each morning. Don't make accusations. Ask her for her perspective on the issue. This allows the caregiver the opportunity to describe the incident from her point of view. Remember, the real issue is always what's best for your child. A positive, supportive discussion will generally lead to a satisfactory outcome and give the caregiver positive insight and dignity.

Sometimes, the positive approach doesn't work. In that event, when you meet with a caregiver, give her your perspective and let her respond. Don't go off on a mud-slinging rampage. Discuss your concerns civilly.

For instance, in many small-family day-care homes, children of various ages will all watch videos together. If you think that some of the videos being shown to the children are, say, too violent for the younger ones, first ask, "What videos do the three-year-olds watch?" or "Do the three-year-olds watch the same videos as the third graders that come here after school?" If the caregiver responds with only a general answer, or doesn't differentiate the children's viewing, then ask, "Do you consider the *Mighty Morphin Power Rangers* or *Snow White* appropriate for toddlers?"

Likewise, many times caregivers show videos that the children themselves bring each day. If that is the case, offer to bring in your videos. Different parents have different tolerance levels for what they allow their children to watch, and the emphasis on quality in video viewing varies from family to family. By offering to bring in a variety of tapes each week, you're taking positive action and supporting the caregiver.

Any caregiver has a difficult job trying to please a large number of children and their families. Make sure to thank her for her energy and effort.

CHANGE PROGRAMS IF NECESSARY If you've tried to communicate your concerns to the caregiver(s) at your child's day-care facility without success, look for child care elsewhere. Once you've selected a new provider, notify the current caregiver and *make the change quickly*. It's generally a good idea to have your child take cupcakes or similar treats to share with the other children and caregivers on her last day. This gives your child positive closure.

WHAT TO DO IF YOU SUSPECT CHILD ABUSE If you suspect child abuse, call your local C.P.S. (Child Protective Services) office, Community Care Licensing office, Department of Social Services, District Attorney's office, or the State's Children's Ombudsman. They are tied into day-care licensing and will order an inspection of the day-care facility.

Document details about the suspected child abuse and/or take photographs of any visible wounds.

If sexual abuse is suspected, take your child to be examined by his pediatrician. The pediatrician will contact the authorities if necessary.

Avoid Headaches: Caring for a Sick Child

What can parents do when their children are sick? Most day-care centers will not allow sick children to attend. Most parents cannot miss work because of a sick child.

What *do* you do when your child is sick? Children like to stay in their warm, comfortable beds when they're not feeling well.

Back in the 1950s, most mothers stayed home with their children. Nowadays, children are often sent back to day-care and school before they have fully recovered, or while they are sick, because of the work pressure placed upon parents.

Sick-care has evolved to meet the needs of the changing family structure. Single-parent families and two-income families have steadily increased over the past few decades. Sick-care programs have qualified nurses and caregivers who tend to your sick child in your home.

Fees vary according to your child's needs. If your child just needs to sleep and drink liquids, you'll normally pay the going rate for in-home caregiving. If your child is taking medication, has an illness that requires careful monitoring, or has a contagious disease (measles, chicken pox, pink eye), you'll pay the going rate for in-home nursing care.

In many smaller cities, sick-care may not yet be available. Call local home-care agencies, such as the Visiting Nurses Association (VNA), Olsten Home Care, and UpJohn Home Care, to inquire about sick-care programs for children. Most home-care agencies have health-care attendants who are CPR-trained, TB tested, fingerprinted, and screened (criminal records). They are supervised by a nurse off site, so if your child takes a turn for the worse, the health-care attendant will be able to seek medical advice quickly. Rates for health-care attendants are usually about three times the cost of regular child care, with a two-hour minimum. In most cases, the same health-care attendant will care for your child if he is sick for any extended period.

Summing Up

Family day-care homes and day-care centers offer specialized programs to meet the needs of most families. With a little research and a few observations, you can find the right day-care environment for your child.

Child-Care Organizers

In-Home Caregiver's Job Description and Contract
In-Home Caregiver Application Form
In-Home Caregiver's Daily Information Form
In-Home Caregiver's Time Sheet
Day-Care Evaluation Checklist

In-Home Caregiver's
Job Description and Contract

Caregiver's name: _____

Caregiver's address: _____ City: _____ ZIP Code: _____

Home phone: _____ Work phone: _____

Scheduled cleaning day: _____ Arrival time: _____ Departure time: _____

Work schedule (days/hours) _____

Responsibilities

☐ **Meals**

Please prepare the following meals (sample meals):

Breakfast: _____

Morning snack: _____

Lunch: _____

After-school snack: _____

Dinner: _____

Dessert: _____

Other: _____

Caregiver _____ will bring her own meals/ _____ will join children for meals.

Food that is off-limits: _____

☐ **Medications**

Please give the following medications to _____ at _____:

Medications are located: _____

Special instructions: _____

☐ **Indoor Activities**

Please do the following activities with my children:

Supplies/materials located: _____

In-Home Caregiver's
Job Description and Contract (continued)

☐ **Outdoor Activities**

Please take my children outdoors, weather permitting, and do the following activities:

If the activity requires transportation by car, please make sure that the children are buckled up. Drive carefully.

☐ **Homework**

Please provide a quiet environment for my children to complete homework, school projects, or music practice. If they need help, please provide assistance, but be careful not to do the work for them. Here are some guidelines for my children:

☐ **Errands**

Please run errands in _____ employer's car _____ caregiver's car. Enter mileage on your Time Sheet. Please drive directly to each destination on your list. Do not do personal errands or make personal stops. Please drive carefully and follow DMV traffic rules. Typical schedule of errands:

☐ **Transportation of Children**

Please transport my children in _____ employer's car _____ caregiver's car. Please carry the Emergency Forms in the transportation vehicle. Make sure all children wear seat belts/car seats while vehicle is moving. Please do not leave children unattended in vehicle. Drive carefully and follow DMV traffic rules. Typical transportation schedule:

In-Home Caregiver's
Job Description and Contract *(continued)*

☐ **Employer's Vehicle**

 ☐ Vehicle will be available for transportation of children and running errands only.

 ☐ Vehicle will be available for all caregiver's needs.

 ☐ Vehicle insurance will be provided by employer.

 ☐ Vehicle insurance will be provided by caregiver.

 ☐ Fuel and automotive tune-ups and repairs will be paid by employer.

 ☐ Fuel and automotive tune-ups and repairs will be paid for by caregiver.

☐ **Light Housecleaning**

Please do the light housecleaning tasks that are checked below:

☐ Empty dishwasher	☐ Wash dishes	☐ Wipe kitchen counter
☐ Sweep kitchen floor	☐ Vacuum bedrooms	☐ Vacuum living room
☐ Vacuum family room	☐ Pick up toys	☐ Make beds
☐ Do laundry/hand wash	☐ Put laundry away	☐ Water plants
☐ Dust family room	☐ Ironing	☐ Other: _____

☐ **Baths and Dressing**

Please bathe children daily at _____ A.M./P.M.

Please wash hair on: _____ with: _____.

Dress them in weather-appropriate clothing. If they attend school or programs outside the home, please pack backpacks with outerwear garments, boots, umbrellas.

☐ **Phones and Mail**

 ☐ Answer phone ☐ Take message: place messages on: _____

 ☐ Collect mail ☐ Sign for deliveries

 ☐ Collect newspaper

If caller asks for employer's work phone, _____ do/ _____ do not give work phone number.

☐ **Visitors**

 ☐ Caregiver's visitors are welcome to visit anytime.

 ☐ Caregiver's visitors are not welcome to visit unless there is an emergency.

 ☐ Caregiver's visitors are welcome, if employer is notified in advance.

In-Home Caregiver's
Job Description and Contract (continued)

☐ **Family Rules**

 ☐ TV is allowed during the following hours: _____

 ☐ TV shows allowed: _____

 ☐ Videos are allowed during the following hours: _____

 ☐ Children are not allowed to watch: _____

 ☐ Electronic games are allowed during the following hours: _____

 ☐ Homework is to be done during the following hours: _____

 ☐ Children's chores are to be done during the following hours: _____

 ☐ Children's chores:

 ☐ Children are allowed to have friends visit during the following hours: _____

 ☐ The following children will have their Emergency Forms in the Emergency Form packet: _____

 ☐ Children's friends allowed to visit:

Friend	Parent's Name	Phone	Friend	Parent's Name	Phone

 ☐ Provide snacks: _____

 ☐ Children are allowed to visit friends during the following hours: _____

 Please send Emergency Form in children's backpack.

 Friends that children are allowed to visit:

Friend	Parent's Name	Phone	Friend	Parent's Name	Phone

 ☐ Other family rules:

In-Home Caregiver's
Job Description and Contract (continued)

☐ **Medical Emergencies**

In case of a medical emergency, first call 911, and then contact parents. If hospitalization is necessary, please go to _____ at _____. Take the Emergency Forms with you! Leave a note indicating child's condition and your destination.

☐ **Disaster Preparedness**

Emergency Forms are located (near exit): _____

Emergency Forms Envelopes include:

☐ Emergency Form for each child

☐ Emergency Evacuation Note

☐ Waterproof tape

☐ Indelible ink pen

First-aid kit is located: _____

Medications are located: _____

Fire extinguishers are located: _____

Smoke alarms are located: _____

Electrical box is located: _____

Water valve is located: _____

Gas valve is located: _____

Earthquake/survival kit is located: _____

Meeting place outside: _____

Neighbor to contact in emergency: _____

Neighbor's phone and address: _____

Do fire and emergency drills with children once a month. Discuss emergency procedures with children.

☐ **In Case of Disaster**

In case of fire or disaster, go to outside meeting place listed above. Take Emergency Form package with you. Keep children calm and make sure that they do not leave in search of other people, pets, or personal belongings. Shut off water, electricity, and gas if it is safe to do so. Call 911 for help. Call parents as soon as possible. The survival kit has blankets, food, first-aid kit, and a radio. See Disaster Kit List.

Emergency evacuation location is: _____.

Select a location that would be away from natural-disaster areas, for example, high-brush areas (fire hazards), lowlands (flooding), and overhead electrical wires (earthquakes/tornadoes).

If it is necessary to evacuate, please go to the location above and wait for parent's arrival. Please post the Emergency Evacuation note on _____ indicating your destination and the condition of the children. If you need to move to another location, post another Emergency Evacuation note in a visible location indicating your new destination. Call phone numbers on the Emergency Forms to communicate with parent. The Emergency Evacuation notes are located in the same envelope as the Emergency Forms. The envelope should also have a pen and tape.

☐ **Driving Record**

 ☐ Please provide your DMV driving record.

 ☐ Please notify employer upon receipt of any moving violations within three days.

While driving children, please make sure they are buckled in seat belts or safely restrained in infant/car seat. Caregiver must also wear seat belt while driving children. Observe all DMV driving rules and regulations. Drive defensively while transporting children. Always carry Emergency Forms in vehicle.

☐ **Time Sheet**

Time sheet is located: _____

Pay days are: _____

Hourly compensation or salary is: _____

Complete W4 Form and give to employer.

Please fill in time sheet daily. Notify parent of planned absences, late arrivals, and early departure dates so that substitutes can be arranged. For emergencies and sick days, call parents as soon as possible.

☐ **Personal and Professional Expectations**

 ☐ Please refrain from doing any personal tasks (for example, personal phone calls, receiving visitors, and reading or writing that does not pertain to the children's activities) while working. Please use proper English and refrain from using profanity.

 ☐ Dress code is casual. Wear comfortable clothes in which you can play and enjoy activities with the children. Blouses and dresses, if worn, should not expose cleavage or be made of sheer fabric. For men, keep shirts on. For women, no short skirts. Hats are to be removed indoors.

 ☐ Personal hygiene is important. Please bathe daily. Clothing should be clean and wrinkle-free. Hair must be clean and groomed.

 ☐ Smoking is not allowed in the home or near the children.

☐ **Discipline**

- ☐ We use the conflict resolution method for discipline. Children are given a "cool-down" period after a conflict and then asked to find a resolution to the problem with the caregiver present. This offers a "win-win" solution to the children.

- ☐ The children are treated with respect and are likewise expected to respect others. As the caregiver, please model respect and guide the children to respect and care for each other. Teasing, hurting feelings with actions or words, and physical violence are unacceptable.

- ☐ Use 3- to 5-minute time-outs to allow children to cool off if they display inappropriate behavior. One time-out per day is acceptable. After the second time-out, child loses privileges for _____. After the third time-out, please call me at work.

Please do not strike or use any physical violence on the children.

In our home we discipline by: _____

Other: _____

☐ **Insurance:**

- ☐ Medical-insurance co.: _____

 Policy #: _____ Agent: _____

 Phone #: _____ Coverage: _____

- ☐ Auto-insurance co.: _____

 Policy #: _____ Agent: _____

 Phone #: _____ Coverage: _____

- ☐ Social Security

- ☐ Unemployment

- ☐ Disability

- ☐ Worker's Compensation

- ☐ Other: _____

In-Home Caregiver's
Job Description and Contract *(continued)*

☐ **Benefits**

 ☐ Vacation pay for _____ days after _____ months.

 ☐ Sick pay for _____ days after _____ months.

 ☐ Room: _____

 ☐ Meals: _____

 ☐ Car: _____

 ☐ Use when doing child-care related transportation

 ☐ Use when doing personal- and work-related transportation

 ☐ Gas paid by employer

 ☐ Gas paid by caregiver

☐ **Live-in Rules**

 Meals: _____

 Room: _____

 Bathroom: _____

 Car: _____

 Phone: _____

 Visitors: _____

 Off-hours living area: _____

 Noise level: _____

 Laundry: _____

 Personal housekeeping: _____

 Other: _____

I have read the above Caregiver's Job Description and Contract and agree to its terms. I will give 30 days written notice in the event that my contract should need to be terminated.

_____ _____

Date Caregiver's signature

_____ _____

Date Parent's signature

In-Home Caregiver Application Form

Personal Information

Name: _____

Maiden name or any other name used: _____

Current address: _____ City: _____ ZIP Code: _____

Home phone number: _____ Work phone number: _____

In case of emergency, person to contact: _____ Phone number: _____

Social Security #: _____ Number of dependents (optional): _____

General Information

What is your current work schedule? _____

What days and hours are you available? _____

How many years have you been a child-care provider? _____

What do you enjoy most about working with children? _____

Do you own your own car? _____ If "yes," is your car in good running condition? _____

Do you have liability insurance? _____ Insurance carrier: _____

Have you ever been convicted of a crime? _____ If "yes," please describe: _____

Educational Background

School	Name of School	City/State	Classes/Major	Degrees	Graduation	Employer's Notes (leave blank)
High						
College						
1st Aid						
Early Childhood Education						
Languages						
Sports/arts						
Other:						

Child-Care References

Name	Address	Phone	Ages	Dates	Wages	Employer's Notes (Leave Blank)

Other Employment Background

Employer	Address	Phone	Job Description	Dates	Wages	Employer's Notes (Leave Blank)

In-Home Caregiver Application Form

Questions About Your Child-Care Experience

What age range do you feel most comfortable working with? _____

Describe your usual approach to discipline: _____

What types of games and activities do you enjoy playing with children? _____

Do you have music, dancing, art, or theater experience? _____ If so, please briefly describe:_____

Do you have training in pediatric CPR and first aid? _____

Questions About Your Personal Background

Are you punctual and responsible? _____

Do you own your own home or rent? _____

Briefly describe your short-term goals: _____

What are your long-term goals? _____

Describe your family (when you were a child). How was discipline handled in your family? _____

Have you ever received traffic violations or been involved in a car accident? _____

Are you willing to be fingerprinted and submit to a background check? _____

Is there anything else you would like us to know about yourself? _____

I understand that false information can result in termination. All of the above is true to the best of my knowledge.

_____ _____

Date Signature of Applicant

In-Home Caregiver's Daily Information Form

Caregiver's name: _____

Caregiver's address: _____ City: _____ ZIP Code: _____

Our children's names and ages: _____

Where I'll be:

Place	Address	Phone	Contact	Arrival Time	Departure Time

Activities to Do While I'm Gone

☐ Read stories ☐ Bath: _____

☐ Play games ☐ Medication: _____

☐ Help with homework ☐ TV/video: _____

☐ Nap time at: _____ ☐ Other: _____

First Aid and Medication

First-aid kit is located: _____ Fire extinguisher is located: _____

Medication is located: _____ Candles/lanterns are located: _____

Meals to prepare:

Breakfast: _____

Lunch: _____

Dinner: _____

Snacks: _____

Rules:

Children's transportation and errands:

Child/Errand	Activity	Phone	Location	Drop-off time	Pick-up time

Light Housekeeping

Please do the following "checked" tasks:

☐ Wash dishes ☐ Pick up toys/clothes ☐ Other:

☐ Vacuum ☐ Laundry _____

Emergency Information

If you can't reach me at the above phone numbers, please call _____ at _____. The Emergency Form is located _____. In case Emergency Form is lost, I hereby give medical authorization to the caregiver in possession of this form to order medical attention for my children whose names are listed above.

Date

Parent's or Legal Guardian's Signature

In-Home Caregiver's Time Sheet

Month: _____ Caregiver: _____

Date	Starting Time	Completion	Breaks	Notes	Mileage	Misc.	Total Hours	Caregiver's Initials	Employer's Initials
1									
2									
3									
4									
5									
6									
7									
8									
9									
10									
11									
12									
13									
14									
15									
16									
17									
18									
19									
20									
21									
22									
23									
24									
25									
26									
27									
28									
29									
30									
31									

Day-Care Evaluation Checklist

Date:_____

Questions/Day Care	1:	2:	3:	4:
Location:				
Phone:				
Director:				
Caregiver:				
Caregiver's education:				
Maximum number of children:				
License number:				
Age range:				
Number who are ___ yrs:				
Philosophy:				
Religious profile:				
Hours:				
Facility size:				
Late pick-up fee:				
Openings:				
Tuition:				
Enrollment fee:				
Insurance fee:				
Field-trip fees:				
Parent volunteer:				
Infant care:				
Toddler care:				
After-school care:				
Transportation:				
Sick care:				
Make-up policy:				
Meals:				
Discipline policy:				
OBSERVATION				
Attitude:				
Children's behavior/disposition:				
Cleanliness:				
Atmosphere:				
References:				
Other:				

Chapter 7

School Days

Once you've made all those child-care decisions and everybody's happy with the setup, your little baby grows up and turns five. Even though you remember when she was still in diapers, now you have a new hurdle to overcome: decisions about schools. Some parents choose to send their children to the local public school, while others select from a variety of private schools. Others consider home schooling an option.

Make an Educated Choice: Selecting Your Child's School

Regardless of where your child is educated, you'll want to keep communication open between yourself and your child's teacher. And after you've selected a school, you then have to find a way to transport your child to and from school and after-school activities. Use your resources and organize a carpool.

Visit the Public School

Public education in the United States is changing under state and federal pressure. Voucher initiatives indicate the general dismay with the public schools' low academic standards. Many parents have banded together to

create better public schools for their children. You may need to seek out good schools within your district, but most families *can* find classrooms where their children will do well, even if financial constraints or working schedules dictate a public school education.

Your school-district office can tell you what school your children will attend. If this school is not acceptable, ask about the process of intraschool transfers. Some districts make it very difficult to transfer to other schools, while others require only a written request form and a signature. You should also inquire about the district's teacher-request policy. Many schools will not allow parents to request a specific teacher or teachers, unless the child has learning or emotional disabilities.

Call the schools to find out when visitors are invited to observe. Some schools open their doors to the public only during scheduled "open houses," while others allow you to roam around their campuses anytime, once you have received permission from the school office.

Ask to review the school's handbooks and curriculum guidelines. Public schools are generally required to follow the curricula mandated by the state for that grade and refer parents to the standard curriculum guides. If you are new to the area or are just starting your child in school, you should inquire into which schools and/or teachers are most successful at meeting or exceeding these guidelines. Review the textbooks and workbooks used in the classrooms.

Get a current school calendar to see how many field trips, seminars, and guest speakers are scheduled during the school year. Inquire about extracurricular activities such as art, music, physical education, and theater.

Look into Private Schools

If you have the financial means to send your child to a private school, get a list of private schools in your area by calling the County Superintendent or checking the Yellow Pages. Call the schools and request application packets.

The application packets include information about the school's educational philosophy, curriculum, extracurricular activities, location, and tuition. Many private schools are parochial schools (affiliated with a specific church or religion). Smaller schools have a wide variety of educational philosophies and curricula.

Arrange a tour through the school and observe every class offered in your child's grade. A school may have a great philosophy, but each teacher implements the curriculum with his or her own style. You may want to take notes as you observe each classroom. Indicate which teachers you like best and why. Look at the children in the class. Are they engaged and enjoying the subject or project?

Request a list of parent references. Call them and inquire about the academic standards and quality of education at the school. Ask questions about any concerns you may have.

Since private schools are funded primarily by tuition and donations, ask about other fees you may be required to pay, for example, for field trips, camp outs, seminars, materials, uniforms, or after-school sports. Does the school expect cash donations in addition to tuition and other expenses? These extra costs can quickly add up. Be sure that you can afford the tuition and all the other miscellaneous expenses before you enroll your child.

Investigate Independent-Study Programs or At-Home Schooling

Independent-study programs, or "home schools," are popping up all over the United States. They are a form of home-schooling because the children are educated in their own homes by their parents. Many parents select home-schooling for religious reasons. Other people home-school in order to let their children receive a more personalized education.

The main difference between home-schooling and independent-study programs is that children are enrolled in an independent-study program through the public school system. They have an assigned teacher with whom they meet once a month. The teacher is responsible for making sure that the child is meeting the district's or state's curriculum standards. He or she collects samples of the child's work and completes paperwork as if the child were in a regular classroom.

For home-schooled children in the primary grades, the parent is usually the educator. The educational program varies from family to family. In some home-schools, children learn essentially from "real-life experiences"; others prefer a strong academic curriculum. Older children and teenagers complete assignments on their own. Some programs are designed to offer an alternative to the regular classroom for children who don't function well in the structured school situations.

Independent-study programs receive A.D.A. (average daily attendance) funds for children enrolled. Parents receive textbooks, workbooks, paper, pencils, and kits. They also have access to school libraries and other public-school resources. Most independent-study programs promote socialization by offering group seminars and classes for the students. Field trips, science projects, and art classes might also be offered.

Home-schooling and independent-study programs are not for everyone. At least one parent needs to stay at home to teach and supervise the children. Parents who work out of the home can hire tutors or join forces with other families, but this significantly increases costs. In any home-schooling project, there are generally curriculum and/or accreditation requirements that the program must meet that are set by the state.

Both home-schooling and independent-study programs take time, creativity, effort, and dedication from parents and children in order to succeed in the goal of providing a quality education. See "School-Evaluation Checklist" (page 159) and "Independent-Studies-Evaluation Checklist" (page 160).

Get Involved: Go to School

Parents who are active in their children's education improve their children's academic performance. It's no longer acceptable, as it was in the sixties, to leave the educating solely to the teachers. In order to ensure that your child gets a good education, you need to know what is going on in the classroom and to understand your child's strengths and weaknesses.

Review your children's schedule and classroom and school rules to give them a sense of security as they start a new school year.

If your child is having problems, or has special needs, you may also need to get outside, private services, such as private tutoring. A tutor can help the child on specific academic weaknesses. Consistent private tutorial sessions can many times boost a child's academic performance. If your child is accelerated, look into accelerated or enrichment programs to stimulate her.

It is important to stay in contact with the teacher to let her know of your concerns. If you're supposed to write notes, call, or stop by, make sure you follow through with your end of the agreement. In many instances, if a teacher feels that there is no support at home, she will "give up" on the *parent* (good teachers never give up on a child). Also, a child having continual behavior problems often falls behind academically. Reversing a problem at that point can be a monumental task.

A teacher should be informed of any changes in your family living situation that could affect your child's performance in school. The teacher is a professional. Tension at home, even if you're not fighting and arguing in front of the children, causes stress for the whole family. Children are intuitive and aware of family problems. They may be worried about their security, even though they don't verbalize it. Daydreaming and lethargy are common behavioral patterns. Children may become extra sensitive or defensive. If the teachers are aware of problems at home, they can be tuned in to your child's needs and help to relieve stresses that your child may not be comfortable resolving at home.

Become a Parent Volunteer

The best way to find out what is going on in the classroom is to be in the classroom. It's hard to tell by just popping your head in as you drop your children off in the morning or pick them up after school, when the teacher is dealing with mobs of children and parents. See "Find Out What Really Happens" on page 130.

Drive on Field Trips

Although this won't give you the classroom dynamics that you might get by helping in the classroom, driving the children on field trips will also give you insight into the social aspects of the class dynamics. While you drive, children forget you're there and interact in their usual manner.

Work on Special Projects

Ask to see the curriculum for the school year and try to select a special project you would like to do with the children. If you have expertise in a subject that would be interesting, offer to share it with the class. One friend of mine, an occupational therapist, went to her son's class and showed the children how she trains accident victims to walk again. If you can, share a special art project or slide show before the holidays. Select a project that relates to the children's studies. Check educational-supply stores for ready-made kits and games for geography, social studies, or science.

Teachers and children alike love treats. You can bring goodies as well as ethnic or holiday traditional meals to the class for educational and social purposes after you check with the teacher.

Handle the Parent-Teacher Conference with Aplomb

Most elementary schools have two parent-teacher conferences during the school year: one in the fall and another in the spring. The purpose of a parent-teacher conference is to inform parents about their child's academic, developmental, and behavioral skills and any weaknesses the child may have. Usually, the meetings are approximately 20-30 minutes in length.

The parent-teacher conference is a good time to give the teacher feedback on how your child likes the class, and to mention any problems you might have observed. To this end, it is a good idea to fill out the "Parent-Teacher Conference Worksheet" (page 161). Ask your child to help you with it, because his input is important. Bring this with you to the conference, so you will remember what you wanted to discuss with the teacher.

How to Schedule After-School Activities Efficiently

When children reach school age, they start developing independence. On one hand, you look forward to their independence, but all the same, most parents are not sure if and when their kids can handle the responsibilities that come with independence. Children enjoy looking forward to activities that take place after school. Preteens and teenagers need after-school activities to keep their minds and bodies moving. Children and teenagers who are left alone without scheduled activities often get involved with less desirable peers or become prematurely sexually active.

Choose a Sports Program

For children in the elementary grades, there are lots of sports-activity options: soccer, baseball, basketball, and softball. Middle-school and junior-high

grades tend to offer fewer after-school sports. High schools offer competitive sports for those with the good fortune to have natural sports abilities.

Signing up your child for a sports program gives him an opportunity to improve coordination skills, build cardiovascular breathing, and learn teamwork. Particularly in the middle-elementary ages (8-11), sports are also important social acclimators: They teach kids *rules*, and the importance of "playing by the rules."

Find Art, Music, Dance, and Theater Programs

The fine arts—dance, music, art, and theater—give children an opportunity to explore their creative and movement talents. Many schools have had to cut back or limit their art, dance, music, and theater programs; many have had their funding eliminated for these programs.

Nonetheless, arts-and-crafts training and the development of artistic skills are important for any child. Even if your child's school is lacking in arts programs, other sources are often available. In many communities, parks and recreation departments offer reasonably priced classes at public facilities, such as schools. These classes generally run for four to eight weeks at a stretch, giving the children an opportunity, if they want, to try lots of different arts and crafts. Many private companies or individuals offer classes that continue for semesters or even the entire school year and beyond, and private instruction is generally also available for children who are serious and who would like to develop skills in a particular area.

Look into Extracurricular Academic Programs

There are after-school programs designed to meet the needs of children who need to complete homework assignments, build academic skills, or add enrichment knowledge. Check with your school, day-care facilities, and private after-school programs for more information about what is available in your area.

Going Places: Setting Up Carpools

If you're like most parents, when you first bring that precious baby into the world, you plan on being with her and taking her everywhere. Generally, this excitement wears off after a few years of driving from lesson to lesson, practice to practice, and game to game, and you start to see the benefits of sharing transportation obligations with other parents. Carpools relieve parents from the "children's-taxi" nightmare that otherwise consumes a parent's afternoons and weekends, day after day, month after month, year after year.

Additionally, carpooling saves time, energy, and money. A parent involved in Monday through Friday carpools with five drivers will drive only two times out of ten. That saves eight trips to the school for each parent.

Organizing carpools takes patience and creativity. Some kids may be part of the morning carpool but may belong to a different carpool in the afternoon because of after-school activities. The easiest carpool to organize involves children going to the same school and after-school programs. It makes school holidays and half-days easier to coordinate.

After the families involved in the carpool have agreed to it, write down each child's name, pick-up time, and location on the Carpool Schedule. You should always fill out any carpool schedule in pencil—you'll be doing lots of erasing as you rearrange the schedule. Ask the various carpool drivers for the days they prefer (or any days they can't be involved), and then you can start to figure out how often and on which days each person will be driving.

Be careful to make the carpool schedule fair for all drivers. In the beginning, everybody is usually just relieved to be part of a carpool, but as time goes on, if the driving isn't equally divvied up, some drivers may become resentful. After the kids' names are entered on the Carpool Schedule, prioritize kids according to how many days per week they are in the carpool. Divvy up the driving according to how often the driver's child is in the carpool.

If you have five children and ten carpool trips per week (both morning and afternoon), each parent drives twice. With four kids and ten carpool trips per week (Monday to Friday: morning and afternoon), you could have each driver drive two times per week with the Friday morning and afternoon pick-up rotating among all four parents during the month. For example, Driver #1 drives on her regular schedule but also drives on the first Friday morning. Driver #2 does the same, but only she'll also drive on the first Friday afternoon. Driver #3 drives the second Friday morning and Driver #4 drives the second Friday afternoon. Then the schedule will start over again with Driver #1 driving on the third Friday morning, and so forth. Another option is to have one driver cover the odd day for a whole month and then the next driver take the odd day for the following month. This would be difficult for the driver for one month but be less confusing and easier to schedule. It may help avoid embarrassing calls asking about those four children stranded at school.

After you work out the logistics and come up with a schedule that pleases everyone, make a master copy and provide copies for all the drivers. They may want to make extra copies for their home (on the fridge), at the office, and in the car.

Establish a Carpool Schedule

The "Carpool Schedule" form (page 162) is designed to organize three different types of carpools: morning pick-up, afternoon pick-up, and afternoon drop-off.

MORNING PICK-UP SCHEDULE Use the Morning Pick-up Schedule to organize carpools that pick up children at their homes or day-care facilities and take them to school. If a family lives considerably off the path to the school, you may need to plan for them to meet the carpool driver somewhere along the route.

AFTERNOON PICK-UP SCHEDULE This is for carpools that pick up children after school from one or more locations and then drop them off at a single location (for example, soccer practice). You need to consider the closing time for each child's school and set a driving path that accommodates both the children's schedule and a straightforward route. This can mean that some children may have to wait a few minutes before they are picked up and, depending on the child's age, supervising him during this time gap may have to be arranged with the child's teacher or yard-duty person. Most schools allow a 15-minute grace period for children to be picked up, while others offer after-school programs that your child can attend while waiting for the carpool driver.

AFTERNOON DROP-OFF SCHEDULE Carpools that pick up kids from one school and drop the kids off at various locations (their homes) should use this form. This is an easy schedule to arrange since you'll be dealing with one school. If the children are in different grades, they may have a staggered release time. In this case, the driver can either arrive at the time the last child is released from class (most convenient for driver) or the driver can plan to arrive at the time the first child is released from class (if the child is young or if there is danger associated with leaving a child unattended).

Be Flexible

Once your schedule is set and you're ready to start carpooling, be prepared for scheduling problems. As you know, with children, schedules are tenuous at best. Children get sick, parents get sick, parents get tied up in meetings, cars get sick, and schools have half-days and holidays. Trying to hold to the "schedule" may create unnecessary anxiety for the drivers. Trade driving days to help other drivers when they get in a pinch so you can ask for driving favors when you need them.

If your child is sick and you can't drive one morning, ask one of the other drivers to take your shift and then reciprocate on another day. When your child is sick, you shouldn't be expected to drive. If you know about appointments or meetings in advance, work out the schedule in advance to make it convenient for the other drivers to change their schedules too. If you have a tight schedule and can't add carpool days but need a driver to fill in for you, offer a gift of chocolates, flowers, or something to make up for your absence. This makes for good relations and mutual respect among carpool drivers.

Consider Your Carpool Drivers

While setting up your carpool, consider the drivers' abilities to drive safely and the condition of their vehicles. Although most parents will drive cautiously when they are driving other children, some drivers should not drive

in carpools. Obviously, drivers with alcohol or drug problems are not good possibilities, but drivers with emotional problems, either personal or marital, can also pose an unsafe risk. If you are aware of their personal problems, be a supportive friend, but don't subject your children to a carpool with drivers under excessive stress. Emotional issues may distract them, causing them to drive offensively, not defensively.

You should also consider what condition the drivers' cars are in when organizing carpools. Dependable cars are important in carpools. The cars must have enough seat belts for *all* the children in the carpool. Children should never double up in seat belts. Older cars may be unreliable. If a driver has an older car, verify that the car is properly maintained. Drivers should check brakes twice a year, get tune-ups once a year, change oil every 4,000 miles, and get a safety inspection every 7,500 miles.

Discuss whether alternate drivers (drivers other than those already in the carpool) or only carpool drivers should drive in place of a scheduled driver in the event that she can't drive one day. Some carpools trade only between designated drivers, while other carpools include spouses or relatives as alternates. If you decide to allow alternate drivers, all parents and children need to know who they are.

Ask each driver to fill out the "Carpool-Driver Information" form (page 163). Alternate drivers for each family should also fill out the form. All drivers must have car insurance with good coverage. Let your insurance company know about your carpool; you may be eligible for a carpool discount.

The drivers' driving records are important. You wouldn't want a driver notorious for getting speeding tickets or convicted for driving under the influence of alcohol or drugs driving your children. The drivers will fill in the information about their driving record on the form. If you have suspicions, ask the drivers to get a DMV printout of their driving record. There is a nominal fee of approximately $5.

After the Carpool-Driver Information form is completed by all drivers, make copies for each driver, along with copies of the Carpool Schedule. Put the Carpool Schedule, Carpool-Driver Information form, and Emergency Forms for each child into a large manila envelope labeled CARPOOL EMERGENCY FORMS in large letters. Drivers should place these packets inside the glove box of each car used for carpooling. This packet of information may be a lifesaver. It has the medical information and parent phone numbers for each child, insurance information, and carpool schedule.

Investing in the Future: Selecting a College

Time has a way of creeping up on you—and children have a way of growing up faster than you thought possible. Suddenly, you have a high school student who's thinking about college.

Meet with the High School Guidance Counselor

High school freshmen should meet with their school counselors to determine the minimum grade-point average (GPA), subject requirements, minimum SAT scores, number of community service hours, and types of extracurricular activities that are recommended for admission into the colleges or universities of their choice. By looking at their goals at the beginning of their high school years, they have the opportunity to make sure that their GPA and extracurricular activities are up to par before it's too late. Many high schools have different tracks available for students who are university bound versus those who have vocational objectives, or those whose formal education will end with high school graduation. It's a good idea for students to fully understand their options and goals so they can chart their academic future.

Prepare for the SATs

In tenth grade, your child will be given the Preliminary Scholastic Aptitude Test (PSAT). This is the qualifying exam for National Merit Awards and Scholarships. The PSAT also helps students prepare for the Scholastic Aptitude Test (SAT), given in eleventh grade.

This test is required for entrance into most universities. If your child needs help in improving test-taking skills, check your local bookstores for SAT preparatory books. These preparation guides offer hints on test-taking skills, review the material that your child will be tested on, and most important, contain several practice exams. By taking the practice exams, the student becomes familiar with the subjects, questions, and testing style of the SAT. Answers to the questions are included at the end of the book so your child can see how she scored. In addition, several educational consulting and tutorial businesses specialize in preparing college-bound students for the exam. Many high schools offer their own SAT-preparation courses, usually before or after regular school hours.

Visit College and University Campuses

When your child is a junior, schedule trips to visit colleges. It is best to visit the campuses while classes are in session. Your child can see classrooms, lecture halls, science labs, dormitories, dining halls, sports facilities, libraries, and so forth, and can meet and talk to students and professors as you tour the campuses. Visit the division offices to get information about programs of interest. Attend a lecture in your child's area of study. This experience will give your child the opportunity to make the best educated decision about the right college or university for her or him.

Apply to Colleges in a Timely Fashion

Colleges have different admission deadlines. It is vital that you check the deadlines on application forms. If you miss application deadlines, your child may have to wait a quarter, semester, or even a year to reapply. Your

child will need to complete the application form, personal statement, and include her SAT scores, Social Security number, and application fee. Upon acceptance, the official transcripts, SAT test scores, and letters of recommendation will be requested. It is also important to apply to several universities to ensure admission.

Put Together a Portfolio

Most colleges admit students based on their grade-point average, advanced-placement (AP) courses, and SAT scores. Active community-service histories, leadership, and awards also play an important part. By putting together a portfolio of awards and certificates for your child, you'll have them at your fingertips when it's time to make copies for admission. It will bolster your child's self-esteem as he or she pores over all of his or her accomplishments. Starting in ninth grade, request letters of recommendation from teachers and employers. Having letters of recommendation over a span of three to four years shows that your child was involved throughout his or her high school years—not just while sending in college applications.

Write a Cover Letter

All college applications should include a well-written cover letter from the applicant. This shows professional flair and personal interest. Your child should include the reasons why he or she selected the university as well as his or her strengths and goals. Many universities require a personal statement (essay) with the application form. This essay should include special interests that make your child stand out.

Apply for Scholarships and Financial Aid

A good portfolio will really pay off when your child applies for an academic scholarship or financial aid. Scholarships are gift aid; the student doesn't need to pay back the funds received. Consult with your high school counselor, scholarship department, or librarian to determine if there are scholarships available to meet your needs. Scholarships vary greatly: Some provide funds to students in a specific academic area, while others may be more general. Apply for the FAFSA (Free Application Federal Student Aid) between January 1 and March 20 to receive funds for September of that same year. Talk to your child's high school counselor about scholarships and financial aid available.

Send for Transcripts

All universities require high school transcripts (upon graduation) to determine the student's GPA and to confirm the subject requirements. Contact your child's high school to order the transcripts and pay the fees. Most universities require sealed transcripts sent directly from the high school to the university. Allow at least two to four weeks.

Summing Up

Selecting your child's school, like selecting day care, takes a little time, research, and observation. Set up a good form of communication from the onset to ensure your child's success in the classroom. Get involved with your child's school activities to improve your child's academic performance. Organize a carpool to minimize your driving time to and from school and after-school activities.

School Organizers

School-Evaluation Checklist
Independent-Studies Evaluation Checklist
Parent-Teacher Conference Worksheet
Carpool Schedule
Carpool-Driver Information
College/University-Entrance Personal Portfolio
College-Evaluation Checklist

School-Evaluation Checklist

Date:_____

Questions/Schools	1:	2:	3:	4:
Location:				
Phone:				
Principal/administrator:				
Class size:				
Philosophy:				
School test scores:				
Learning disability programs:				
Accelerated-learner programs:				
Religious profile:				
Uniforms required:				
Hours:				
Open house or observ. dates:				
Before-school hours and fees:				
After-school hours and fees:				
Openings:				
Tuition:				
Enrollment fee:				
Insurance fee:				
Field-trip fees:				
Other fees:				
Uniform costs:				
Mandatory donations:				
Parent volunteer:				
Teachers' credentials:				
Transportation:				
Snacks/lunches:				
Discipline policy:				
Facility size:				
# of violent incidents:				
# of drug incidents:				
# of weapons found on campus:				
# of sex-offense charges:				
After-school programs:				
Parent references:				
Other:				

Date:_____ Independent-Studies Evaluation Checklist				
Questions/ Independent-Studies Programs	1:	2:	3:	4:
Location:				
Phone:				
Director:				
Grade levels:				
Philosophy:				
School test scores:				
Learning disability teachers:				
Accelerated-program teachers:				
Religious profile:				
Accreditation:				
Student requirements:				
Parent requirements:				
# Hours/days to complete work:				
Facility hours:				
Monthly meeting with teacher:				
Open house or observ. dates:				
Openings:				
Field-trip fees:				
Other fees:				
Teachers' credentials:				
Facility size:				
Library:				
Resource center:				
Art center:				
Science lab:				
Language lab:				
Seminars:				
Field trip with other students:				
Materials available for students:				
Texts and workbooks available:				
Parent references:				
Other:				

Parent-Teacher Conference Worksheet for: _____

1. What does my child like about school?

2. Which subjects does my child like and why? (Please explain): _____

3. What subjects does my child dislike and why? (Please explain): _____

4. What does my child tell me about school?

5. We have homework trouble when . . .

6. My child is involved in the following sports/hobbies:

7. Describe my child's typical weekday schedule:

8. My child's typical weekend schedule is:

9. Do I have any concerns I would like to share with the teacher?

Carpool Schedule

Morning Pick-up Schedule

Children picked up at various locations and dropped off at one location.

Drop-off Location:_____
Drop-off Time:

Sunday	Monday	Tuesday	Wednesday	Thursday	Friday	Saturday
Driver:	Driver:	Driver:	Driver:	Driver:	Driver:	Driver:
P/U Time: Name: P/U Loc:	P/U Time: Name: P/U Loc:	P/U Time: Name: P/U Loc:	P/U Time: Name: P/U Loc:	P/U Time: Name: P/U Loc:	P/U Time: Name: P/U Loc:	P/U Time: Name: P/U Loc:
P/U Time: Name: P/U Loc:	P/U Time: Name: P/U Loc:	P/U Time: Name: P/U Loc:	P/U Time: Name: P/U Loc:	P/U Time: Name: P/U Loc:	P/U Time: Name: P/U Loc:	P/U Time: Name: P/U Loc:
P/U Time: Name: P/U Loc:	P/U Time: Name: P/U Loc:	P/U Time: Name: P/U Loc:	P/U Time: Name: P/U Loc:	P/U Time: Name: P/U Loc:	P/U Time: Name: P/U Loc:	P/U Time: Name: P/U Loc:
P/U Time: Name: P/U Loc:	P/U Time: Name: P/U Loc:	P/U Time: Name: P/U Loc:	P/U Time: Name: P/U Loc:	P/U Time: Name: P/U Loc:	P/U Time: Name: P/U Loc:	P/U Time: Name: P/U Loc:

Afternoon Pick-up Schedule

Children picked up at various locations and dropped off at one location.

Drop-off Location:_____
Drop-off Time:

Sunday	Monday	Tuesday	Wednesday	Thursday	Friday	Saturday
Driver:	Driver:	Driver:	Driver:	Driver:	Driver:	Driver:
P/U Time: Name: P/U Loc:	P/U Time: Name: P/U Loc:	P/U Time: Name: P/U Loc:	P/U Time: Name: P/U Loc:	P/U Time: Name: P/U Loc:	P/U Time: Name: P/U Loc:	P/U Time: Name: P/U Loc:
P/U Time: Name: P/U Loc:	P/U Time: Name: P/U Loc:	P/U Time: Name: P/U Loc:	P/U Time: Name: P/U Loc:	P/U Time: Name: P/U Loc:	P/U Time: Name: P/U Loc:	P/U Time: Name: P/U Loc:
P/U Time: Name: P/U Loc:	P/U Time: Name: P/U Loc:	P/U Time: Name: P/U Loc:	P/U Time: Name: P/U Loc:	P/U Time: Name: P/U Loc:	P/U Time: Name: P/U Loc:	P/U Time: Name: P/U Loc:
P/U Time: Name: P/U Loc:	P/U Time: Name: P/U Loc:	P/U Time: Name: P/U Loc:	P/U Time: Name: P/U Loc:	P/U Time: Name: P/U Loc:	P/U Time: Name: P/U Loc:	P/U Time: Name: P/U Loc:

Afternoon Drop-off Schedule

Children picked up at one location and dropped off at various locations.

Pick-up Location:_____
Pick-up Time:

Sunday	Monday	Tuesday	Wednesday	Thursday	Friday	Saturday
Driver:	Driver:	Driver:	Driver:	Driver:	Driver:	Driver:
D/O Time: Name: D/O Loc:	D/O Time: Name: D/O Loc:	D/O Time: Name: D/O Loc:	D/O Time: Name: D/O Loc:	D/O Time: Name: D/O Loc:	D/O Time: Name: D/O Loc:	D/O Time: Name: D/O Loc:
D/O Time: Name: D/O Loc:	D/O Time: Name: D/O Loc:	D/O Time: Name: D/O Loc:	D/O Time: Name: D/O Loc:	D/O Time: Name: D/O Loc:	D/O Time: Name: D/O Loc:	D/O Time: Name: D/O Loc:
D/O Time: Name: D/O Loc:	D/O Time: Name: D/O Loc:	D/O Time: Name: D/O Loc:	D/O Time: Name: D/O Loc:	D/O Time: Name: D/O Loc:	D/O Time: Name: D/O Loc:	D/O Time: Name: D/O Loc:
D/O Time: Name: D/O Loc:	D/O Time: Name: D/O Loc:	D/O Time: Name: D/O Loc:	D/O Time: Name: D/O Loc:	D/O Time: Name: D/O Loc:	D/O Time: Name: D/O Loc:	D/O Time: Name: D/O Loc:

Carpool-Driver Information

Name: _____ Alternate driver/relationship: _____

Address: _____ City: _____ ZIP Code: _____

Home phone: _____ Work phone: _____

Driver's license number: _____ Vehicle make/model: _____

Vehicle regis. number: _____ Insurance carrier/policy number: _____

Moving violations (past 3 years): _____

Name: _____ Alternate driver/relationship: _____

Address: _____ City: _____ ZIP Code: _____

Home phone: _____ Work phone: _____

Driver's license number: _____ Vehicle make/model: _____

Vehicle regis. number: _____ Insurance carrier/policy number: _____

Moving violations (past 3 years): _____

Name: _____ Alternate driver/relationship: _____

Address: _____ City: _____ ZIP Code: _____

Home phone: _____ Work phone: _____

Driver's license number: _____ Vehicle make/model: _____

Vehicle regis. number: _____ Insurance carrier/policy number: _____

Moving violations (past 3 years): _____

Name: _____ Alternate driver/relationship: _____

Address: _____ City: _____ ZIP Code: _____

Home phone: _____ Work phone: _____

Driver's license number: _____ Vehicle make/model: _____

Vehicle regis. number: _____ Insurance carrier/policy number: _____

Moving violations (past 3 years): _____

We are in a carpool to help conserve energy and time. I have completed the Emergency Form for my child and it is attached to this Carpool-Driver Information form. I hereby give power of attorney to the drivers listed above, to seek medical attention for my child named below:

_____ _____ _____
Child's Name Parent/Guardian's Signature Date

_____ _____ _____
Child's Name Parent/Guardian's Signature Date

_____ _____ _____
Child's Name Parent/Guardian's Signature Date

_____ _____ _____
Child's Name Parent/Guardian's Signature Date

College/University-Entrance Personal Portfolio

Description	#1:	#2:	#3:
Application form			
Cover letter			
Transcripts			
Letter of recommendation #1			
Letter of recommendation #2			
Letter of recommendation #3			
Awards			
Certificates			
Articles written about student			
SAT application			
SAT test			
SAT test results			
Application fees			
Date application sent			
Response			
Scholarship application			
Financial-aid application			
Grant application			

College-Evaluation Checklist

Description	1	2	3
College/university			
Address			
Phone			
Tuition			
Scholarships			
Quarter/semester			
Requirements			
Emphasis			
Campus			
Dorm fees			
Meal service fees			
Fraternity/sorority			
Dormitories			
Bathrooms			
Transportation			
Parking permits			
Sports			
Activities			

Notes

Chapter 8

When School Is Out

Now that your child is in school and you've overcome the monstrous ordeal of selecting the best school for your child, school closes for vacation. What do you do? Whether it's winter, spring, or summer vacation, school's out and you have to work. Don't spin your wheels; check your options and plan ahead. Your children's vacation may be a great opportunity to set up visits to grandparents or to enroll them in specialized programs that your children couldn't participate in during the regular school session. Keep your chin up—school vacations can offer your children enriching experiences.

Planning for School Closures

Most schools, both private and public, have school calendars. This keeps parents informed about teacher in-service work days, half-days, school holidays, legal holidays, and vacation dates. As soon as you get your child's school calendar, enter the dates in your appointment book or personal calendar.

If the school doesn't release the calendar soon enough and you need to make plans, call the school office to request the pending calendar.

Take Time Off from Work

The most natural solution to school vacations is to take time off from work. Those who work part time or whose jobs have flexible hours may be able to request several weeks of vacation time. In some work situations, the first person who asks for specific dates gets the preferred time off. Your employer will be more likely to give you vacation leave if you make the request months in advance.

Work at Home

Telecommuting has become a viable alternative for many professionals. By using the telephone, many parents are able to work at home when their children are ill or during school holidays and vacations. With sophisticated computer networks, e-mail, and the Internet, in many instances, employees can be just as productive in their home as they are in the corporate office. Even though you may prefer to work at the office, consider setting up the option to telecommute on those days when child care is a problem for you. Discuss this with your supervisor and/or your employer and set it up before you need it.

Share Child Care with Your Spouse or a Friend

Plan to take your vacations during school holidays and vacations. Share child care with your spouse, friends, or other families. If you take off the first two weeks from work and your spouse or friend takes the next two weeks, your children are covered for four weeks. Similarly for school holidays, alternate supervision of your children among several families. This will save you hundreds of dollars in recreational tuition.

Send the Children to Visit Relatives

With the busy schedules people face today, grandparents and relatives are often left out of the daily routines of their grandchildren. School vacations offer kids an opportunity to spend quality time with relatives they don't often see. This works especially well when your relatives live in town so the children can go home each night. For relatives who live out of town, it's nice to send the children to visit for a week or up to four weeks, depending upon the children's ages. Staying with cousins who are the same ages as your children will make the visits entertaining and fun.

School's Out: Arrange Your Child's Summer Program

You may be able to cover school holidays, occasional in-service days, or snow days by using your own vacation time or by sharing care. However, planning for an entire summer vacation—usually around ten or eleven weeks—presents a far greater challenge.

Take Advantage of City or County Recreation Programs

Many city and county recreation programs offer classes and day care during the holidays and summer vacations. These have become very popular because of their wide variety of classes and programs and affordable prices. There are specialty classes where your child can learn ballet, watercolor painting, wood shop, or karate, and there are day-camp programs where your child can arrive at 8:00 A.M. and stay until 6:00 P.M.

If you're looking for a summer or holiday program through your local city or county recreation departments, get started right away. Call to request a schedule of classes and program for the upcoming season. If you're not already on the mailing list (most city or county residents are usually on a mailing list), request to be put on the list so that you don't miss out. See the "Summer-Program Selection Worksheet" (page 174). Most programs have a registration day when parents sign up their children for summer classes or programs. Inquire about the registration process. Many programs fill up so quickly that parents wait in lines hours before or even camp out overnight to ensure that their children get into the programs of their choice.

Explore Private Day Camps

If you're not happy with the programs available in your area, private day camps may be your answer. Although they may fill up quickly, you certainly won't have to camp overnight to get a space. There are private day camps that specialize in various activities, such as kayaking, horseback riding, sports, dieting, theater, computers, science, or academics. Other camps are run by various organizations, such as the Scouts, or cultural or religious organizations. They usually operate Monday through Friday. Private day camps may not operate during your child's entire vacation period. Request brochures so that you have each camp's schedule and fully understand its focus.

Consider Private Residential Camps

Children ages eight and up often enjoy "sleep-away camp" or residential camps. Although tuition is pricey, the kids get the opportunity to be away from home and meet new friends. Residential camps, like private day camps, operate with a theme. There are camps that specialize in horseback riding, baseball, soccer, basketball, canoeing, fishing, swimming, archery, science, survival, dieting, theater, computers—you name it, there's a camp for everyone. Residential camps are open for as short as a weekend and as long as eight or nine weeks.

Plan Transportation to Your Child's Program

Unless your child attends his or her regular school's vacation program, your child's transportation needs will change. Get the names and phone numbers of other children attending the same summer program and who live in your area, to set up a carpool. If you need to start work at the regular time but

can leave a little early, you may find a family that is willing to take the kids to the program in the morning so you can pick them up in the afternoon. See "Going Places: Setting Up Carpools" (page 152). You may need to arrange your work hours to accommodate the new routine. Put in a request as soon as you work out your family's schedule. If you get in a bind, check into the children's taxi services in your area. Many areas have services that will pick up your children at home and deliver them to their destination for an affordable fee. For a regular pick-up schedule, most companies offer a discount.

Juggle Multiple Programs

Most summer vacations last about ten weeks. This can be a long time for kids to be at home or in an all-day program. The ideal program for your child may not take place at the ideal time for you, or it may be only a one- or two-hour class. You may need to select several classes or activities to fill your child's day. Use the "Vacation-Schedule Worksheet" (page 175) to help organize your child's daily activities and transportation. Hire a caregiver who can stay with your child at home a few days per week and transport your child to activities on the other days. See "Making Choices: An In-Home Caregiver" (page 115).

Once you've juggled your children's schedules so that all of their needs are met during school holidays, fill out the Vacation-Schedule Worksheet. List daily activities for each child. Include the time it starts and ends, the program, location, phone, operating hours, transportation, and fees. Indicate how the children will get to and from each activity and whether or not the fees have been prepaid.

Post the Vacation-Schedule Worksheet where the children and/or the caregiver can refer to it. Leave directions and fees in an envelope when necessary.

Take Care of Paperwork

Once you've selected the best program for your children, get organized. Fill out the application and registration forms, medical-history forms, and field trip release forms. Many city and county programs require proof of residency. In order to minimize your running around, call the programs to find out exactly what is required for enrollment. Some sports teams require birth certificates to prove the child's age; other programs require proof of residency in a certain area, which requires a copy of your electric or water bill or something similar.

Once you've collected all the necessary information, make copies of the originals and store them in a safe place. Keep extra sets of the originals available in a file for future use. Mail the registration form and call a few days later to confirm receipt of the packet. For in-person registration, set your alarm and *be prepared*. It's common to hear about parents lining up at 3:00 A.M. the day before the registration day to be sure of getting their chil-

dren into the programs they want. Take turns with other parents to wait in line (you do it this year and they do it next year), or send someone in your place for a small fee. Many people make a social event out of it, bringing lounge chairs, hot chocolate or coffee, playing cards, lanterns, or a good book.

Set Up Your Own Summer Program

If, after all your searching, you can't find a program that suits your family's needs, start your own program. Those who are intrigued but intimidated by starting their own day-care business or private schools may be more inclined to do a special limited program for the duration of the summer break.

Select a theme for the summer and lay out your daily activities. Children enjoy theater productions, poetry, arts and crafts, and sports. Include academics: reading book club, journal writing, poetry, creative writing, math games, and computer learning games. Once you select your theme, lay out activities. It's best to organize the day in time increments. See the "Setting Up Your Summer Program" worksheet (page 176). Here's a sample program:

Juliette's Summer Program

9:00 – 10:00 A.M.	Silent Reading
10:00 – 11:00 A.M.	Arts and Crafts
11:00 – 11:15 A.M.	Snacks
11:15 – 12:00 Noon	Math Games
12:00 – 1:00 P.M.	Lunch
1:00 – 3:00 P.M.	Theater
3:00 – 5:00 P.M.	Sports

* Fridays: All-Day Field Trips

Field trips can include amusement parks, museums (art, science, history), zoos, beaches or lakes, and so forth. By setting up the program yourself, you're setting up an ideal program for your children.

After you've filled out the activities and time increments portion of the worksheet, add information about transportation, field trips, and materials needed and their related costs. Complete a Setting Up Your Summer Program worksheet for every day of your program. Add all of the "Total Activity Cost/Day" figures to get the "Total Activities Cost" for your program.

Calculate your operating budget based on the cost of the activities, transportation, employees, insurance, advertising, and overhead. See "Costs for Setting Up Your Summer Program" (page 177). Consider the number of counselors (employees) you plan to have based on the number of students (6:1 student/counselor ratio). Do you want a 4:1, 6:1, 10:1 ratio? Find the going rate for counselors by checking the classified ad section under teacher and day-care wages. If the children will leave your home to

go on field trips, select the form of transportation. Will the counselors drive their own cars, or will one of the parents? Check into insurance coverage on the transportation vehicle.

Check with your city and state agencies' Business Licensing Departments to see if there are policies and mandates that you must follow to run your summer program. Check with the Day-Care Licensing Department to make sure that your summer day camp does not fall into their jurisdiction.

Add up your total costs for two, four, six, and twelve children (including yours) and then divide the costs by the number of anticipated children (excluding yours). If your goal is to provide affordable care and to have a break-even financial situation, this total figure can be the tuition you charge each child for joining your program. If you would like to profit from your venture, increase the enrollment or tuition accordingly.

Once the financial calculations and activities are laid out, design your brochure for advertising. Send the brochures to families with children who are the same ages as yours. Post fliers at libraries, schools, laundromats, and recreation centers.

Other parents will see the benefits that your summer program offers and may sign their children up. Get the word out that you are putting together a special vacation program. Your children's friends may join the program, too.

Setting up your own program gives you control over your children's vacations. You choose the activities, teachers, students, location, and so on. In other programs, parents usually choose the program that meets *most* of their children's needs, not *all* of them. If you want to add an academic vein through your program, than go right ahead and do it. Learning is fun, and children often prefer learning new concepts to watching TV. Even though you might have the good intention of taking your children to a new exhibit at the museum or doing special art projects or science experiments, free time often gets absorbed into daily routines such as grocery shopping, running errands, and the children's extracurricular activities. By setting up your own program, your children will have the opportunity to do all the activities and events that you select for their daily summer program.

Summing Up

Whether you're looking for a half-day program or an entire summer program for your child, you need to start planning in January or February. Good programs fill up quickly. If you're planning to run a program out of your home, start planning in November to December. Children deserve a good holiday program whether it's a one-day school holiday or a ten-week summer program.

School's-Out Organizers

Summer-Program Selection Worksheet
Vacation-Schedule Worksheet
Setting Up Your Summer Program
Costs for Setting Up Your Summer Program

Summer-Program Selection Worksheet

Questions/Summer Prog.	1:	2:	3:	4:
Program:				
Address:				
Phone:				
Director:				
Teachers:				
License number:				
Age ranges:				
Number who are ___ years:				
Theme/type:				
Philosophy:				
Hours:				
Facility size:				
Late-pickup fee:				
Openings:				
Registration:				
Enrollment Fee:				
Tuition:				
Field-trip costs:				
Parent volunteer:				
Transportation:				
Sick care:				
Make-up policy:				
Meals:				
Snacks:				
Discipline policy:				
Reference #1:				
Reference #2:				
Reference #3:				
Other:				

Vacation-Schedule Worksheet

Day	Child	Time	Activity	Location	Phone	Hours	Transportation	Fees
M O N								
T U E								
W E D								
T H U								
F R I								

Setting Up Your Summer Program

	Summer-Program Curriculum				
Time	Activity	Transportation	Materials Needed	Misc.	Cost

Theme: _____ **Total Activity Cost/Day**

Costs for Setting Up Your Summer Program

Categories/# of Children	2 Children	4 Children	6 Children	12 Children
Academic materials				
Art materials				
Sports equipment				
Office supplies				
Field trips				
Special events				
Transportation				
Insurance				
Advertising				
Employees				
Employee taxes				
Employee benefits				
Rental space				
Snacks				
Meals				
Misc.				
Program costs				
Tuition (Divide by # of students)				

Notes

Part Three
Doctors and Lawyers: Medical and Legal Planning

Chapter 9
Caring for Your Family's Health and Safety

Chapter 10
Powers of Attorney, Wills, and Living Trusts

Chapter 11
Elder Care

Chapter 9

Caring for Your Family's Health and Safety

Injuries and disasters occur without warning. You can be prepared for such a situation, however, by doing your best to make your house and yard safe for children, by knowing basic first aid, and by having well-stocked first-aid and disaster kits. Do you know how to help the injured person and whom to call for assistance? After a disaster hits, can you give your insurance company a complete list of your personal belongings, or report lost or stolen credit cards to all of your credit card companies? A few minutes of time and preparation can save immense headaches (or worse) later on.

An Ounce of Prevention: Avoiding Childhood Injuries

Most childhood injuries can be prevented with common sense. Take a few minutes to reevaluate your home, yard, and life style for safety. The American Red Cross recommends the following guidelines:*

Set Up Safe Play Areas

Most playground injuries happen when children fall from playground equipment. Make sure that there is sand, wood chips, or pea gravel beneath outdoor equipment. Check to see if there are any sharp corners or nails exposed on play equipment and toys. Repair potential problems and cover sharp corners with foam padding or pillows.

Install Gates on Stairs

Place gates at the tops and bottoms of stairs. Make sure that you select gates that have small enough holes that a small child's head can't fit through. Keep the gates closed.

Practice Water Safety

A child can drown in just a few inches of water. An adult must *always* supervise young children in or near water: bathtubs, pools, toilets, buckets, ponds, and fish tanks. If you live near a body of water (ocean, lake, river) or have a swimming pool, you should make sure your child learns how to swim as soon as possible.

Establish a Fire-Escape Plan

Develop a fire-escape plan and establish a meeting place. In case of fire, everybody in the house should know how to exit. Once each person gets outside, he or she should go directly to the meeting place. This plan saves lives. There are many horror stories about the hero who went into a burning house in search of a child when the child was safely out of the house looking for the hero. Children often hide when there is a fire. Practice this fire drill and escape plan once a month. Children need to know the plan thoroughly for them to follow it in case of an actual fire.

If your children are three or older, teach them to "Stop, Drop, and Roll" if they should catch fire. This simple rule *saves children's lives*. When children think they're caught on fire, they should first *Stop* where they are—not run. Then, they should *Drop* to the ground and cover their faces with their hands, and then *Roll* to put out the flames. Once the fire is out, cool the burn with water. Call 911. Contact your local fire department for the latest information on fire-safety and educational programs for your children.

A fire extinguisher should be kept in the kitchen near the stove, in a central location in your home, and in the garage. Purchase fire extinguishers that have the "ABC" label, indicating that they put out all types of fires.

Smoke detectors should be placed in all areas of your home. If you have a multilevel home, smoke detectors are more effective at the top of the stairway. Replace batteries twice a year.

Prevent Burns

Children's skin is thinner than adults' and can burn easily. Prevent hot-water burns by setting your water heater to 120 degrees. Check the temperature of your hot water by running the hot water over a meat thermometer for three minutes. Check the bath water by touching it before placing a child in the tub.

Don't place hot foods (soups, fried foods) near the edges of tables or on counters that a child can easily reach. Don't use tablecloths that a child can grab and pull. Many children are burned each year because they have pulled hot foods on top of themselves.

It goes without saying that it is important to teach your children about the dangers of hot stoves, ovens, and pots and pans. Keep pots' and pans' handles turned away from the edge of the stoves. Help them associate pain (owees) with dangerous areas.

Don't carry a baby while carrying a hot pot or a cup of hot coffee or tea. The result can be hazardous to both you and the baby.

Use Seat Belts

Children and infants must always be buckled up when riding in a vehicle. Purchase a federally approved car seat and follow manufacturer's directions for use. Most states have "buckle-up" laws to protect children and passengers. Car accidents kill more children than any other accidents.

Teach Street-Crossing Safety

Teach your child always to look left, right, left before crossing a street, even at crosswalks. Younger children should be programmed always to reach for an adult's hand before crossing any streets.

Be Careful with Plastic Bags and Small Toys

For children three and younger, make sure that your home is toddler-proof. Any toys smaller than a golf ball should be enclosed in a box and kept out of the toddler's reach. Food items such as hot dogs, hard candies, nuts, raw vegetables, and grapes can cause choking. Drapery cords and electrical sockets can also be dangerous.

Keep Guns Out of Sight

Keep guns unloaded and locked away; ammunition should be locked away separately from the weapon. A child may sometimes think that a gun is a toy, with tragic results. Every day at least one child is killed by a gun in the United States. Guns and other weapons are lethal and should never be in a setting where children play.

Toy guns can also present danger because they are made to look realistic and can be mistaken for a real weapon. This could put your child in a

dangerous situation. A police officer, parent, or stranger may shoot your child in self-defense if he or she were to find himself or herself staring down the shaft of a realistic-looking gun.

Post Emergency Numbers

See "Emergency Phone Numbers" (page 192). Fill in the important phone numbers, make copies, and post them near all the phones in your home.

Identify Poisonous Materials

Children can be poisoned by ingesting many things: medicines, poisonous plants, cleaning solutions, art materials, and rancid foods. Poisonous materials should always be locked up, to eliminate the possibility of accidental poisoning.

BEWARE OF POISONOUS PLANTS Keep all plants away from young children. Many common and/or indigenous plants are poisonous. Teach your child not to put unknown plants into their mouths. Here is a partial list of poisonous plants compiled by the American Red Cross:

Vegetable-Garden Plants

Sprouts and green parts of potato
Rhubarb leaves
Green parts of tomato

Flower-Garden Plants

Autumn crocus
Bleeding heart
Chrysanthemum
Daffodil
Foxglove
Hyacinth
Iris
Jonquil
Lily of the valley
Morning glory
Narcissus

House Plants

Bird of paradise
Castor bean
Dumbcane (Dieffenbachia)
English ivy
Holly

Jequirty bean (rosary pea)
Jerusalem cherry
Mistletoe
Mother-in-law
Oleander
Philodendron
Rhododendron

Trees and Shrubs

Black locust
Boxwood
Elderberry
English yew
Horse chestnut
Oak Tree

Wild Plants

Bittersweet
Buttercup
Jack-in-the-pulpit
Jimson weed
Mushroom (some varieties)
Nightshade
Hemlock
Poison ivy, oak, or sumac
Skunk cabbage

Check Children's Art Supplies

Avoid problems by purchasing nontoxic materials whenever possible. If nontoxic supplies are not available, make sure children are carefully supervised when using art materials.

All solvents
Aerosol and mist-type sprays
Instant glues and adhesives
Permanent markers
Dust from clay, tempera paints, instant papier maché, chalk, and plaster
Plaster for casting
Scented felt pens

Call the Poison Control Center

If you suspect your child has been poisoned, *call the Poison Control Center immediately*. Follow their directions exactly. If you don't have the Poison Control Center's phone number, dial 911.

First Aid: Planning to Help

First-aid skills and knowledge can save your child's life. All parents should receive first aid, rescue breathing, and CPR (cardio-pulmonary resuscitation) training. If a child stops breathing, he or she has less than four minutes to be resuscitated before permanent brain damage or death occurs. How many times have you been more than four minutes from a medical facility?

Set Up a First-Aid Kit

Every home, office, and car should have a first-aid kit. See First-Aid Kit List (page 193). The supplies can be purchased at drugstores, medical-supply stores, or hospitals. Make sure that items (such as Ipecac) in your first-aid kit do not expire. Restock first-aid kit after each use. Place a large red cross on the cover of your first-aid kit so it is easily identified in an emergency.

Emergency First-Aid Information

Note: *The first-aid information provided here is for your general knowledge and is intended to provoke you into taking pediatric first-aid and CPR classes. This information is* **not** *intended to replace first-aid instruction or professional medical advice. Seek professional help in any medical emergency. Medical emergencies, by their very nature, involve life-and-death situations, where doing the wrong thing is often worse than doing nothing at all.* **Do not** *attempt to provide help you are not qualified to administer.*

The American Red Cross offers classes in first aid and CPR for reasonable fees and schedules classes in the evening and on weekends to meet the needs of working parents. Local hospitals and community organizations also offer first-aid courses.

Call 911

First Aid for Choking: The Heimlich Maneuver This has been accepted as the most effective method for dislodging an obstruction from the windpipe. Here are simple instructions to follow.

- ☐ Stand behind the person who's choking. If it's a child, you may have to kneel.
- ☐ Put your arms around the person's waist.
- ☐ Make a fist with one hand and place your thumb against the person's abdomen, just above the navel.
- ☐ Press your fist into the person's abdomen with a quick, upward motion.
- ☐ Continue doing this at two-second intervals, until the object is dislodged.

Controlling Bleeding

☐ Apply pressure to the wound with a clean cloth. Bandage the wound to keep the pressure constant.

First Aid for Burns

☐ Plunge the affected area into cold water immediately. Then apply ice. Keep ice on the burn until the pain subsides.

INDICATE BLOOD TYPE Knowing your child's blood type is helpful in expediting emergency care. More important, if you have family members who share the same blood type, arrange for them to be donors in the event your child needs transfusions. List their information on the form.

REQUEST A PLASTIC SURGEON There is a clause on the "Emergency Form" (page 194) that may save your child from having unnecessary multiple surgeries to the face. Often in an Emergency Room, the doctors are rushed and treat patients according to medical needs. Facial lacerations may be stitched up quickly without consideration to scarring and may require later cosmetic surgeries to correct the scarring problems. A plastic surgeon can either advise or perform the surgery so that minimal scarring occurs. Sign this section if you would like a plastic surgeon involved in the surgery on facial lacerations.

Make multiple copies of the completed Emergency Form. Keep one near your phone in the kitchen, or in a central location in the house. Keep one in each car's glove box, each spouse's office desk, each child's backpack, child's luggage, and child's purses. Give copies to friends and family members who watch your child often. Put one in your child's file at school.

Update this Emergency Form once a year. September 1 is a good date since school begins at that time.

Keep Everyone Healthy: Schedule Regular Checkups

Pediatricians recommend checkups for healthy children, to ensure proper development and to receive disease-preventing immunizations. It will be easier to keep track of appointments if you always make them for the same day of the week and at the same time. See schedule below:

☐ At Birth
☐ Before One Month
☐ Two Months
☐ Four Months
☐ Six Months
☐ Nine Months
☐ Twelve Months

- ☐ Fifteen Months
- ☐ Eighteen Months
- ☐ Two Years
- ☐ Three Years
- ☐ Four Years
- ☐ Five Years
- ☐ Six Years
- ☐ Eight Years
- ☐ Ten Years
- ☐ Twelve Years
- ☐ Fourteen Years
- ☐ Sixteen Years
- ☐ Eighteen Years

Keep Immunizations Up to Date

Children attending day-care centers, preschools, or schools should be immunized against childhood diseases. Potential illness or death can be prevented by immunizations. The American Academy of Pediatrics and the U.S. Public Health Service set the immunization schedule for children. This schedule is updated annually. See "Immunization Chart" (page 196).

Since 1991, two vaccines for Haemophilus influenzae infections can be given to children younger than 15 months of age. Check with your pediatrician about doses given to children who have received previous immunizations.

If the mother of an infant tests seropositive for hepatitis B (HBsAG+), the infant must receive hepatitis B immune globulin (HBIG) shortly after the first dose, a second dose at one month, and a third at six months of age. If the mother of an infant tested seronegative for hepatitis B, the infant may begin the three-dose schedule after the infant leaves the hospital.

Establish a Disaster Plan

In case of a major disaster, for example, an earthquake, fire, or hurricane, you should have a disaster plan. Oftentimes, in a natural disaster, phone lines are dead or limited and you can only call out of the area. Select a family member or close friend who will be willing and likely to be available to relay messages between you and the caregiver or other family members.

In case of fire, select a place where everybody can meet outside the home. A driveway is a good location because it is concrete or asphalt, not flammable.

Select a place other than home to meet in case of major disasters, such as earthquakes or hurricanes, when the home is destroyed and family mem-

bers are not together. Talk about the route you'll take to the meeting place. Discuss how and where you will leave messages in case you have to go to another location.

Describe the locations of all medical and emergency supplies and the location of all utilities. Keep a wrench near valves that are hard to turn. Keep the utility area cleared so there is easy access to electrical boxes and water and gas valves.

Use the Emergency-Evacuation Notice

Make several copies of the "Emergency-Evacuation Notice" (page 197). Keep two copies in each envelope with Emergency Forms.

Post this notice when you are forced to evacuate. Indicate your evacuation destination, the path you plan to take, which children are in your care, children's physical condition, where you will call (if possible), and what supplies you need. Keep an indelible ink pen and waterproof tape with each notice. Post in a conspicuous location. If a second evacuation is necessary, post another Emergency-Evacuation Notice with updated information.

Prepare a Disaster Kit

Earthquakes, fires, tornadoes, hurricanes, and floods threaten regions across the nation. Be prepared. Put together a disaster kit for your household now. See "Disaster-Kit List" (page 198).

Most of the items for your disaster kit can be found in your home. The experts suggest that you have enough food, water, and clothing to last three days for each person in your household. You may need to purchase food and first-aid supplies. Put clothing in plastic zippered bags to keep moisture out. Wrap the sleeping bags or blankets in large trash bags to keep them mildew-free. Store all items in a large container such as a metal or plastic trash can. Seal the can with duct tape to keep out moisture and animals.

Check the disaster kit once a year. Water and food will need to be replaced. Children will probably need larger clothing and diaper sizes. Medication may need updating. Enter annual check date on your "Permanent Calendar" (page 39).

Prepare Inventory Lists

Keep a complete, updated inventory list of your personal belongings on file in case of a disaster (fire, earthquake, flood, or burglary). It will expedite dealings with insurance claims and aid in the replacement process. The best way to account for your belongings is a photo inventory. Take pictures of every wall, closet, drawer, and cabinet in your home. Take close-up pictures of your bookshelves (close enough to read titles). This will allow you to replace every book that gets damaged or stolen if you have replacement-cost insurance coverage. You can also take videos.

In conjunction with your photo or video inventory, fill out the Inventory lists (pages 199–213). The Inventory List makes it easy to place

values, brand names, serial numbers, and other details on your belongings not displayed in the photographs. If you know current pricing on any items, enter them in the "Today's Value" column. This will help your insurance adjuster.

Have valuable or priceless items professionally appraised and place appraisals in your safe-deposit box. Inform your insurance company of appraisals to make sure you have enough insurance coverage to replace those valuables.

Make a Credit Card List

Those who have lost or misplaced their wallets probably remember feeling panicked and angry. Trying to remember how much cash and which credit cards and identification cards you had in your wallet is frustrating.

Set aside 20 minutes to fill out the "Credit Card List" (page 214). Open your wallet and write the name of the credit card, the name on the card (spelled exactly as it appears on the card with typos, and so forth), account number (include expiration date), address (for claims), phone number, and date cards were lost (if applicable).

Keep this list in your bank safe-deposit box and in your home with other important documents. When you travel, carry this list with you so you can easily cancel stolen cards.

Summing Up

Be prepared for injuries and disasters. By taking first-aid classes, you will know what to do if your child gets hurt. Complete the Emergency Form to ensure that your child receives proper medical attention in the event of a serious accident. Stock your first-aid and disaster kits so you're always prepared in the event of an emergency. To help with lost or stolen goods, complete the Inventory and Credit Card lists.

It may sound trite, but it's still true that "an ounce of prevention is worth a pound of cure."

Emergency Organizers

Emergency Phone Numbers—Post Near All Phones
First-Aid Kit List
Emergency Form

Immunization Chart for:_____
Emergency Evacuation Notice
Disaster-Kit List
Inventory List: Living Room
Inventory List: Family Room
Inventory List: Kitchen
Inventory List: Master Bedroom
Inventory List: Bedroom (_____)
Inventory List: Bedroom (_____)
Inventory List: Bedroom (_____)
Inventory List: Bedroom (_____)
Inventory List: Master Bathroom
Inventory List: Bathroom (_____)
Inventory List: Bathroom (_____)
Inventory List: Library
Inventory List: Outdoor Equipment
Inventory List: Shop and Tools
Inventory List: Valuables
Credit Card List

Emergency Phone Numbers
Post Near All Phones

Emergency Numbers
911

Emergency Medical Services: _____

Poison Control Center: _____

Police: _____

Fire: _____

Ambulance: _____

Nearest medical facility: _____

Taxi: _____

Family doctor/pediatrician: _____

Mom's work number: _____

Dad's work number: _____

Mom's car phone/beeper: _____

Dad's car phone/beeper: _____

Neighbor's name and phone: _____

Relative's/friend's name and phone: _____

This phone: _____

This address: _____

Directions and landmarks: _____

Don't hang up the phone until EMS dispatcher tells you to do so. Be prepared to describe emergency.

First-Aid Kit List

Date Kit Made:_____

Qty.	Emergency Items	Packed	Qty.	Emergency Items	Packed
	First-Aid Kit for:			**First-Aid Kit for:**	
1	First-Aid Guide or Book		1	First-Aid Guide or Book	
1 bx.	1/2" adhesive-strip bandages		1 bx.	1/2" adhesive-strip bandages	
1 bx.	3/4" adhesive-strip bandages		1 bx.	3/4" adhesive-strip bandages	
1 bx.	1" adhesive-strip bandages		1 bx.	1" adhesive-strip bandages	
1 bx.	4" × 4" gauze, nonstick, sterile bandages		1 bx.	4" × 4" gauze, nonstick, sterile bandages	
1	Rolled flexible/stretch gauze		1	Rolled flexible/stretch gauze	
1	Rolled bandages		1	Rolled bandages	
1	Bandage tape		1	Bandage tape	
1 bx.	Nonstick, sterile pads (assorted)		1 bx.	Nonstick, sterile pads (assorted)	
1 bx.	Triangular bandages		1 bx.	Triangular bandages	
1–2	Small splints		1–2	Small splints	
1 bx.	Eye dressing or pads		1 bx.	Eye dressing or pads	
1	Scissors		1	Scissors	
1	Tweezers		1	Tweezers	
10	Safety pins		10	Safety pins	
1	Thermometer		1	Thermometer	
1	Flashlight with fresh batteries		1	Flashlight with fresh batteries	
1 set	Disposable latex gloves		1 set	Disposable latex gloves	
1	3 oz. rubber-bulb syringe		1	3 oz. rubber-bulb syringe	
1 kit	Bee-sting kit		1 kit	Bee-sting kit	
1	Emergency telephone guide		1	Emergency telephone guide	
1	Emergency contact information		1	Emergency contact information	
4	Quarters for pay phone		4	Quarters for pay phone	
1 set	Pad of paper and pen		1 set	Pad of paper and pen	
1	Cold pack or ice bag		1	Cold pack or ice bag	
1	Clean cloth		1	Clean cloth	
1	Soap		1	Soap	
1	Small plastic cup		1	Small plastic cup	
1	Cleansing wipes (sealed packets)		1	Cleansing wipes (sealed packets)	
1	Syrup of Ipecac (1 oz. bottle)		1	Syrup of Ipecac (1 oz. bottle)	
	Misc.			**Misc.**	

Emergency Form

FOR MEDICAL EMERGENCIES FOR: _____

To Whom It May Concern:

 We, the parents or legal guardians of _____, hereby give medical authorization to any person in possession of this Emergency Form to order any medical attention needed as he/she sees necessary for the child named above.

General Information

Child's name: _____ Birthdate: _____ Age: _____

Child's home address: _____ City: _____ ZIP Code: _____

Does child live with both parents? _____ If no, please describe: _____

Mother's name: _____ Home phone: _____

Mother's address: _____ City: _____ ZIP Code: _____

Mother's occupation: _____ Work phone: _____

Mother's car phone: _____ Mother's beeper #: _____

Father's name: _____ Home phone: _____

Father's address: _____ City: _____ ZIP Code: _____

Father's occupation: _____ Work phone: _____

Father's car phone: _____ Father's beeper #: _____

Insurance Information

Insurance company: _____ Subscriber's name: _____

Policy number: _____ Group number: _____

Insured's name: _____ Type of coverage: _____

Phone number for claims: _____ Phone number for emergency care: _____

Address for claims: _____ City: _____ ZIP Code: _____

Personal Information

Friend who will most likely know how to reach us in case of emergency: _____

Friend's home phone (____) _____ Friend's work phone: (____) _____

Closest relative: _____ Relationship to child: _____

Relative's home phone: (____) _____ Relative's work phone: (____) _____

Disaster Plan

Contact Person: (Out-of-state person who will relay messages if local phone lines won't go through) _____

Home phone: _____ Work phone: _____

Meeting place (at home): _____

Meeting place (other than home): _____

First-aid and medical supplies are located: _____

Electrical power box is located: _____

Water valve is located: _____

Gas valve is located: _____

Fire extinguisher is located: _____

Emergency Form (continued)

Medical Information

Pediatrician's name: _____ Phone: (____) _____

Pediatrician's address: _____ City: _____ ZIP Code: _____

Family doctor's name: _____ Phone: (____) _____

Family doctor's address: _____ City: _____ ZIP Code: _____

Dentist's name: _____ Phone: (____) _____

Dentist's address: _____ City: _____ ZIP Code: _____

Orthodontist's name: _____ Phone: (____) _____

Orthodontist's address: _____ City: _____ ZIP Code: _____

Other specialist's name: _____ Phone: (____) _____

Other specialist's address: _____ City: _____ ZIP Code: _____

My child has had all immunizations required for his/her age except: _____

My child is allergic to: _____

My child is on the following medications: _____

My child's blood type is: _____ The following people have the same blood type:

Donor's name: _____ Phone: _____ Relationship: _____

Donor's name: _____ Phone: _____ Relationship: _____

 If my child receives emergency medical attention to his/her face a plastic surgeon may be involved in the decision-making process to avoid cosmetic surgery at a later date. I would _____/ would not _____ like a plastic surgeon involved in the medical care my child receives. If hospitalization is necessary, please go to _____, if there is a choice. Medical information I would like emergency physicians to know: _____

Miscellaneous Information

 All of the above is true to the best of my knowledge. I agree to be financially responsible for any emergency treatment given to my child.

_____ _____

Date Parent's or Legal Guardian's Signature

Immunization Chart

for: _____

VACCINE/AGE	Birth	1–2 Months	2 Months	4 Months	6 Months	6–18 Months	12–15 Months	15 Months	15–18 Months	4–6 Years	11–12 Years	14–16 Years
DTP:												
(Diphtheria, Tetanus, Pertusis)												
Polio												
MMR:												
(Measles, Mumps, Rubella)												
Hepatitis B												
Haemophilus												
Influenza type b (Hib)												
Varicella												

Immunization Chart

for: _____

VACCINE/AGE	Birth	1–2 Months	2 Months	4 Months	6 Months	6–18 Months	12–15 Months	15 Months	15–18 Months	4–6 Years	11–12 Years	14–16 Years
DTP:												
(Diphtheria, Tetanus, Pertusis)												
Polio												
MMR:												
(Measles, Mumps, Rubella)												
Hepatitis B												
Haemophilus												
Influenza type b (Hib)												
Varicella												

Emergency Evacuation Notice

We are going to relocate to: _____

We plan to take the following path: _____

The following children are with us: _____

Everybody is okay except: _____

We will call _____ at this phone number: _____, as a contact

person for future changes. Please bring the following to our new destination: _____

Notes: _____

Thank you,

Disaster-Kit List

Date Kit Made:_____

Qty/ Person	Emergency Items	Packed		Qty/ Person	Emergency Items	Packed
	Food				**Clothing**	
3 qts.	Water			1 set	Clothes (pants, shirt, underwear, socks)	
3	Canned meat/beans (8 oz.)			1	Jacket	
3	Canned soups/stews (12 oz.)			1	Waterproof jacket/poncho	
3	Canned vegetables/fruit (12 oz.)			1	Shoes (thick soled, covered toes)	
3	Powdered milk (packets)			1	Gardening gloves (for cleaning)	
3	Canned juices (12 oz.)			1	Sleeping bag/heavy blanket	
1	Dried fruit and nuts (packaged)			1	Hat/cap	
1	Pet food			1	Tent (optional)	
1	Can opener					
1	Pot (for boiling and cooking)					
1	Portable stove (hibachi)				**Toiletries**	
1	Charcoal & starter fluid			1	Toothpaste/toothbrush	
9 ea.	Paper plates & cups			3	Towelettes	
9 ea.	Plastic forks, spoons, & knives			1	Bar soap	
1	Aluminum foil			1	Shampoo/conditioner	
1	Paper towels			1	Brush	
1 set	Matches (waterproof)			1	Deodorant	
				1	Denture cleanser	
	First Aid			1	Contact solutions/cleansers	
1	First-aid kit			12–21	Feminine pads (3 days)	
1	First-aid book			1 set	Diapers/wipes/powder (3 days)	
1	Portable battery-operated radio			1	Toilet paper	
1	Flashlight (spare bulb)			1	Chlorine/bleach (purifying)	
1	Batteries (radio/flashlight)			1	Newspaper (insulation/wrapping)	
1	Fire extinguisher (A-B-C)			1	Razor/knife	
1	Medication					
1	Eye care (glasses/contacts)					
1	Cash (for emergencies)				**Tools**	
1	Candles			1	Wrench (for turning gas valve)	
1	Water filter (mini-portable)			1	Ax, hammer, screwdriver, pliers	
				1	Rope (heavy-duty)	
	Misc.			1	Pail	
1	Deck of cards/travel toys			1	Duct tape	
				1	Pen and pad of paper	
				1 bx.	Trash bags (plastic)	

Inventory List: Living Room

Last Update:_____

Item	Qty.	Brand Name/Type	Size	Value at Purchase	Today's Value	Miscellaneous Description/ Serial Numbers
Furniture:						
Tables:						
Entertainment center:						
Antiques:						
Stereo system:						
TV/VCR:						
Lamps:						
Paintings:						
Prints:						
Decorations:						
Other:						

Inventory List: Family Room

Last Update:_____

Item	Qty.	Brand Name/Type	Size	Value at Purchase	Today's Value	Miscellaneous Description/ Serial Numbers
Furniture:						
Entertainment center:						
Stereo system:						
TV/VCR:						
Lamps:						
Computer:						
Art:						
Tennis equipment:						
Golf equipment:						
Skiing equipment:						
Scuba equipment:						
Swim equipment:						
Camp equipment:						
Hunting equipment:						
Decorations:						
Other:						

Inventory List: Kitchen

Last Update:_____

Item	Qty.	Brand Name/Type	Size	Value at Purchase	Today's Value	Miscellaneous Description/ Serial Numbers
Furniture:						
Crystal:						
China:						
Silver:						
Serving pieces:						
Appliances:						
Stoneware:						
Glasses/cups:						
Flatware:						
Utensils:						
Pots/pans:						
Linen:						
Other:						

Inventory List: Master Bedroom

Last Update:_____

Item	Qty.	Brand Name/Type	Size	Value at Purchase	Today's Value	Miscellaneous Description/ Serial Numbers
Furniture:						
Computer:						
Lamps:						
Linen:						
Evening clothes:						
Suit/coats:						
Sweaters:						
Sweatshirts:						
Casual dresses:						
Shirts/blouses:						
Slacks:						
Shoes:						
Lingerie:						
Underwear:						
Stockings:						
Purses/bags:						
Other:						

Inventory List: Bedroom

Last Update:_____ _____

Item	Qty.	Brand Name/Type	Size	Value at Purchase	Today's Value	Miscellaneous Description/ Serial Numbers
Furniture:						
Computer:						
Lamps:						
Linen:						
Evening clothes:						
Suit/coats:						
Sweaters:						
Sweatshirts:						
Casual dresses:						
Shirts/blouses:						
Slacks:						
Shoes:						
Lingerie:						
Underwear:						
Stockings:						
Purses/bags:						
Other:						

Inventory List: Bedroom

Last Update:_____ _____

Item	Qty.	Brand Name/Type	Size	Value at Purchase	Today's Value	Miscellaneous Description/ Serial Numbers
Furniture:						
Computer:						
Lamps:						
Linen:						
Evening clothes:						
Suit/coats:						
Sweaters:						
Sweatshirts:						
Casual dresses:						
Shirts/blouses:						
Slacks:						
Shoes:						
Lingerie:						
Underwear:						
Stockings:						
Purses/bags:						
Other:						

Inventory List: Bedroom

Last Update:_____

Item	Qty.	Brand Name/Type	Size	Value at Purchase	Today's Value	Miscellaneous Description/ Serial Numbers
Furniture:						
Computer:						
Lamps:						
Linen:						
Evening clothes:						
Suit/coats:						
Sweaters:						
Sweatshirts:						
Casual dresses:						
Shirts/blouses:						
Slacks:						
Shoes:						
Lingerie:						
Underwear:						
Stockings:						
Purses/bags:						
Other:						

Inventory List: Bedroom

Last Update:_____

Item	Qty.	Brand Name/Type	Size	Value at Purchase	Today's Value	Miscellaneous Description/ Serial Numbers
Furniture:						
Computer:						
Lamps:						
Linen:						
Evening clothes:						
Suit/coats:						
Sweaters:						
Sweatshirts:						
Casual dresses:						
Shirts/blouses:						
Slacks:						
Shoes:						
Lingerie:						
Underwear:						
Stockings:						
Purses/bags:						
Other:						

Inventory List: Master Bathroom

Last Update:_____

Item	Qty.	Brand Name/Type	Size	Value at Purchase	Today's Value	Miscellaneous Description/ Serial Numbers
Furniture:						
Linen:						
Toiletries:						
Makeup:						
Appliances:						
Other:						

Inventory List: Bathroom

Last Update:_____

Item	Qty.	Brand Name/Type	Size	Value at Purchase	Today's Value	Miscellaneous Description/ Serial Numbers
Furniture:						
Linen:						
Toiletries:						
Makeup:						
Appliances:						
Other:						

Inventory List: Bathroom

Last Update:_____

Item	Qty.	Brand Name/Type	Size	Value at Purchase	Today's Value	Miscellaneous Description/ Serial Numbers
Furniture:						
Linen:						
Toiletries:						
Makeup:						
Appliances:						
Other:						

Inventory List: Library

Last Update:_____

Item	Qty.	Brand Name/Type	Size	Value at Purchase	Today's Value	Miscellaneous Description/ Serial Numbers
Furniture:						
Lamps:						
Hard-cover:						
Soft-cover:						
Video tapes:						
CDs/albums:						
Antiques:						
Computer:						
Stereo:						
Other:						

Inventory List: Outdoor Equipment

Last Update:_____

Item	Qty.	Brand Name/Type	Size	Value at Purchase	Today's Value	Miscellaneous Description/ Serial Numbers
Furniture:						
Recreational equip.:						
Garden supplies:						
BBQ supplies:						
Pool supplies:						
Bikes:						
Sports equip.:						
Other:						

Inventory List: Shop and Tools

Last Update:_____

Item	Qty.	Brand Name/Type	Size	Value at Purchase	Today's Value	Miscellaneous Description/ Serial Numbers
Power tools						
Hand tools:						
Misc:						

Inventory List: Valuables

Last Update:_____

Item	Qty.	Brand Name/Type	Size	Value at Purchase	Today's Value	Miscellaneous Description/ Serial Numbers
Jewelry:						
Cash:						
Photographs:						
Videos:						
Negatives:						
Important documents:						
Other:						

Credit Card List

Last Update:_____

Credit Card	Name on Card	Account Number	Address	Phone	Exp. Date

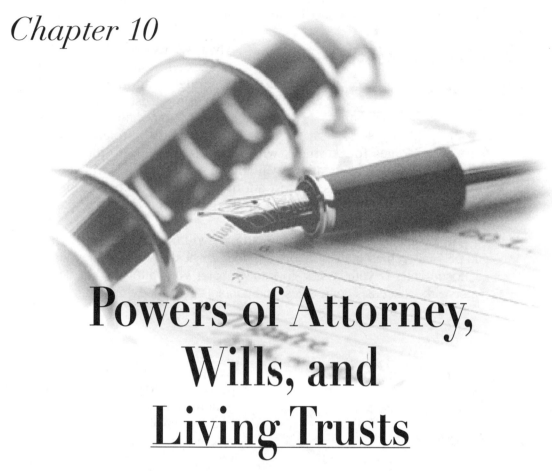

Chapter 10

Powers of Attorney, Wills, and <u>Living Trusts</u>

The ultimate disaster or emergency for your family will be your death. Who will make decisions for you if you become incapacitated, or if medical decisions need to be made about life-sustaining procedures? Nobody likes to think about these kinds of situations, but there are various types of estate planning that can help to protect your family's rights to your estate, and, if you have children, make sure your desires regarding their guardianship, education, and the like are followed.

You should always consult with an attorney who specializes in estate planning (particularly if setting up a living trust or similar document). I have included forms that can give your attorney and the people you choose as guardians for your children important information about how you would like your children to be educated and how heirlooms should be distributed.

Will the trustee, executor, or administrator of your estate know where to find your will, safe-deposit keys, or partnership agreements? It is most important that you organize your personal information to make it easy for your family and friends to settle your estate. Update this information annually.

How to Select an Attorney

Always select an attorney who specializes in estate planning when selecting an attorney to write your will, living trust, or power of attorney. If you can't get references from friends or relatives, check in the Yellow Pages for attorneys who specialize in "estate planning." The Martindale Hubbel publication, available in law libraries, will list the background and qualifications of most attorneys. If you still have trouble finding one, call attorneys specializing in other areas (or your local bar association), and ask for a referral.

In the event of your death, your attorney will meet with your beneficiaries and personal representatives to discuss your wishes as stated in the most updated documents. If your assets go into probate, your attorney handles all the paperwork, schedules court dates, and contacts everybody named in the will.

Delegate Authority with the Power of Attorney

In general, there are two types of power-of-attorney documents: (1) general and (2) health care. A general power of attorney allows a representative you appoint to act in your place (essentially, as if he or she were you) in a particular matter (for example, buying or selling real estate), or in your place if you become incompetent, or are otherwise unable to act in your own interests.

The health-care power of attorney allows your appointed representative to make decisions about life-sustaining procedures when you are injured, according to specific requests you have previously set forth.

The "Power-of-Attorney Information" form on page 220 will let your attorney, personal representative, family, and friends know your desires about what to do in the case of a medical emergency, if you are unable to make decisions about life-sustaining procedures, burial, organ donations, and the like. This may be an uncomfortable form to complete, but it will make decision making much easier on your family and friends when they are dealing with their loss. If, for example, you are uncomfortable with losing control over decisions, you can require that two doctors certify you as "brain dead," or require a brain scan before life-sustaining procedures are stopped. *Consult with an attorney to set up your durable power of attorney.* This is a legal document that will protect your rights when you become incompetent and when medical decisions need to be made, but it also gives someone else the power to make those decisions.

It is also important to note that the laws relating to health-care powers of attorney vary from state to state and that the powers of a designated representative will vary according to the laws of your state. In other words, the powers that your representative might have in Colorado will not necessarily

be the same in Kansas or New York. Again, you should consult with an attorney before signing any document of this nature.

Prepare a Will to Show the Way

A will is a legal document that transfers your assets to your beneficiaries after your death, through probate. In probate, your executor pays all debts and distributes assets in a court-supervised process. An attorney handles the legal requirements and normally receives a fee paid out as a percentage of the gross value of the estate (before mortgages and debts are paid). Probate is a time-consuming process that can take a year or longer. While your assets are tied up in probate, in most circumstances your beneficiaries can't use them.

You will need a will to designate a guardian for your minor children other than a spouse or next of kin.

Save Taxes with a Living Trust

A living trust transfers assets while you are alive, into a transparent, changeable, and revocable account that becomes irrevocable at the time of death. Depending upon the type of trust, you can retain more-or-less complete control over the property in the trust, with the power to make changes until the time of your death. Property that has been transferred into a living trust does not go through probate. The trustee has access to the property and has the power to sell, transfer, or distribute the property in the trust without going through the courts.

Wills, living trusts, and powers of attorney can be extremely complicated and should be drawn up by a professional. Consult with an attorney who handles estate planning. These documents can help to protect your children and assets and help ensure that your estate is distributed according to your wishes.

Select a Guardian to Care for Your Children

Selecting a guardian for your children is probably the most difficult task you will ever face as a parent. Thoughts such as "nobody will love my children the way I do" will enter your mind as you think about

guardian possibilities. Typically, aunts, uncles, or grandparents are named as guardians. Close friends or godparents are also often named. Make your choice known to your family.

The nomination of a guardian can be handled only through a will and must be confirmed by a court. After a guardian has been appointed, that person has the power to raise your children as he or she sees fit, subject to certain exceptions. Your living trust or will specifies how the estate will be divided. The "Notes to Guardian" form (page 221) provides personal input relating to your child that may help the guardian.

Many family feuds start when family members fight over heirlooms and other valuables. Family picture albums, videos, awards, and jewelry (wedding rings) are often sought by family members when they become adults. If you evenly divide heirlooms in your will, you may be able to prevent your children from fighting over your estate. Be specific. If you have eight photo albums, specify which albums go to each child. You may even enter a clause stating that the heirlooms stay within the family so they won't be sold off or given to in-laws (in the case of a divorce).

If your estate allows your children the luxury of private education or special career guidance, indicate your desires. Stipulate that your children participate in music, art, sports, theater, and/or academics. Prioritize your wishes so the guardian can make good decisions based on your children's needs.

Your children will become part of the new family, experiencing events with their relatives and friends. If you have family members of whom your children are fond and you want to ensure that their relationship doesn't dissolve, ask the guardian to establish special visits. Suggest that the children visit once a month or once a year. Consider who will be paying for the trips (if flights are involved). Suggest certain times of the year for these visits (such as Grandma's birthday or Memorial Day). Let these special people know what you've set up with the guardian, so that they can pursue the schedule themselves.

Your guardian may not know about your ancestors and family tree. If you have a family tree and other documents about the family, make copies and file them with the guardian information. This way, when your children get old enough and start asking questions about you and your family, the guardian will be a good resource. Old photo albums and videos are another way to help your children learn about their lineage.

If you have words of advice for your children that you think will help them deal with their new living situation and coping with life, write them out and seal them in an envelope with the child's name. Consider letters to be given right after your death, on birthdays, during the teenage years, when college bound, when getting married, or when having a child. Place date, occasion, or year on envelopes to ensure that they are opened at the appropriate time.

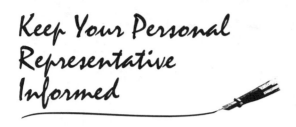

Keep Your Personal Representative Informed

The "Information for Personal Representative" form (page 223) is for the personal representative who will be in charge of your estate in the case of your death. With the chaos that generally follows a death (particularly if the death is unexpected), finding bank information, assets, and keys is often a detective game. Although your daily routine and schedule makes sense to you, will your trustee/executor be able to find your stock certificates, your living trust, or the documents relating to the personal loan you made to your sister? Does your family know your burial or cremation preferences?

Completing this form will give your trustee all the information necessary to settle your estate quickly and easily. It will take out the guesswork and ensure all assets are found. It's a great resource for you, too. You'll have a list of all your important documents, certificates, and other assets right at your fingertips in case of a fire or major disaster.

Fill in all information that applies. Get the serial numbers (appliances and tools) and VINs (cars). Put the completed Information for Personal Representative form in a safe place, and give a copy to the person whom you have chosen to administer the estate. *Do not* put this information, that is, your *only* copy (or a will) in a safe-deposit box, as normally these are sealed at the time of death and cannot be opened without a court order. This worksheet contains financial and personal information that should not be available until your death. Your will, living trust, and power of attorney should also be placed with this worksheet.

Summing Up

It's a good idea to complete the Information for Personal Representative form while you're thinking about it. It's easy to put this important task on the back burner. By filling out the various forms included, you are giving valuable information to the individuals who will be responsible for the administration of your estate, and you are helping your children and their guardians through a traumatic time in their lives.

Legal Organizers

Durable Power-of-Attorney Information
Notes to Guardian
Information for Personal Representative

Durable Power-of-Attorney Information

(USE THIS TO COLLECT INFORMATION ONLY. THIS IS NOT A LEGAL DOCUMENT.)

Power of attorney for: _____

Address: _____

Designated health-care agent: _____

Address: _____ Phone: _____

Alternate health-care agent: _____

Address: _____ Phone: _____

STATEMENT OF DESIRES, SPECIAL PROVISIONS, AND LIMITATIONS:

_____ I do / _____ I do not want to receive medical treatment that, although sustaining my life, has the effect of prolonging my inevitable death if the burdens of such treatment outweigh the anticipated benefits. In making this decision, my agent shall consider the quality and duration of my remaining life if such treatment is provided or continued and the relief from pain if such treatment is withheld or withdrawn.

_____ I do / _____ I do not wish to be maintained by machine if I am "brain dead."

Other provisions: _____

Funeral Arrangements

Clergy: _____ Religion: _____

Church/temple: _____ Phone: _____

Funeral preferences: _____

Address: _____ City: _____ ZIP Code: _____

Cemetery: _____ Plot #: _____

Contact: _____ Phone: _____

Address: _____ City: _____ ZIP Code: _____

Total purchase amount: _____ Terms: _____

Organ Donations

I would like to donate my _____ organs and/or _____ tissues to research.

_____ _____
Date Signature

Notes to Guardian

Family Heirlooms

Please divide heirlooms (family photos, family albums, videos, medals, honors, awards, jewelry [wedding rings], etc.) in the following way: _____

Education

The estate should have enough funds to provide the following types of education for my children:

- ☐ Private elementary
- ☐ Private junior or middle school
- ☐ Private high school
- ☐ Public college
- ☐ Private college
- ☐ Graduate school
- ☐ Vocational school
- ☐ Private tutorials
- ☐ Music lessons
- ☐ Dance lessons
- ☐ Sports
- ☐ Other: _____

Please encourage guidance in the following academic/vocational areas: _____

Family Ties

Please make sure that my children continue their relationships with relatives and friends. (Indicate how often you would like the children to visit special family and friends)_____

Notes to Guardian (continued)

When my children ask about me and my family, please give them the following information and documents: _____

Please give the following advice to my children (include age if appropriate): _____

Please give my children the following gifts: _____

Information for Personal Representative

(Trustee, Executor, or Administrator)

General Information

Husband's name: _____

Husband's address: _____ City: _____ ZIP Code: _____

Home phone: _____ Date of birth: _____ Place of birth: _____

Social Security #: _____ Driver's license #: _____

Employer: _____ Work phone: _____

Parents' name (if alive): _____

Parents' address: _____ City: _____ ZIP Code: _____

Parents' home phone: _____

Wife's name: _____

Wife's address: _____ City: _____ ZIP Code: _____

Home phone: _____ Date of birth: _____ Place of birth: _____

Social Security #: _____ Driver's license #: _____

Employer: _____ Work phone: _____

Parents' name (if alive): _____

Parents' address: _____ City: _____ ZIP Code: _____

Parents' home phone: _____

Executor/Trustee: _____

Address: _____ City: _____ ZIP Code: _____

Phone: _____ Form of reimbursement: _____

Legal Documents

Our will is located: _____

Our will was prepared by: _____ On (date): _____

Attorney's address: _____ City: _____ ZIP Code: _____

Attorney's phone: _____

Our living trust is located: _____

Our living trust was prepared by: _____ On (date): _____

Attorney's address: _____ City: _____ ZIP Code: _____

Attorney's phone: _____

Our Power-of-Attorney document is located: _____

Our Power-of-Attorney document was prepared by: _____ On (date): _____

Attorney's address: _____ City: _____ ZIP Code: _____

Attorney's phone: _____

Information for Personal Representative *(continued)*

Accountants/CPA's

Accountant/CPA: _____ Phone: _____

Accountant's address: _____ City: _____ ZIP Code: _____

Services rendered: _____

Banks/Safe Deposit Boxes

Safe-deposit box is located: _____ Phone: _____

Address: _____ City: _____ ZIP Code: _____

Safe-deposit box number: _____ Safe-deposit key is located: _____

Names of safe-deposit box users: _____

Names of beneficiaries on safe-deposit box: _____

Safe-deposit box is located: _____ Phone: _____

Address: _____ City: _____ ZIP Code: _____

Safe-deposit box number: _____ Safe-deposit key is located: _____

Names of safe-deposit box users: _____

Names of beneficiaries on safe-deposit box: _____

Bank (checking account): _____ Phone: _____

Bank address: _____ City: _____ ZIP Code: _____

Checking account #: _____ Check-overdraft-protection account: _____

Average daily balance: _____ Date of this average daily balance: _____

ATM Card #: _____ Password: _____

Bank (checking account): _____ Phone: _____

Bank address: _____ City: _____ ZIP Code: _____

Checking account #: _____ Check-overdraft-protection account: _____

Average daily balance: _____ Date of this average daily balance: _____

ATM Card #: _____ Password: _____

Bank (savings account): _____ Phone: _____

Bank address: _____ City: _____ ZIP Code: _____

Savings account #: _____ ATM card #: _____ Password: _____

Average daily balance: _____ Date of this average daily balance: _____

Bank (savings account): _____ Phone: _____

Bank address: _____ City: _____ ZIP Code: _____

Savings account #: _____ ATM card #: _____ Password: _____

Average daily balance: _____ Date of this average daily balance: _____

Information for Personal Representative *(continued)*

Money-Market/Certificate-of-Deposit Accounts

Bank: _____ Phone: _____

Address: _____ City: _____ ZIP Code: _____

Account #: _____ Terms: _____

Balance: _____ Date of balance: _____ Interest rate: _____

Grace period: _____ Maturation date: _____

Location of certificate and policies: _____

Bank: _____ Phone: _____

Address: _____ City: _____ ZIP Code: _____

Account #: _____ Terms: _____

Balance: _____ Date of balance: _____ Interest rate: _____

Grace period: _____ Maturation date: _____

Location of certificate and policies: _____

Bonds/Treasury Bills

Type: _____ Name on certificate: _____

Value: _____ Date purchased: _____

Social security #: _____ Bonds/Treasury bills located: _____

Type: _____ Name on certificate: _____

Value: _____ Date purchased: _____

Social security #: _____ Bonds/Treasury bills located: _____

Type: _____ Name on certificate: _____

Value: _____ Date purchased: _____

Social security #: _____ Bonds/Treasury bills located: _____

Type: _____ Name on certificate: _____

Value: _____ Date purchased: _____

Social security #: _____ Bonds/Treasury bills located: _____

Trust Funds

Type: _____ Name on certificate: _____

Value: _____ Date purchased: _____

Attorney: _____ Trustee: _____

Type: _____ Name on certificate: _____

Value: _____ Date purchased: _____

Attorney: _____ Trustee: _____

Information for Personal Representative *(continued)*

I.R.A.s/Retirement Plans

Bank/institution: _____ Account holder: _____

Broker/agent: _____ Phone: _____

Address: _____ City: _____ ZIP Code: _____

Value: _____ Purchase dates: _____ Account #: _____

Maturation date: _____ Beneficiary: _____

Location of I.R.A.'s: _____

Bank/institution: _____ Account holder: _____

Broker/agent: _____ Phone: _____

Address: _____ City: _____ ZIP Code: _____

Value: _____ Purchase dates: _____ Account #: _____

Maturation date: _____ Beneficiary: _____

Location of I.R.A.'s: _____

Profit Sharing

Company: _____ Contact: _____

Address: _____ City: _____ ZIP Code: _____

Year started: _____ Maturation date: _____

Location of document: _____

Company: _____ Contact: _____

Address: _____ City: _____ ZIP Code: _____

Year started: _____ Maturation date: _____

Location of document: _____

Stocks/Securities

Type of stock: _____ Full name of stockholder: _____

Transfer agent: _____ Phone: _____

Address: _____ City: _____ ZIP Code: _____

Certificate #: _____ # of shares: _____ Date of purchase: _____

Value of stock at time of purchase: _____ Location of certificates: _____

Type of stock: _____ Full name of stockholder: _____

Transfer agent: _____ Phone: _____

Address: _____ City: _____ ZIP Code: _____

Certificate #: _____ # of shares: _____ Date of purchase: _____

Value of stock at time of purchase: _____ Location of certificates: _____

Information for Personal Representative *(continued)*

Interests in Partnerships

Name of partnership: _____ # of partners: _____

Partner #1: _____ Address: _____

City: _____ ZIP Code: _____ Phone: _____ Percentage: _____

Partner #2: _____ Address: _____

City: _____ ZIP Code: _____ Phone: _____ Percentage: _____

Partner #3: _____ Address: _____

City: _____ ZIP Code: _____ Phone: _____ Percentage: _____

Company/product interest in: _____

Invested capital: _____ Your percentage: _____ Date of partnership: _____

Dividends: _____ Terms: _____

Location of Partnership Agreement: _____

Name of partnership: _____ # of partners: _____

Partner #1: _____ Address: _____

City: _____ ZIP Code: _____ Phone: _____ Percentage: _____

Partner #2: _____ Address: _____

City: _____ ZIP Code: _____ Phone: _____ Percentage: _____

Partner #3: _____ Address: _____

City: _____ ZIP Code: _____ Phone: _____ Percentage: _____

Company/product interest in: _____

Invested capital: _____ Your percentage: _____ Date of partnership: _____

Dividends: _____ Terms: _____

Location of Partnership Agreement: _____

Limited Partnership

Name of partnership: _____ # of partners: _____

Partner #1: _____ Address: _____

City: _____ ZIP Code: _____ Phone: _____ Percentage: _____

Partner #2: _____ Address: _____

City: _____ ZIP Code: _____ Phone: _____ Percentage: _____

Partner #3: _____ Address: _____

City: _____ ZIP Code: _____ Phone: _____ Percentage: _____

Company/product interest in: _____

Invested capital: _____ Your percentage: _____ Date of partnership: _____

Dividends: _____ Terms: _____

Location of Partnership Agreement: _____

Information for Personal Representative (continued)

Notes Receivable

Lendee: _____ Phone: _____

Address: _____ City: _____ ZIP Code: _____

Total loan amount: _____ Date of loan: _____

Terms: _____ Due date: _____

Location of documents: _____

Lendee: _____ Phone: _____

Address: _____ City: _____ ZIP Code: _____

Total loan amount: _____ Date of loan: _____

Terms: _____ Due date: _____

Location of documents: _____

Lendee: _____ Phone: _____

Address: _____ City: _____ ZIP Code: _____

Total loan amount: _____ Date of loan: _____

Terms: _____ Due date: _____

Location of documents: _____

Notes Payable

Lender: _____ Phone: _____

Address: _____ City: _____ ZIP Code: _____

Total loan amount: _____ Date of loan: _____

Terms: _____ Due date: _____

Location of documents: _____

Lender: _____ Phone: _____

Address: _____ City: _____ ZIP Code: _____

Total loan amount: _____ Date of loan: _____

Terms: _____ Due date: _____

Location of documents: _____

Lender: _____ Phone: _____

Address: _____ City: _____ ZIP Code: _____

Total loan amount: _____ Date of loan: _____

Terms: _____ Due date: _____

Location of documents: _____

Information for Personal Representative *(continued)*

Real Estate: Home

Home address: _____ City: _____ ZIP Code: _____

First mortgage co.: _____ Loan #: _____ Phone: _____

Mortgage co. address: _____ City: _____ ZIP Code: _____

Term: _____ Interest rate: _____ Percentage of ownership: _____

Second mortgage co.: _____ Loan #: _____ Phone: _____

Second mortgage co. address: _____ City: _____ ZIP Code: _____

Term: _____ Interest rate: _____ Percentage of ownership: _____ APN: _____

Improvements made: _____

Cost of improvement: _____ Added value: _____

Location of documents: _____

Partner: _____ Percentage of ownership: _____

Address: _____ City: _____ ZIP Code: _____

Partner's phone: _____ Special terms or arrangement: _____

Partner: _____ Percentage of ownership: _____

Address: _____ City: _____ ZIP Code: _____

Partner's phone: _____ Special terms or arrangement: _____

Real Estate: Investment (Type: _____)

Investment address: _____ City: _____ ZIP Code: _____

First mortgage co.: _____ Loan #: _____ Phone: _____

Mortgage co. address: _____ City: _____ ZIP Code: _____

Term: _____ Interest rate: _____ Percentage of ownership: _____

Second mortgage co.: _____ Loan #: _____ Phone: _____

Second mortgage co. address: _____ City: _____ ZIP Code: _____

Term: _____ Interest rate: _____ Percentage of ownership: _____ APN: _____

Improvements made: _____

Cost of improvement: _____ Added value: _____

Location of documents: _____

Partner: _____ Percentage of ownership: _____

Address: _____ City: _____ ZIP Code: _____

Partner's phone: _____ Special terms or arrangement: _____

Partner: _____ Percentage of ownership: _____

Address: _____ City: _____ ZIP Code: _____

Partner's phone: _____ Special terms or arrangement: _____

Real Estate: Investment (Type: _____)

Investment address: _____ City: _____ ZIP Code: _____

First mortgage co.: _____ Loan #: _____ Phone: _____

Mortgage co. address: _____ City: _____ ZIP Code: _____

Term: _____ Interest rate: _____ Percentage of ownership: _____

Second mortgage co.: _____ Loan #: _____ Phone: _____

Second mortgage co. address: _____ City: _____ ZIP Code: _____

Term: _____ Interest rate: _____ Percentage of ownership: _____ APN: _____

Improvements made: _____

Cost of improvement: _____ Added value: _____

Location of documents: _____

Partner: _____ Percentage of ownership: _____

Address: _____ City: _____ ZIP Code: _____

Partner's phone: _____ Special terms or arrangement: _____

Partner: _____ Percentage of ownership: _____

Address: _____ City: _____ ZIP Code: _____

Partner's phone: _____ Special terms or arrangement: _____

Partner: _____ Percentage of ownership: _____

Address: _____ City: _____ ZIP Code: _____

Partner's phone: _____ Special terms or arrangement: _____

Cemetery Plot/Crematory

Cemetery: _____ Plot #: _____

Address: _____ City: _____ ZIP Code: _____

Contact: _____ Phone: _____

Total purchase amount: _____ Terms: _____

Location of documents: _____

Crematory: _____

Address: _____ City: _____ ZIP Code: _____

Contact: _____ Phone: _____

Total purchase amount: _____ Terms: _____

Location of documents: _____

Copyrights, Patents, and Trademarks

Company: _____ Contact: _____

Address: _____ City: _____ ZIP Code: _____

Phone: _____ ID #: _____

Description: _____

Terms: _____

Location of documents: _____

Company: _____ Contact: _____

Address: _____ City: _____ ZIP Code: _____

Phone: _____ ID #: _____

Description: _____

Terms: _____

Location of documents: _____

Company: _____ Contact: _____

Address: _____ City: _____ ZIP Code: _____

Phone: _____ ID #: _____

Description: _____

Terms: _____

Location of documents: _____

Automobiles

Automobile make: _____ Model: _____ Year: _____

VIN: _____ License plate #: _____

Registration #: _____ Date purchased: _____

Percentage of ownership: _____ Partners: _____

Partner's address: _____ City: _____ ZIP Code: _____

Loan company: _____ Loan #: _____

Loan amount: _____ Terms: _____

Location of pink slip and loan documents: _____

Automobile make: _____ Model: _____ Year: _____

VIN: _____ License plate #: _____

Registration #: _____ Date purchased: _____

Percentage of ownership: _____ Partners: _____

Partner's address: _____ City: _____ ZIP Code: _____

Loan company: _____ Loan #: _____

Loan amount: _____ Terms: _____

Location of pink slip and loan documents: _____

Information for Personal Representative (continued)

Boats

Boat make: _____ Model: _____ Year: _____

Hull #: _____ Certificate: _____

Registration #: _____ Date purchased: _____

Percentage of ownership: _____ Partners: _____

Partner's address: _____ City: _____ ZIP Code: _____

Loan company: _____ Loan #: _____

Loan amount: _____ Terms: _____

Location of pink slip and loan documents: _____

Boat make: _____ Model: _____ Year: _____

Hull #: _____ Certificate: _____

Registration #: _____ Date purchased: _____

Percentage of ownership: _____ Partners: _____

Partner's address: _____ City: _____ ZIP Code: _____

Loan company: _____ Loan #: _____

Loan amount: _____ Terms: _____

Location of pink slip and loan documents: _____

Insurance Policies

Homeowner's insurance company: _____ Phone: _____

Address: _____ City: _____ ZIP Code: _____

Agent: _____ Policy #: _____

Premium amount: _____ Premium due date: _____

Coverage: _____

Insurance documents are located: _____

Renter's insurance company: _____ Phone: _____

Address: _____ City: _____ ZIP Code: _____

Agent: _____ Policy #: _____

Premium amount: _____ Premium due date: _____

Coverage: _____

Insurance documents are located: _____

Landlord's insurance company: _____ Phone: _____

Address: _____ City: _____ ZIP Code: _____

Agent: _____ Policy #: _____ For: _____

Premium amount: _____ Premium due date: _____

Coverage: _____

Insurance documents are located: _____

Landlord's insurance company: _____ Phone: _____

Address: _____ City: _____ ZIP Code: _____

Agent: _____ Policy #: _____ For: _____

Premium amount: _____ Premium due date: _____

Coverage: _____

Insurance documents are located: _____

Life-insurance company: _____ Phone: _____

Address: _____ City: _____ ZIP Code: _____

Agent: _____ Policy #: _____ For: _____

Beneficiaries: _____

Face amount: _____ Type of insurance: _____

Premium amount: _____ Premium due date: _____

Coverage: _____

Insurance documents are located: _____

Life-insurance company: _____ Phone: _____

Address: _____ City: _____ ZIP Code: _____

Agent: _____ Policy #: _____ For: _____

Beneficiaries: _____

Face amount: _____ Type of insurance: _____

Premium amount: _____ Premium due date: _____

Coverage: _____

Insurance documents are located: _____

Information for Personal Representative *(continued)*

Recreational insurance company: _____ Phone: _____

Address: _____ City: _____ ZIP Code: _____

Agent: _____ Policy #: _____ For: _____

Premium amount: _____ Premium due date: _____

Coverage: _____

Insurance documents are located: _____

Umbrella-insurance company: _____ Phone: _____

Address: _____ City: _____ ZIP Code: _____

Agent: _____ Policy #: _____ For: _____

Premium amount: _____ Premium due date: _____

Coverage: _____

Insurance documents are located: _____

Condominium-insurance company: _____ Phone: _____

Address: _____ City: _____ ZIP Code: _____

Agent: _____ Policy #: _____ For: _____

Premium amount: _____ Premium due date: _____

Coverage: _____

Insurance documents are located: _____

Medical-insurance company: _____ Phone: _____

Address: _____ City: _____ ZIP Code: _____

Agent: _____ Policy #: _____

Plan: _____

Premium amount: _____ Premium due date: _____

Coverage: _____

Insurance documents are located: _____

Dental-insurance company: _____ Phone: _____

Address: _____ City: _____ ZIP Code: _____

Agent: _____ Policy #: _____

Plan: _____

Premium amount: _____ Premium due date: _____

Coverage: _____

Insurance documents are located: _____

Information for Personal Representative (continued)

Automobile-insurance company: _____ Phone: _____

Address: _____ City: _____ ZIP Code: _____

Agent: _____ Policy #: _____ For: _____

VIN: _____ License plate #: _____

Premium amount: _____ Premium due date: _____

Coverage: _____

Insurance documents are located: _____

Automobile-insurance company: _____ Phone: _____

Address: _____ City: _____ ZIP Code: _____

Agent: _____ Policy #: _____ For: _____

VIN: _____ License plate #: _____

Premium amount: _____ Premium due date: _____

Coverage: _____

Insurance documents are located: _____

Boat-insurance company: _____ Phone: _____

Address: _____ City: _____ ZIP Code: _____

Agent: _____ Policy #: _____ For: _____

Hull #: _____ Certificate #: _____

Premium amount: _____ Premium due date: _____

Coverage: _____

Insurance documents are located: _____

Disability-insurance company: _____ Phone: _____

Address: _____ City: _____ ZIP Code: _____

Agent: _____ Policy #: _____ For: _____

Premium amount: _____ Premium due date: _____

Coverage: _____

Insurance documents are located: _____

Other insurance company: _____ Phone: _____

Address: _____ City: _____ ZIP Code: _____

Agent: _____ Policy #: _____ For: _____

Premium amount: _____ Premium due date: _____

Coverage: _____

Insurance documents are located: _____

Information for Personal Representative *(continued)*

Keys

House keys are located: _____

Car #1 (_____) Keys are located: _____

Car #2 (_____) Keys are located: _____

Car #3 (_____) Keys are located: _____

Mail-box keys are located: _____

Safe-deposit keys are located: _____

Investment property (_____) Keys are located: _____

Investment property (_____) Keys are located: _____

Investment property (_____) Keys are located: _____

Investment property (_____) Keys are located: _____

Boat keys are located: _____

Storage keys are located: _____

Safe (_____) Keys are located/combination: _____

Safe (_____) Keys are located/combination: _____

Other: _____

Bills and Records

Adoption papers are kept: _____

Appraisals for antiques and jewelry are kept: _____

Archive of bills and records is kept: _____

Archive of tax records is kept: _____

Birth certificates are kept: _____

Business records and agreements are kept: _____

Completed insurance claims forms are kept: _____

Dental records are kept: _____

Incoming bills are kept: _____

Lease agreements are kept: _____

Marriage certificates are kept: _____

Medical bills are kept: _____

Medical records are kept: _____

Military records are kept: _____

Naturalization papers are kept: _____

Paid bills and receipts are kept: _____

Pet (AKC) records are kept: _____

Retirement plans are kept: _____

Safes and hiding places for cash or valuables are located: _____

Social security cards are kept: _____

Tax records are kept: _____

Union records are kept: _____

Information for Personal Representative *(continued)*

Physicians

Physician: _____ Phone: _____

Address: _____ City: _____ ZIP Code: _____

Practice: _____ For: _____

Physician: _____ Phone: _____

Address: _____ City: _____ ZIP Code: _____

Practice: _____ For: _____

Physician: _____ Phone: _____

Address: _____ City: _____ ZIP Code: _____

Practice: _____ For: _____

Dentist/Orthodontist

Dentist: _____ Phone: _____

Address: _____ City: _____ ZIP Code: _____

Practice: _____ For: _____

Orthodontist: _____ Phone: _____

Address: _____ City: _____ ZIP Code: _____

Practice: _____ For: _____

Schools

School: _____ For: _____

Address: _____ City: _____ ZIP Code: _____

Teacher: _____ Phone: _____

School: _____ For: _____

Address: _____ City: _____ ZIP Code: _____

Teacher: _____ Phone: _____

School: _____ For: _____

Address: _____ City: _____ ZIP Code: _____

Teacher: _____ Phone: _____

Travel Agent

Travel agency: _____

Address: _____ City: _____ ZIP Code: _____

Agent: _____ Phone: _____

Credit card used for travel: _____ Life-insurance coverage: _____

Information for Personal Representative *(continued)*

Important Family Members

Name: _____ Relationship: _____ Phone: _____
Address: _____ City: _____ ZIP Code: _____

Name: _____ Relationship: _____ Phone: _____
Address: _____ City: _____ ZIP Code: _____

Name: _____ Relationship: _____ Phone: _____
Address: _____ City: _____ ZIP Code: _____

Name: _____ Relationship: _____ Phone: _____
Address: _____ City: _____ ZIP Code: _____

Name: _____ Relationship: _____ Phone: _____
Address: _____ City: _____ ZIP Code: _____

Name: _____ Relationship: _____ Phone: _____
Address: _____ City: _____ ZIP Code: _____

Name: _____ Relationship: _____ Phone: _____
Address: _____ City: _____ ZIP Code: _____

Close Friends Who Can Help

Name: _____ Relationship: _____ Phone: _____
Address: _____ City: _____ ZIP Code: _____

Name: _____ Relationship: _____ Phone: _____
Address: _____ City: _____ ZIP Code: _____

Name: _____ Relationship: _____ Phone: _____
Address: _____ City: _____ ZIP Code: _____

Name: _____ Relationship: _____ Phone: _____
Address: _____ City: _____ ZIP Code: _____

Name: _____ Relationship: _____ Phone: _____
Address: _____ City: _____ ZIP Code: _____

Name: _____ Relationship: _____ Phone: _____
Address: _____ City: _____ ZIP Code: _____

Chapter 11

Elder Care

Parents of the Baby Boom generation are reaching the age where they may need assistance when their health begins to fail them. The exploding Baby Boom generation (born between 1946 and 1965) will turn 65 between the years 2011 and 2030, exponentially increasing the geriatric population. Even now, the government, medical programs, and insurance companies are faced with addressing the question "Who is going to care for the massive numbers of elderly people?" Managing your mom's or dad's health care in addition to having a full-time job, children in school, and a spouse takes awareness of your resources and careful planning.

Handling elder care is probably something that you've never had to deal with. Unlike preparing to start a family or saving dollars for college tuition, most families don't set aside money for their parents' care. As the average life expectancy increases each decade, it will soon become commonplace for families to have children in day care and grandparents in adult care. Learning how to manage elder care is something that we'll all have to face.

Getting Started: Discuss Care with Your Parents

Although the bond between a parent and a child is strong, it is constantly changing. A mother and father bring their child into the world and care for the helpless infant with love. As the baby explores his or her world and interacts with the environment, a parent's role begins to change to accommodate the child's independence. Each parent reflects the guidance received from his or her parents and what is learned from the environment. Parents use trial and error and their best judgment to raise their children; they often make mistakes. Unfortunately, babies don't come into this world with a user's manual. As a result, many parent-child relationships are strained by feelings of guilt, pressure, anger, or injustice. The teenage years are often riddled with turmoil, followed by young adulthood, which usually brings better relationships between parent and child. Marriages and grandchildren bring both good and bad memories of childhood. When a parent reaches the age when he or she begins to lose control over mind and body, the parent-child role is reversed. The child becomes the parent and the parent becomes the child. This period is awkward for both parent and child as they wrestle with denial, diplomacy, and guilt. Until a major event occurs—an accident or health problem—both parent and child hope that they will never have to deal with the inevitable—parent care.

It is important to discuss parent care with your siblings or others who—you hope—will need to help you handle your parents' care. It's important to get your parents' input about their future before it's too late for them to communicate their wishes. Find a time to discuss their future desires. Use the "Questions to Ask Your Parent" worksheet on page 248. Ask questions candidly. Use the Inventory lists on page 199 to get a complete list of their personal possessions. This will help them to remember what they own and what they would like to pass on to others. Complete the "Information for Personal Representative" on page 223. This information will be invaluable in the event of a parent's death. If more than one sibling will participate in parent care, arrange meetings at which all can attend. For those who live out of the area, suggest a conference call. If it is impossible to find a time when everyone can meet, videotape or tape-record the meeting and send it to those who could not attend. (It's the next best thing to being there.) Personal letters written to summarize the meeting often do not reflect the true intentions or the tone of those present. Use the "List of Parent's Documents and Information" on page 249 to keep track of your parents' documents.

How to Get the Medical and Legal Information You Need

You should know about your parents' medical conditions or problems, as well as their medical coverage, so you will be able to offer your parents any help that they may need.

Meet with Your Parents' Doctors

Gather information about your parents' health history. Ask detailed questions about current symptoms before going to the doctor's office; elderly people often become confused when talking to the doctor. Fill out the "Parent's Medical-Assessment Worksheet" on page 250. Include the length of time, onset, and severity of each symptom. Also list the history of past illnesses, surgeries, tests, procedures, and other health and mental complications. Fill out the list of prescription drugs, over-the-counter drugs, vitamin supplements, homeopathic remedies, and any kinds of pharmaceutical supplements that your parents have taken in the past or are currently taking. Include information about diet, allergies, exercise, eyeglasses and hearing aids, substance abuse, exposure to heavy metals or toxic chemicals, and a family history of physical and mental illnesses. Make copies and take them with you when meeting with new doctors. This makes the appointment more efficient and gives the doctor reliable information to keep in the file. Use the "Doctor's Appointment Checklist" on page 251.

Copy all insurance, Medicare, Medicaid, and Medigap documents. Keep the cards in a file in a safe place. Take copies of these documents with you to the doctor's office.

Check Your Parents' Insurance Policies

Although medical bills are usually covered by private health-insurance policies and Medicare, long-term health care is not. Check to ensure that your parents have a policy that covers health care and long-term care. They'll get better coverage at a more reasonable premium if they set it up now. Your parent may become ineligible for insurance coverage when diagnosed with a serious illness or when in need of long-term care. Hospital stays, prescription drugs, rehabilitation services, and long-term care costs can bankrupt everyone but the independently wealthy. Make sure insurance premiums are paid on time to avoid cancellation of a policy when your parent really needs it.

Explore Medical Programs

Familiarize yourself with the various programs available, and for which your parents may be qualified.

MEDICARE Medicare is a federal health-insurance program for people over the age of 65 and for some disabled people under the age of 65. If your parent receives Social Security payments, enrollment in Medicare will be automatic at age 65. If your parent doesn't receive Social Security payments, application for Medicare should be made 3 months before the sixty-fifth birthday. There is a 7-month enrollment period: 3 months before to 4 months after the sixty-fifth birthday. Missing the enrollment period can delay payments.

There are two parts to Medicare—Part A and Part B. Most hospital costs and limited nursing-home care costs are covered by Medicare Part A. Your parent will be required to pay some deductibles and co-payments.

Doctor's fees, medical equipment, tests, outpatient hospital care, limited medications, and some preventative care are covered by Medicare Part B. Enrollment in Part B is automatic when a parent is qualified for Plan A; however, there is a monthly premium, an annual deductible, and a co-payment.

QUALIFIED MEDICAL BENEFITS If your parents' income is below the national poverty level and they have little in the way of assets, they may be eligible for Qualified Medical Benefits. The state pays Medicare Plan B monthly premiums, annual deductibles, and most co-payments.

SPECIFIED LOW-INCOME MEDICARE-BENEFICIARY PROGRAM If your parents' income is only 10 percent above the national poverty level, they would qualify for the Specified Low-Income Medicare-Beneficiary Program that covers Part B premiums.

MEDICAID Medicaid covers most health-care costs (including long-term care) for those in financial need. Unfortunately, many doctors and health-care services won't accept patients on Medicaid because their reimbursement schedule is low compared to Medicare and private insurance. Many of the finer nursing homes and retirement communities have waiting lists for enrollment, making it unlikely that they would take people on Medicaid. (This program is called Medi-Cal in California.)

Although the care received may not be what you want, when your parents' assets are gone, it can be a relief to know that Medicaid is there to pay the bills. A person is allowed to own a home, car, personal belongings, and to have a small savings account to qualify for Medicaid. Because eligibility requirements vary from state to state and depend upon whether both parents are living, what type of life insurance they have, and what other government assistance is being received, it is often a good idea to consult an attorney who specializes in Medicaid planning before applying to the program. Even though your parents may have a sizable savings account, the exorbitant costs of nursing care can quickly drain their assets, making them candidates for Medicaid. By meeting with an attorney before your parents' savings are depleted, they may be able to protect their assets and go on Medicaid, before losing everything.

To apply for Medicaid, contact the Area Agency on Aging, local senior organizations, the American Association of Retired Persons (AARP), or the Department of Social Services to get the most current information about Medicaid. Make copies of birth certificates, Social Security cards, tax records, proof of current income from Social Security and retirement benefits, current bank and savings statements, rent and utility bills or receipts, and all health-insurance policies and take them with you when applying for Medicaid.

MEDIGAP Understanding what your parents' private insurance and Medicare insurance policies cover is confusing even to those in the health-care profession. State and federal laws are constantly changing regarding insurance-policy coverage. Private insurance companies offer Medigap to cover many of the fees and claims that Medicare does not

(monthly premiums, co-payments, deductibles, and excess doctor's fees). Medigap coverage should be applied for within six months of enrolling in Medicare Part B, to ensure that your parents will not be denied coverage because of existing medical conditions. After the six-month period, the insurance companies can refuse coverage or increase premiums. Medigap does not cover long-term care or options outside the regular Medicare coverage.

MANAGED-CARE PLANS Managed-care plans combine health care, Medicare, and health insurance into one policy. The patient receives comprehensive coverage and pays a lower premium. The downside is that the choice of physicians, nurses, and other specialists is limited to those approved by the plan. Although the choice is limited, the plans include services such as dental care, preventative care, medications, eyeglasses, and hearing aids.

LONG-TERM CARE POLICIES Assuming your parents will need nursing home or in-home care for an extended period of time and don't qualify for Medicaid, their personal savings and assets will pay for all long-term care until they run out of money and qualify for Medicaid, if they do not have a long-term care policy. Long-term care is not generally covered by personal health insurance or Medicare. Relatively new to the insurance world, long-term care protects the assets of the wealthy.

When selecting long-term care insurance, make sure it covers in-home care, custodial care, homemakers, companions, and respite care if your parents want to live at home. Be careful to select a policy that doesn't have prerequisites for coverage. Your parents should be able to get the help they need without taking unnecessary steps to satisfy the insurance company.

Most insurance companies pay a fixed dollar amount per day for long-term care. If your parents buy the policy today but may not need it for 10 to 15 years, they may find that the policy pays only a small fraction of their long-term-care costs and they'll need to contribute personal funds to pay the balance. If it is unlikely that your parents will need nursing care in the near future, consider the inflation policy that will increase the fee-per-day benefit based on an inflation schedule.

Legal Information

Review your parents' wills, living trusts, durable power of attorney, and powers of attorney for health care (if any).

If your parents have not written or considered a will, living trust, or power of attorney, now would be a good time to encourage them to consider these. By not having documents updated, your parents' wishes may not be guaranteed when they are unable to care for themselves, or after their death. If siblings or other family members are involved, a will can help reduce the likelihood of family squabbles over personal belongings or family heirlooms. See Chapter 10, "Powers of Attorney, Wills, and Living Trusts."

How to Protect Your Parents from a Distance

Whether you live out of state or in the next town, if your parents are living alone, set up some precautionary systems so that if a parent falls or incurs a serious problem, help will be available immediately.

Put a medical-emergency card in your parents' wallets or on a chain to be worn around the neck. Use the "Medical Emergency Card" form on page 252. To protect the card, laminate it at a copy service center.

Emergency-response systems give both you and your parent a sense of security knowing that if something should happen, a push of a button (on the clothing) will get an immediate response from the center over the phone or on two-way intercom. If your parent doesn't respond or if he or she is having a serious health problem, emergency medical crews are sent immediately. Ask your parent's doctor for a referral to set up an emergency-response system in the home. These systems can be purchased or rented.

Seek Help Through Local Agencies

While your mom or dad are still living at home, there are many senior-service programs (funded by the government or privately) that can help them to be as independent as possible. Geriatric-care management helps the elderly to understand their situation, to set up appropriate services, and to organize all health aides. Personal-care services provide assistance with bathing, dressing, feeding, walking, medical care, and light housekeeping. Homemakers and assistants help with household activities, shopping, and transportation. Physical therapists and occupational therapists assist recovering patients in relearning basic skills such as taking care of personal hygiene, eating, and walking. Nurses are available for hire to provide necessary medical care. Adult day care is available for those who enjoy out-of-home activities. Respite caregivers offer the primary caregiver a break from round-the-clock care. Call your local hospital's discharge planner or senior center for the names and phone numbers of agencies that have services available in your area. These services are often covered by Medicare or charge fees on a sliding scale.

Most communities have organizations that are comprised of volunteers who provide handyman services and light housekeeping for seniors. There are meal programs that either deliver dinners to seniors who can't leave their homes or that provide dining-room service in community centers. Activities for those over 65 are offered by senior centers and adult day-care centers for a fee (often on a sliding scale). Use the "Elder-Care In-Home Service Worksheet" on page 253.

Find Transportation

If your parent becomes immobile and requires a wheelchair for mobilization, seek transportation services that have vans with wheelchair ramps.

Many transportation services for the handicapped are available at low costs. Ask your doctor for a referral for transportation options. Use the "Transportation-Service Worksheet" on page 254.

Difficult Choices: Select the Best Housing Option

As safety becomes a concern, you'll need to change your parents' living situation to provide safety for them and sanity for you. Many families opt to rotate the responsibility of checking up on parents among the siblings. This is often a temporary measure. You will want to find a permanent nursing solution most suitable for your parents' needs. Consider the options that follow.

Home Health Aides

If your parents are comfortable in their own home, but need some assistance, hire in-home health aides or seek out volunteers. Use the "In-Home Job Description" on page 255 and "In-Home Caregiver Application Form" on page 256. See "Developing a Job Description" on page 117 and "How to Hire a Caregiver" on page 118. If your parent is terminally ill (that is, the prognosis is less than six months), in many instances hospices may provide health aides, nurses, and counseling staff at little or no cost.

Move Parents into Your Home

When it becomes obvious that your parents can't stay in their home because they need round-the-clock care, you may opt to move them into your home. If your children are still living at home, they will have the opportunity to spend lots of time with them and they'll learn about the process of aging. If you work, adult-day care centers are starting to open up across the country to meet the needs of busy families and the growing population of senior citizens.

Adult day-care centers provide a safe environment filled with activities, classes, and entertainment. Meals, medications, and medical services are also available. Check with your Area Agency on Aging for a list of centers.

Look into Assisted-Living Complexes

Assisted-living complexes provide seniors with guidance and help with daily tasks in the privacy of their own apartments or rooms. This is ideal for those who want to maintain their independence and are continent and lucid.

Check Out Congregate Housing

When managing the day care and health care of your parents becomes impossible or overwhelming both physically and emotionally, they are probably ready for congregate housing. This includes anything from shared rooms with friends to group housing. Congregate housing offers shared expenses to seniors who enjoy the companionship of others. Use the "Adult-Housing Worksheet" on page 258 to compare facilities.

Examine Nursing Homes

If your parent becomes incontinent, immobile, or suffers from dementia, a nursing home may be the only suitable option. Nursing homes offer round-the-clock medical care and supervision. With planned visits and shared visitation responsibilities with siblings, friends, and relatives, this move can be a good one. Your parent can enjoy the company of friends and family, while feeling secure knowing that qualified medical attention is available at all times.

Summing Up

Having to care for an aging or dying parent is a wrenching emotional experience, and lack of proper planning can only make it worse. In the near future, our elderly population will soar as the Baby Boom generation ages and medical advances increase life expectancy. With good planning, your parents' health-care needs can be met so that they will live the rest of their lives in the most comfortable fashion possible while you can maintain control over your life and your family. Discuss their needs and desires and then get the ball rolling. Make sure that their legal documents are current and reflect their wishes. Check their insurance policies to ensure that they have good coverage to handle all their medical and long-term care needs. Meet with a Medicaid planner or your attorney to protect their assets and ensure that necessary funds will be there for the rest of their lives. By starting to take these precautionary steps now, you'll be prepared for the time when they may need your care, as well as your love.

Elder-Care Organizers

Questions to Ask Your Parent
List of Parent's Documents and Information
Parent's Medical-Assessment Worksheet

Doctor's Appointment Checklist
Medical Emergency Card
Elder-Care In-Home Service Worksheet
Transportation-Services Worksheet
In-Home Job Description
In-Home Caregiver Application Form
Adult-Housing Worksheet
Physical-Therapy and Rehabilitation-Services Worksheet
Important Phone Numbers

Questions to Ask Your Parent

1. Are there any goals you'd like to achieve that you haven't already?_____

2. Do you have any unresolved conflicts that you would like to clear up? _____

3. Whom would you like to spend time with? _____

4. Is there a religious organization with which you would like to become affiliated?_____

5. Is there a special place you would like to visit?_____

6. May I look at your finances? _____

7. Do you have a will? Attorney? Last update? _____

8. Do you have a living trust? Attorney? Last update?_____

9. Do you have a durable power of attorney? Attorney? Last update? _____

10. Do you have a durable power of attorney for health care? Attorney? Last update? ____

11. Do you have a CPA or an accountant? _____

12. Who handles your finances and tax information?_____

13. Do you have a list of assets? _____

14. Do you have life insurance, health insurance, long-term-care insurance, homeowner's
 insurance, and so on? Are they current? What types of coverage do you have? Is the
 coverage enough to handle your future needs? _____

15. When it becomes difficult for you to manage your home on your own,
 where would you like to live? _____

16. Is there a project you'd like to do? _____

17. If your health becomes unstable, where would you like to live? _____

18. If you become incontinent, where would you like to live? _____

19. Would you like to live in another area or near someone? _____

20. Does your doctor meet your health-care needs? _____

21. What aspects about your health are you concerned about? _____

22. Are you afraid of pain or about how you'll feel while taking pain killers? _____

23. At what point would you like to stop aggressive medical treatment? _____

24. What do you think happens after death? _____

25. What aspects of dying frighten you? _____

26. What type of funeral service would you like? _____

27. Would you like to be buried or cremated? If buried, where? Have you made burial
 arrangements?_____

List of Parent's Documents and Information

- ☐ Will
- ☐ Living trust
- ☐ Durable power of attorney
- ☐ Durable power of attorney for health care
- ☐ Medical records
- ☐ List of doctors, dentists, alternative medical professionals
- ☐ CPA or accountant
- ☐ Tax records (last 3-5 years)
- ☐ Stocks, bonds, mutual funds
- ☐ Pensions
- ☐ Mortgage documents
- ☐ Insurance policies
- ☐ Medicare policy
- ☐ Medicaid policy
- ☐ Medigap policy
- ☐ Safe-deposit keys
- ☐ Other keys:
- ☐ Personal loan documents
- ☐ Location of safes
- ☐ Location of hidden valuables
- ☐ Location of monthly bills

Parent's Medical-Assessment Worksheet

Name: _____ Caregiver: _____

Address: _____ City: _____

Home phone: _____ Caregiver phone: _____

Age: _____ Medications/dosage: _____

Vitamin supplements: _____ Allergies: _____

Problem: _____

Description of ailment: _____

Symptoms started: _____

Are the symptoms constant or periodic? _____

Are the symptoms severe or dull? _____

What have you done to remedy the symptoms?_____

Two-week record of symptoms

Sunday	Monday	Tuesday	Wednesday	Thursday	Friday	Saturday
Symptom:	Symptom:	Symptom:	Symptom:	Symptom:	Symptom:	Symptom:
Symptom:	Symptom:	Symptom:	Symptom:	Symptom:	Symptom:	Symptom:

Other doctors' diagnosis: _____

Other practitioners' diagnosis: _____

Medical history _____ Date _____ Outcome_____

Past surgeries _____

Past tests _____

Past procedures _____

Past illnesses _____

Past medications _____

Past treatments _____

Other information

Diet _____

Allergies _____

Vision _____

Hearing _____

Substance abuse _____

Exposure to heavy metals_____

Exposure to toxic chemicals_____

Other: _____

Family history of medical and mental illness _____

Illness _____ Relationship _____ Treatment _____ Outcome _____

Doctor's Appointment Checklist

- ☐ Patient's medical-assessment worksheet

- ☐ Insurance card

- ☐ Medicare card

- ☐ Medicaid card

- ☐ Medigap card

- ☐ Eyeglasses

- ☐ Hearing aid

- ☐ Walking aid

- ☐ X-rays

- ☐ Other medical records

Medical Emergency Card

Name:_____

Address: _____

Home phone: _____ Work phone: _____

Medical condition: _____

Medications: _____

Allergies:_____

Important information:

Doctor: _____ Phone: _____

Contact: _____ Home phone: _____

Cell phone: _____ Work phone: _____

Beeper #: _____ Car phone: _____

Medical Emergency Card

Name:_____

Address: _____

Home phone: _____ Work phone: _____

Medical condition: _____

Medications: _____

Allergies:_____

Important information:

Doctor: _____ Phone: _____

Contact: _____ Home phone: _____

Cell phone: _____ Work phone: _____

Beeper #: _____ Car phone: _____

Elder-Care In-Home Service Worksheet

Facility #1 _____
Address _____
Director _____
Phone _____
Hours _____
Program _____
Activities _____
Meals _____
Medication _____
Restrictions _____
Medical staff _____
Fees _____

Facility #2 _____
Address _____
Director _____
Phone _____
Hours _____
Program _____
Activities _____
Meals _____
Medication _____
Restrictions _____
Medical staff _____
Fees _____

Facility #3 _____
Address _____
Director _____
Phone _____
Hours _____
Program _____
Activities _____
Meals _____
Medication _____
Restrictions _____
Medical staff _____
Fees _____

Transportation-Services Worksheet

Company #1 _____

Address _____

Phone _____

Manager _____

Hours _____

Costs _____

Insurance _____

Type of Vehicle _____

Wheelchair accessible _____

Reservations _____

Driving range _____

Company #2 _____

Address _____

Phone _____

Manager _____

Hours _____

Costs _____

Insurance _____

Type of Vehicle _____

Wheelchair accessible _____

Reservations _____

Driving range _____

Company #3 _____

Address _____

Phone _____

Manager _____

Hours _____

Costs _____

Insurance _____

Type of Vehicle _____

Wheelchair accessible _____

Reservations _____

Driving range _____

In-Home Job Description

Days: _____ Hours: _____

Personal hygiene

Clothing: Wear comfortable, clean clothing appropriate for working with an elderly person.
Shower and wash hair daily. Use unscented deodorant and refrain from wearing perfumes.

Morning duties

☐ Bath:_____

☐ Brush teeth: _____

☐ Dress: _____

☐ Diaper:_____

☐ Hair: _____

☐ Makeup: _____

☐ Exercise: _____

☐ Walk: _____

☐ Meal preparation: _____

☐ Other: _____

Afternoon duties

☐ Meal: _____

☐ Hygiene check: _____

☐ Activities: _____

☐ Exercise: _____

☐ Meal preparation: _____

☐ Light housekeeping: _____

☐ Other: _____

Evening duties

☐ Meal: _____

☐ Hygiene: _____

☐ Activities: _____

☐ Exercise: _____

☐ Bath:_____

☐ Brush teeth: _____

☐ Bedtime: _____

☐ Light housekeeping: _____

☐ Other: _____

In-Home Caregiver Application Form

Personal Information

Name: _____

Maiden name or any other name used: _____

Current address: _____ City: _____ ZIP Code: _____

Home phone number: _____ Work phone number: _____

In case of emergency, person to contact: _____ Phone number: _____

Social Security #: _____ Number of dependents (optional): _____

General Information

What is your current work schedule? _____

What days and hours are you available? _____

How many years have you been an adult-care provider? _____

What do you enjoy most about working with adults? _____

Do you own your own car? _____ If "yes," is your car in good running condition? _____

Do you have liability insurance? _____ Insurance carrier: _____

Have you ever been convicted of a crime? _____ If "yes," please describe: _____

Educational Background

School	Name of School	City/State	Classes/Major	Degrees	Graduation	Employer's Notes (leave blank)
High						
College						
1st Aid						
Early Childhood Education						
Languages						
Sports/arts						
Other:						

Adult-Care References

Name	Address	Phone	Ages	Dates	Wages	Employer's Notes (leave blank)

Other Employment Background

Employer	Address	Phone	Job Description	Dates	Wages	Employer's Notes (leave blank)

In-Home Caregiver Application Form (continued)

Questions About Adult-Care Experience

In which age range do you feel most comfortable working? _____

Can you transfer? _____

Can you help with baths? _____

Can you cook? _____

Do you have training/certification in C.P.R. and first aid? _____

Questions About Your Personal Background

Are you punctual and responsible? _____

Do you own your own home or rent? _____

What are your short-term goals? _____

What are your long-term goals? _____

Describe your family (your relationship with your grandparents). Who handled their personal care? _____

Have you ever been charged with a traffic violation or involved in a car accident? _____

Are you willing to be fingerprinted and checked for abuse history with the state or federal government? _____

Is there anything you would like us to know about yourself? _____

All the above is true to the best of my knowledge.

_____ _____

Date Signature of Applicant

Adult-Housing Worksheet

Description	#1	#2	#3
Facility			
Address			
Director/manager			
Phone			
Hours			
Description			
Activities			
Programs			
Meals			
Housekeeping			
Transportation			
Health aides			
Medical staff			
Number of units			
Rooms			
Privacy			
Policy			
Restrictions			
Costs			
Insurance			
Waiting list			
Other:			

Physical-Therapy and Rehabilitation-Services Worksheet

Therapist/program #1 _____
Address _____
Phone _____
Hours _____
Director _____
Program _____
Facility _____
Qualification of staff_____
Dates/hours _____
Transportation _____
Insurance _____
Costs _____

Therapist/program #2 _____
Address _____
Phone _____
Hours _____
Director _____
Program _____
Facility _____
Qualification of staff_____
Dates/hours _____
Transportation _____
Insurance _____
Costs _____

Therapist/program #3 _____
Address _____
Phone _____
Hours _____
Director _____
Program _____
Facility _____
Qualification of staff_____
Dates/hours _____
Transportation _____
Insurance _____
Costs _____

Important Phone Numbers

Patient: _____

Address: _____

Home phone: _____

Doctor: _____ Phone: _____

Specialist: _____ Phone: _____

Dentist: _____ Phone: _____

Care manager: _____ Phone: _____

Health aide: _____ Phone: _____

Homemaker: _____ Phone: _____

Respite caregiver: _____ Phone: _____

Hospice: _____ Phone: _____

Hospital: _____ Phone: _____

Relative: _____ Phone: _____

Patient: _____

Address: _____

Home phone: _____

Doctor: _____ Phone: _____

Specialist: _____ Phone: _____

Dentist: _____ Phone: _____

Care manager: _____ Phone: _____

Health aide: _____ Phone: _____

Homemaker: _____ Phone: _____

Respite caregiver: _____ Phone: _____

Hospice: _____ Phone: _____

Hospital: _____ Phone: _____

Relative: _____ Phone: _____

Index